John Shaw's
CLOSEUPS
IN NATURE

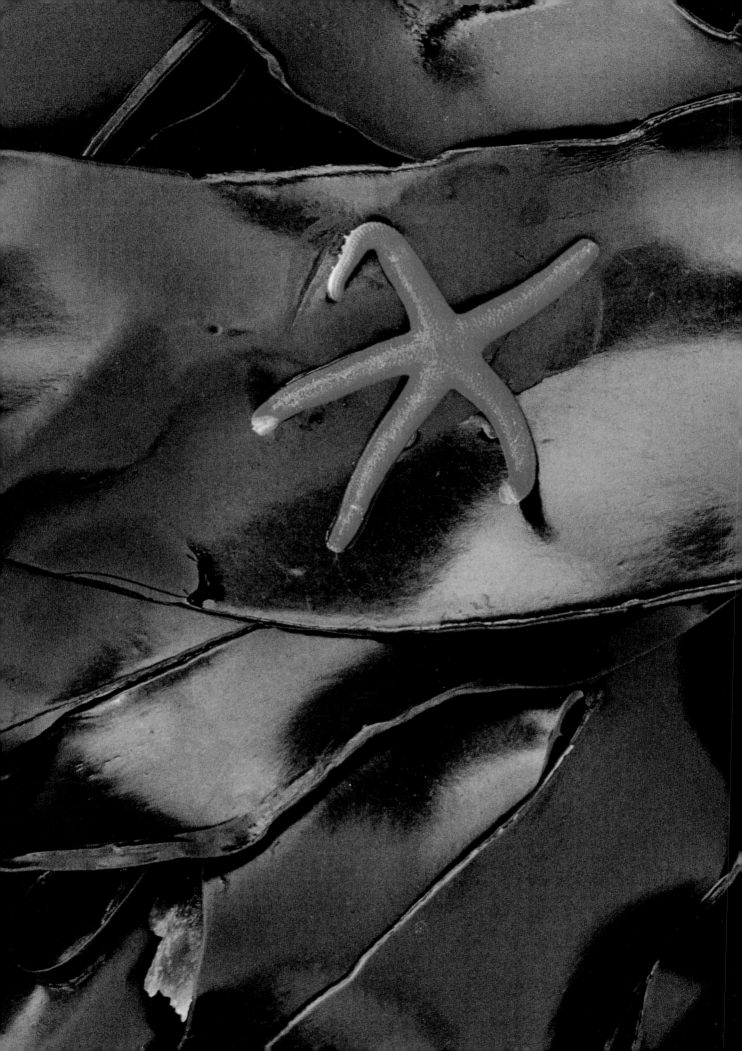

John Shaw's
CLOSEUPS
IN NATURE

AMPHOTO BOOKS
an imprint of Watson-Guptill Publications
New York

In thanks to my parents, John and Doris,
for giving me my first camera
and thereby letting me discover a new world.

Copyright © 1987 by John Shaw

First published 1987 in New York by AMPHOTO,
a division of VNU Business Media, Inc.
770 Broadway, New York, N.Y.10003
www.amphotobooks.com

Library of Congress Cataloging-in-Publication Data

Shaw, John, 1944–
John Shaw's closeups in nature.

Includes index.
1. Photography, Close-up. 2. 35mm cameras.
3. Single-lens reflex-cameras. 4. Nature photography.
I. Title.
TR683.S53 1987 778.3'24 87-12609
ISBN 0-8174-4051-8
ISBN 0-8174-4052-6 (pbk.)

Manufactured in Japan

First printing, 1987

16/05 04

Editorial concept by Marisa Bulzone
Edited by Robin Simmen
Designed by Jay Anning
Graphic production by Ellen Greene

Foreword

This is a book about closeup photography techniques for field work with a 35mm single-lens-reflex (SLR) camera. As such, it is not about optical theories or studio procedures. Under field conditions I am far more interested in obtaining practical results—in taking a quality picture—than I am in theoretically correct photography methods. However, I trust that the two are not always mutually exclusive.

This is also a book about options, about the different ways to achieve an end result. Many beginning closeup photographers believe that there is one and only one way to take a picture, while the experienced photographer realizes there are many approaches. There is no one right way of working, no one lens for all subjects, no one answer to a photographic problem. Problem solving in the field is a matter of what equipment you already own, what subject matter you want to photograph, and most realistically, what lenses and accessories you happen to have with you when you find a subject.

For readers who are interested in a broader discussion of general nature photography, I refer you to my previous book, *The Nature Photographer's Complete Guide to Professional Field Techniques*. Those who have read it will realize that some of its material, such as the discussion of exposure, is covered here also. This was necessary since certain concepts form the basis for all photography whether scenic, wildlife, or closeup.

In terms of locating subject matter and "working" it in the field, my best advice is to learn as much as you can about the natural world. I've said it before, but it still holds true: To be a better nature photographer, you must first become a better naturalist. Only through direct contact and intimate observation can we learn about the natural world and it is through direct effort and experience that we learn to photograph that world. As a result of efforts to record what we see and experience, I hope that a natural ethic will develop, an ethic of respect, concern, and love for our subject matter.

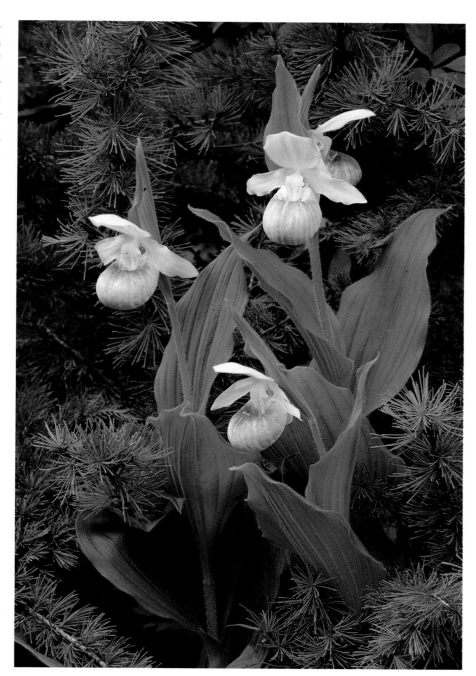

Showy lady's slipper orchids and tamarack. *Kodachrome 25, 200mm lens, 1/8 sec. at f/11*

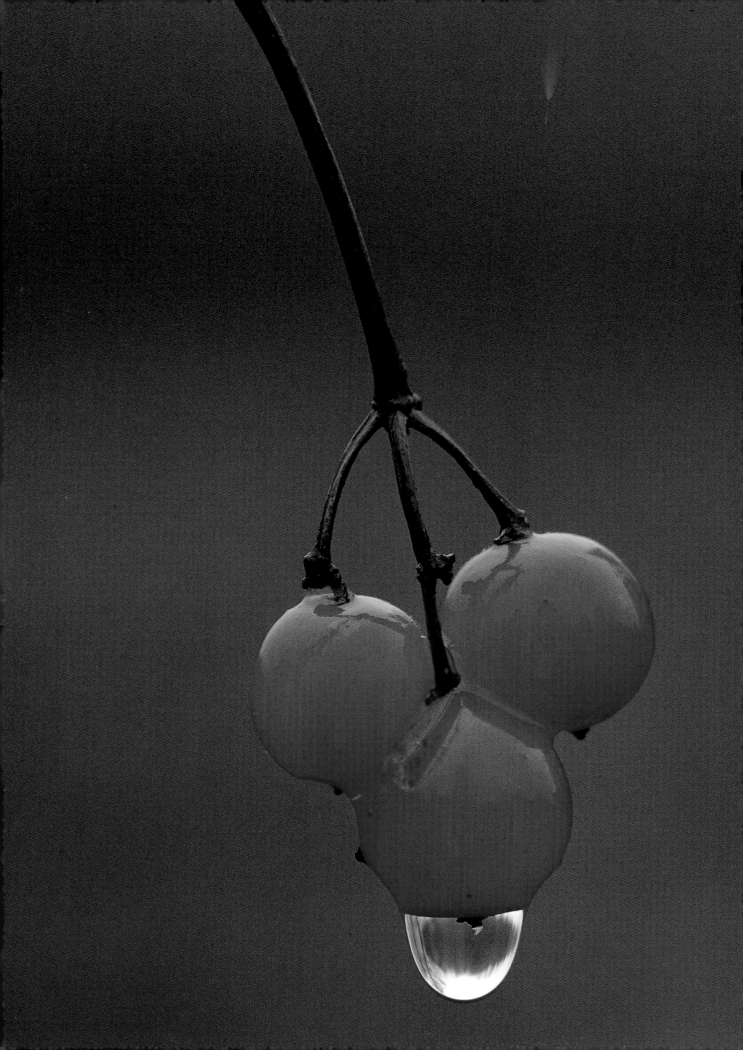

Contents

Introduction

Before I talk about the technical aspects of closeup photography, the theme of this book, I need to define my pictures' subject matter: It is not the grand scenic, but the details that comprise the scenic. It is not the wide scope of nature, but the intricate texture of nature itself. It is not the overview, but the closer view.

Closeup photography basically requires an observant and discerning eye, as well as a willingness to witness in the commonplace a display of the miraculous. This kind of photography can be practiced anywhere. I am always surprised when people ask me how to find subjects for closeup photography. Discovering subjects is as easy as a trip to your backyard or a vacant field and is more a journey of inner vision than a journey in terms of location.

I confess that I am intrigued by the world of nature. In fact, to be honest, I am far more than intrigued—I have a compulsion to look at and to deal with nature. I want to see each and every part of it that I can, and in the process of looking so intently, I have found that nature can indeed bear the closest of inspections. I firmly believe that by learning more about the parts of things, we can learn more about the whole. By seeing the precision and the appropriateness of the small, we can become more appreciative of the large.

It never ceases to amaze me that a close view of a natural detail always invites an even closer view. I am endlessly fascinated by the components of the world around us, and the detail within the detail. First we see the great vista, then a patch of color in one corner of the frame. A closer look reveals flowers and, on one flower, a butterfly. Its wings reveal a distinct pattern, the pattern is produced by a precise arrangement of wing scales, and each

scale is perfect in and of itself. If we could truly understand the perfection that makes up that one butterfly wing scale, we could conceivably start to understand the perfection of the scheme that is nature.

When we photograph people, we use the term "portrait" to refer to a picture that shows the face of the person. A portrait is emphatic because it calls attention to the special features that make up someone we recognize to be a specific and unique person. I've always thought that photography of nature's details is also portraiture. Closeup photography displays the uniqueness, the "suchness" of such subjects as a flower, an insect, a leaf.

Part of the process of photography is deciding what to place within the frame of the photograph and what to leave out. By this very act we stress the importance of our subject matter, in effect saying, "Look at this and only this." The technical side of closeup photography demands careful and precise execution, and the aesthetic side requires the same precision. Attention to detail is paramount in both.

After you've found a good subject, you are ready for the actual photographic procedure. A successful picture unites both your technical and poetic skills. One side of you must be a rational, scientific clinician who sets up the camera, chooses an exposure setting, and goes through the mechanics of photography. The other side should be a sensitive, mystical artist who intuitively reacts to a subject and decides on matters of composition and design. Good photography synthesizes these two approaches to the world while not allowing either to dominate. A technocrat without emotion is clinical and soulless, while a poet without order is bound within personal imagery and cannot convey his or her feelings to others.

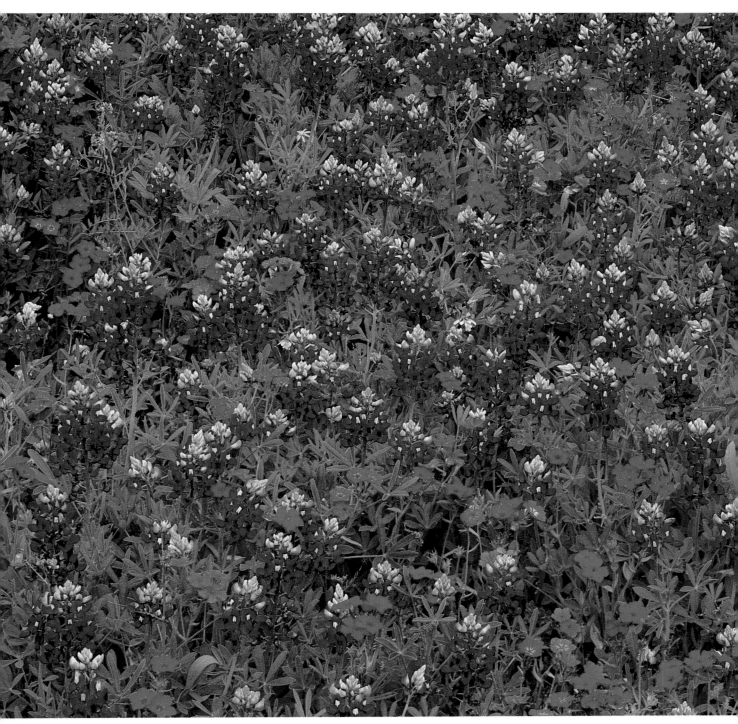

Texas prairie wildflowers. *Fujichrome 50, 105mm lens, 1/15 sec. at f/22*

Part I
GETTING STARTED

Magnification Rates

Photographers who are starting to think about working in the closeup range often ask, "How close can I get with this particular lens or accessory?" With normal subjects at normal distances, the closer the photographer is to the subject, the larger the image is on the film. If you are photographing a person, getting closer means that more of the person fills the photographic frame. But when you get into the realm of closeup photography, asking how close you can get to your subject is not the most valid or useful question, since the physical distance between the camera and the subject does not by itself determine how frame-filling the subject will be in the resulting photo.

In order to talk about closeup pho-tography we need to develop a mutual vocabulary for agreement about what we're actually discussing. The best way of describing closeups is not in terms of "how close" but rather in terms of magnification on the film; we need to be able to refer to some constant factor that does not vary. Magnification on the film is the ratio between the physical size of the image on the film and the physical size of the object being photographed. Notice that I say the "image on the film"; I'm not referring to the size of a finished print or to how large a slide is projected, but rather to the actual size of the image itself on the slide or negative.

The ratio between film-image size and subject size is called the magnification rate, and it is usually written as a power. Fractional rates, such as 1/8X, 1/4X, or 1/2X, mean that the film image is smaller than the subject's real size. At a fractional magnification rate, a one-inch subject will appear smaller than one inch if its image is measured on the film. At 1X, though, the image and the subject are the same size; now a one-inch subject will create a one-inch image on the film. At rates over 1X, the image is larger than the subject—in other words, you are now truly starting to magnify on film.

A magnification rate of 1X is often called "life-size" because at 1X you are photographing subjects that appear the exact same size on the film as they are in real life. Another way of thinking about this is that at life-size you are photographing a subject area

Cardinal flower. *Kodachrome 64, 180mm lens, 1/15 sec. at f/5.6, photographed at about 1/4 life-size*

New cones on red spruce. *Kodachrome 25, 105mm lens, 1/8 sec. at f/16, photographed at roughly 1/3 life-size*

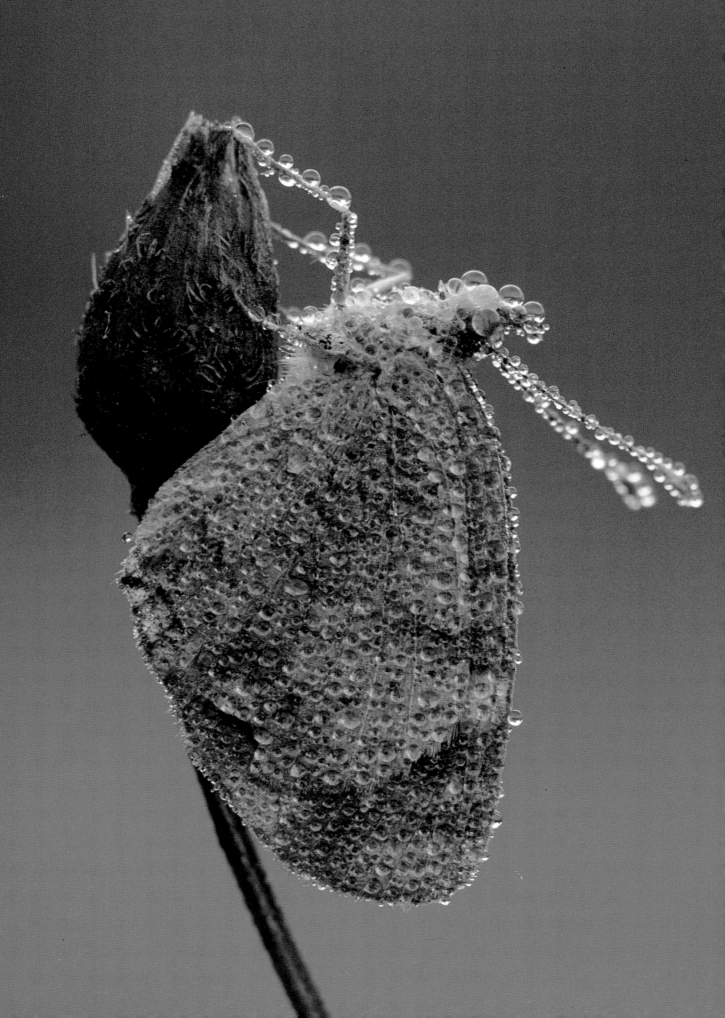

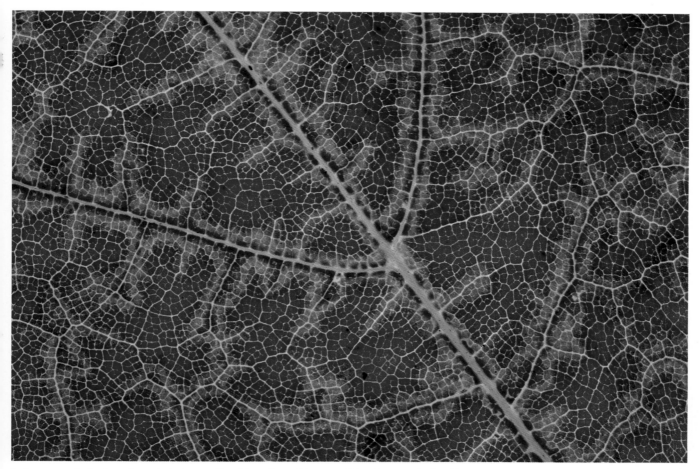

Autumn maple leaf section. *Kodachrome 25, 105mm lens, 1/4 sec. at f/11, photographed at life-size*

that has the same dimensions as the film format you're using. With 35mm film you are working on a subject that is 24mm × 36mm, or roughly 1 × 1½ inches. This is basically the same thing as taking a 35mm slide mount and holding it flush against an object, then photographing what you can see within the rectangular opening of the slide mount. Whatever lies within that rectangle is what will appear on the film if you photograph at 1X, life-size.

Knowing the magnification rate also means knowing the area being photographed, or vice versa. If you divide each dimension of a 35mm frame (1 × 1½ inches) by the magnification rate you'll find the size of the subject being photographed. A magnification rate of 1/10X means a subject size of 10 × 15 inches, 1/8X is 8 × 12 inches, 1/6X is 6 × 9 inches, 1/4X is 4 × 6 inches, and 1/2X is 2 × 3 inches. A magnification rate of 2X is

Pearl crescent and dew. *Kodachrome 25, 105mm lens, 1/2 sec. at f/16, photographed at about 3/4 life-size*

½ × 1 inch, 3X is ⅓ × ½ inch, 4X is ¼ × ⅜ inch, and so on. To find the magnification rate when you know the size of your subject, divide the dimensions of the frame by the dimensions of the subject.

To be honest, you'll almost never need to know the precise magnification rate unless you're doing scientific work. However, there are many uses for knowing roughly what the magnification rate is, as we will see later when we discuss ways of making lenses focus close. And as I've already stated, this is about the only consistent way to refer to closeup work.

All by themselves, most camera lenses will focus down to cover roughly 1/10X. Standard lenses are limited to this range for several reasons: primarily the added cost and complexity of making a closer-focusing lens, as well as the slight loss in image quality when a lens designed for normal photography is used for closeup work. Does this last statement mean you must have special "macro" lenses to take quality close-ups? Far from it, as you will see.

For practical purposes the closeup photography realm can be divided into three parts. For low magnification work up to about 1/10X, you generally do not have to do anything special to take a picture. I call this area of work the "almost closeup range." From 1/10X down to about 1½X is what I call the "real close range." In this magnification range you must definitely start altering your camera equipment in order to gain the magnification needed. However, there are many different options. Past 1½X magnification is what I call "damned closeup." Once you get to this area, you are starting to do a very specialized type of work. Indeed, the first question I would ask you here is, "Do you really want to photograph such small subjects?" After all, a house mosquito photographed at 2X is full-frame to the point that its legs and antennae barely fit into the frame. At 4X you'll have a portrait of the mosquito's face. Do you really want to shoot at these magnification rates? If so, you must be willing to work very methodically and carefully.

Exposure

Controlling exposure is your key to controlling the entire photographic process. The degree of control exercised is what separates the good photographer from the snapshooter; you want to be able to control and repeat your successes, rather than having your good photography be a matter of chance accident. Good technique is the ability to produce technical quality at your inclination, knowing beforehand how a procedure will work instead of being amazed at the outcome after the fact. Far too often we fall into the trap of believing that a new lens or a new camera will make our pictures better, when what we really need is good technique and a foundation in exposure control. One person's photographic jewels may be another person's throwaways, but an understanding of exposure basics is vital regardless of your proficiency level if you want to grow as a photographer. I know that for some of you this will be review; still, let's go over

exposure theory together so that we can develop a common vocabulary and a common knowledge.

Everything connected with the photographic process works in values called *stops*. The more you can learn to think and to compare exposures in terms of stops, the easier cameras are to use. A stop is defined as a doubling or halving or any value; you have twice the level of something, or half the level. An actual exposure determination depends on three things: shutter speed, aperture, and film sensitivity. The *shutter speed* is the length of time that the camera's shutter is open, thereby admitting light to the film when you take a picture. The *aperture*, measured in terms of *f-stops*, is the size of the lens opening through which the light passes. Together these two control how much total light actually falls on the film. The *film sensitivity* measures the intensity of light necessary to record an image on a particular type of film. All three of

these variables work in stops.

The normal shutter-speed sequence found on cameras is a progression of seconds and fractions of seconds. The boundary speeds vary according to the camera model—some models have very slow speeds, and some have quite fast ones. The shutter-speed sequence, however, is the same on all cameras and runs through at least the following settings: 1, 1/2, 1/4, 1/8, 1/15, 1/30, 1/60, 1/125, 1/250, 1/500, and 1/1000 sec. (There are some fully automatic cameras that offer no shutter speeds or apertures for the user to set. The only control possible is via the film speed set on the exposure meter. Given any choice whatsoever, I would avoid these cameras in favor of those that give you some input. The pictures are yours, so the decisions about how they are taken should be yours, too.)

Each shutter speed in the sequence is half the preceding speed but double the following speed. A speed of

Sweetgum leaves opening in spring. *Kodachrome 25, 180mm lens, 1/8 sec. at f/11*

1/15 sec., for example, is half as long as 1/8 sec. but twice as long as 1/30 sec. From 1/8 sec. to 1/15 sec. is a one-stop change (one doubling); from 1/8 sec. to 1/30 sec. is a two-stop change (two doublings). When most cameras are set in their "manual-exposure-control" mode, you must set the shutter-speed dial at the marked speeds and not in between them. The shutter speed you select affects how motion is portrayed, whether it is stopped by a fast speed or blurred by a slow one.

The apertures on a lens—the marked f-stops—are also designed in the same doubles and halves progression (although the numbers representing them are not). The normal series of f-stop numbers is $f/1$, $f/1.4$, $f/2$, $f/2.8$, $f/4$, $f/5.6$, $f/8$, $f/11$, $f/16$, $f/22$, and $f/32$, which represents a series of one-stop changes. Not all lenses have all these numbers, yet some lenses have even more. Each number is simply an indication of the size of the lens opening, and the larger the number, the smaller the hole. An aperture of $f/2$ is a large lens opening that admits a lot of light, while $f/22$ is a small one permitting only a tiny ray of light. Each number represents an opening that lets in twice as much light as the following number or half the light of the preceding number. For example, $f/8$ lets in twice as much light as $f/11$ (a one-stop difference) or half the light of $f/5.6$ (a one-stop difference in the other direction). You can set the aperture anywhere you want since the marked numbers are only there for your convenience. If you start off with the aperture set half way between $f/8$ and $f/11$, a one stop change would be either halfway between $f/11$ and $f/22$ or halfway between $f/5.6$ and $f/8$.

The f-stop you use controls the depth of field, or the section of a photograph between the nearest and farthest points from the camera, that appears in sharp focus. The smaller the lens opening is, the greater the depth of field will be; the larger the opening, the more shallow the depth of field.

Two traditional terms are used when referring to a change of aperture. *Stopping down* means reducing the light reaching the film and increasing the depth of field by going to a smaller aperture. *Opening up* is just the opposite and means letting more light reach the film while simultaneously decreasing the depth of field by using a larger aperture.

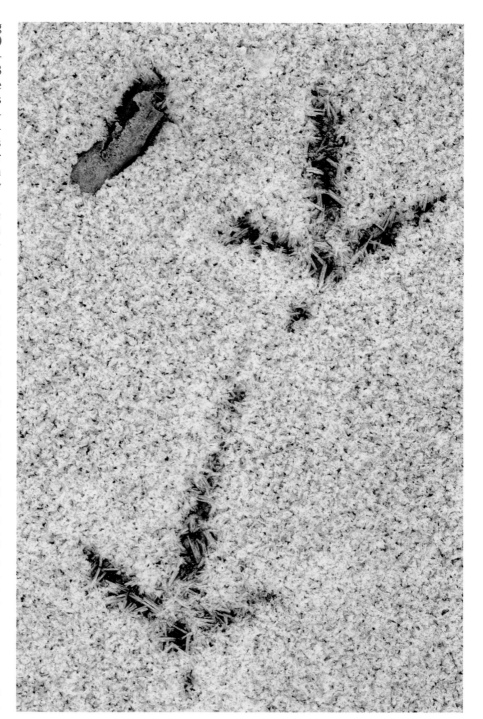

Grouse tracks in frost on frozen stream. *Kodachrome 25, 105mm lens, 1 sec. f/16*

On the the morning I took this picture I learned just how cold a metal tripod can be. The temperature was −20°F, and even though I was wearing gloves, my hands soon started to ache because the tripod acted as a heat sink. I've since covered the tripod legs with electrician's tape to help prevent this.

Shutter speed and aperture are related to each other by something called *reciprocity*. Since both affect the amount of light reaching the film (remember that speed is time and aperture is intensity) and both work in the same doubles and halves progression, there is a direct relationship between them. In terms of the overall amount of light reaching the film, a one-stop change in one value equals a one-stop change of the other value in the opposite direction. Doubling the time and halving the intensity is exactly the same as halving the time and doubling the intensity. To illustrate this concept I've always used the example of drawing a gallon of water from a spigot. It does not matter if you turn the tap on full force for a short period of time, or let it trickle for a long period of time; either way, you end up with a gallon of water. Correspondingly, you can use a slow shutter speed with a small lens opening or a fast shutter speed with a wide opening to get the same amount of light. The effects you obtain are different in terms of depth of field and motion, but the amount of light reaching the film remains the same.

What this means in practical terms is that by working in stop values, you can pick and choose shutter speeds and apertures and then vary the proper exposure. Suppose that 1/30 sec. and *f*/8 is the correct exposure. If you double the time to 1/15 sec. and halve the lens opening to *f*/11, you end up with exactly the same amount of light reaching the film. Do it again to reach 1/8 sec. and *f*/16, and it's still the same amount of light. Or you could go the other way. From your starting point, halve the time to 1/60 sec. and double the aperture to *f*/5.6, or go one more stop to 1/125 sec. and *f*/4. These combinations are all exactly the same amount of light, and consequently, they would all be the correct exposure. What this means is

that once you know one correct exposure level, you can simply pick the shutter speed you want and whatever *f*-stop is needed or vice versa. With a camera in your hands this is even easier—you simply count the number of stops while making changes on either the shutter-speed dial or the aperture ring. Then change the other setting by the same number of stops, and you're still at the correct exposure. For example, suppose you start at 1/500 sec. at *f*/5.6. A four-stop change to 1/30 sec. (more time) requires a four-stop change to *f*/22 (less intensity) to stay at the same light level.

The aperture and shutter speed you choose will, of course, be determined in part by the film you're using. Different films have different sensitivities to light, and this is expressed in their film-speed ratings, or ISO numbers. A film that has a low ISO number is called a "slow" film because it needs a lot of light to record an image, while films with high ISO numbers are called "fast" films and need less light. Examples of slow, low-speed films are Kodachrome 25 at ISO 25 and Fujichrome 50 at ISO 50. Ektachrome 400 at ISO 400 is a fast film. A very fast film is Fujichrome 1600 at ISO 1600.

Film-speed ratings also work in doubles and halves, in stop values. Each numerical doubling is a one-stop jump. Going from ISO 25 to ISO 50 is a one-stop change. Going to ISO 100 would be another stop, and ISO 200 is one more. Let's calculate how many stops there are between ISO 25 and ISO 1600 by counting as we double the values: Starting with 25, we get 50, 100, 200, 400, 800, and 1600—a total of six stops.

If you know the correct exposure for one film and the ISO rating for another film, you can calculate the correct exposure for the second film if you work in stops. Take the known exposure and change it the number of stops that the two film speeds differ. Let's

assume that Kodachrome 25 is properly exposed at 1/4 sec. at *f*/5.6. What is the correct Ektachrome 400 exposure in the same light? Ektachrome 400 is four stops faster than Kodachrome 25, so change the Kodachrome exposure by four stops to 1/60 at *f*/5.6 or its equivalent (for example, 1/30 sec. at *f*/8, 1/15 sec. at *f*/11, 1/8 sec. at *f*/16, or 1/4 sec. at *f*/22.)

What happens, however, if the numbers don't come out even, such as when comparing Kodachrome 25 at ISO 25 and Kodachrome 64 at ISO 64? Technically, there is a one-and-one-third stop difference between these two films. Going from ISO 25 to ISO 50 is a one-stop change, and ISO 100 would be the next stop. ISO 64 is one-third of a stop—in practical terms, just a little smidge—more than ISO 50. To compensate for this extra difference, simply turn the aperture ring a little more. Another way to look at this problem is by starting with the ISO 64 rating. Half of that, ISO 32, would be one-stop slower, while one more stop would be ISO 16. So ISO 25 is one-and-one-third stops slower than ISO 64. Because you might find it handy, here is the normal progression of ISO film speeds in one-third stop increments:

16 – 20 – 25 – 32 – 40 – 50 – 64 – 80 – 100 – 125 – 160 – 200 – 250 – 320 – 400 – 500 – 640 – 800

Films are not available at all these speeds. Remember that doubling the ISO number always means a one-stop change.

As I said earlier, the more you can think about photography in stops, the easier and clearer it becomes. The concept of stops is the basic concept underlying all photography, the core around which the rest revolves. If you don't fully comprehend this idea, please take the time to reread this section because it is fundamental to the rest of this book.

Viceroy and dew. Kodachrome 64, 180mm lens, 1/30 sec. at f/8

Calibrating a meter

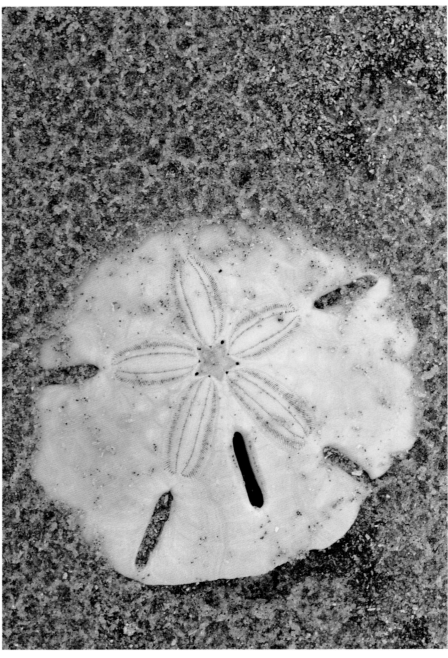

Sand dollar on beach. *Kodachrome 25, 135mm lens, 1/2 sec. at f/16*

The wet beach sand here is a perfect middletoned area to meter. However, the exposure won't be correct unless the meter is calibrated to read a middletoned value.

Having built-in through-the-lens (TTL) metering is without a doubt a godsend for the closeup photographer. Cameras with TTL meters are so common today that we take them for granted; indeed, a 35mm camera without a built-in meter is a real rarity today. But taking a meter reading or letting the camera set the aperture and shutter-speed based on its metering is no guarantee of correct exposure regardless of what the camera ads say. A meter does not think, and there is no reason to assume that the meter always gives the correct exposure values for any scene. Before I discuss how you take meter readings for correct and consistent exposures, there are some preliminaries I want you to understand.

Proper exposure can be determined two ways: You can estimate the light level, or you can take a meter reading to measure it. Estimating the light is not usually very practical for field work since the natural light is always changing. There is, however, one situation where the light is at a constant level, and that is when you're working in bright sunlight. From about two hours after sunrise until two hours before sunset on a bright, clear, pollution-free day it is far easier to photograph using an estimated exposure than to meter the light. In a bright, sunny situation, the correct exposure anywhere in the world for a middletoned frontlit subject larger than a breadbox is expressed by the *sunny f/16 rule*. A middletoned subject is defined as being photographically average in tonality. It is neither light nor dark, but halfway in between. In terms of black and white, it is a medium gray. According to the sunny f/16 rule, the correct exposure for this tonality is f/16 at the shutter speed with a number closest to the film's ISO number.

In other words, a sunny f/16 exposure is 1/ISO at f/16, or any equivalent exposure. Let's assume you are shooting Kodachrome 25 with an ISO of 25. The sunny f/16 rule says that correct exposure is 1/30 sec. (30 is the number closest to ISO 25) at f/16, or it could be any equivalent. An exposure of 1/30 sec. at f/16 is exactly the same as 1/60 sec. at f/11, 1/125 sec. at f/8, 1/250 sec. at f/5.6, 1/500 sec. at f/4. The sunny f/16 exposure for Fujichrome 50 starts at 1/60 sec. at f/16; for Ektachrome 200, 1/125 sec. at f/16; for Ektachrome 400, 1/500 sec. at f/16.

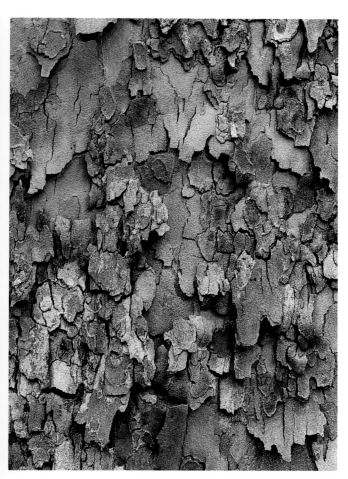

Sycamore bark. *Kodachrome 64,
50–135mm zoom lens, 1/4 sec. at f/22*

*Once your meter is calibrated to a
middletone value, it will give the proper
exposure values for any middletoned
subject, such as this sycamore bark. I
simply metered and shot.*

*This is the lighting in which to calibrate
your meter by using the sunny-f/16
exposure value. Make sure you pick
something middletoned to meter, such
as the sky in this photo but not the
yellow foliage of the autumn maple.*

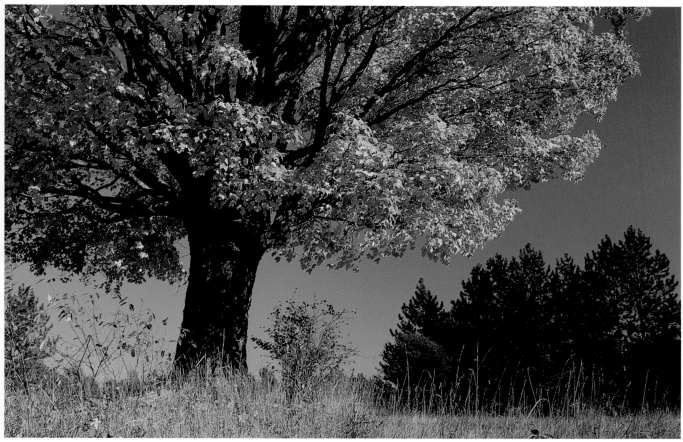

Autumn maple tree. *Kodachrome 25, 35mm lens, 1/30 sec. at f/16*

When you use Kodachrome 64 (K64) at ISO 64, you must modify the sunny f/16 rule just a little. We know that there is one-and-one-third stops between the ISO film speeds of Kodachrome 25 and Kodachrome 64. If Kodachrome 25 (K25) is properly exposed at a sunny f/16 exposure of 1/30 sec. at f/16—and believe me, that *is* the proper exposure—then Kodachrome 64 should be one-and-one-third stops faster. But the sunny f/16 rule for K64 suggests an exposure of 1/60 sec. at f/16, which is only one stop different. So with K64 when you're estimating the light and shooting nonmetered sunny f/16 exposures, you must stop down one-third stop more. In other words, for K64 the rule changes to "sunny f/16 and one-third," or "sunny f/16 and a smidge down."

I know you're trying to figure out what all this has to do with closeup photography since sunny f/16 exposures don't apply directly to closeups. Before you can confidently take an exposure-meter reading, you must first calibrate your meter. For some reason we think that just because we've bought an expensive camera, the meter is perfectly adjusted. Don't assume this. In fact, I would urge you to assume the exact opposite.

Consider the fact that when you buy a car (and a car is a lot more expensive than a camera), you don't believe that the gas gauge is 100 percent accurate. You learn from experience that perhaps when the gauge says "1/4" you had better search for a gas station immediately, or that when it says "E" you really have several gallons left. All you are doing is calibrating the car's gas meter, and you think nothing of doing this. You must do the same with your camera meter.

You'll want to calibrate your meter so that it gives a correct reading when pointed at a middletoned subject. Why a middletoned one? Because there are many more natural subjects of average tonality than unaverage. Middletoned subjects include the tonality of green grass, most foliage, dry tree trunks, or the clear north sky in the middle of the day.

The way to calibrate a meter is based upon the one correct exposure you already know, the sunny f/16 exposure. Just go outside on a clear, sunny day and meter something middletoned with a normal or longer lens set at the infinity focusing mark. Ad-

just the ISO dial until you get the right sunny f/16 reading for whatever film you're using.

Suppose you want to calibrate your meter for Kodachrome 25 film. Proper exposure, according to the sunny f/16 rule, is 1/30 sec. at f/16 or any equivalent. With your camera on manual, set your shutter speed and aperture to this exposure. Now meter your middletoned subject leaving the lens set at infinity. Change the ISO dial until the meter indicates that 1/30 sec. at f/16 is correct. It does not matter what number you end up with on the dial because those numbers are just reference marks. You know what the right answer should be, so get your meter to tell you this answer. Whatever setting you come up with is now the number you'll use whenever you are shooting K25 in that camera body. (I've always thought that meters would make more sense if, instead of ISO numbers, the marks were labeled A, B, C, and D and the instructions said, "Pick the one which gives you the results you like.") All you have done is correct the camera's film-speed dial. Now you can go out and photograph as usual.

Most TTL meters are set on the overexposure side by the manufacturer. In my summer workshops I have all the participants set their meters to the exact same ISO number, then we meter the same subject in the same light. Normally, there is at least a two-stop variation in the meters' answers, but there should only be one correct exposure if we are all using the same film.

You must calibrate your own equipment because the ISO setting on your camera has no relationship to any other camera. You might have heard someone say, "Always rate Kodachrome 25 at an exposure index of 32." This is not valid information, and is similar to saying that because one car's gas gauge reads "1/4" when in reality its tank is empty, then all gas gauges must read this way. Not true! You must test *your own* equipment. My Kodachrome 25 camera is set at the ISO 50 mark because that's where its meter gives me the correct answers. But that's not necessarily where another meter will be set. I have several camera bodies, and no two of them are set at the same number for the same film. However, what's important is that they all give me the same exposure information.

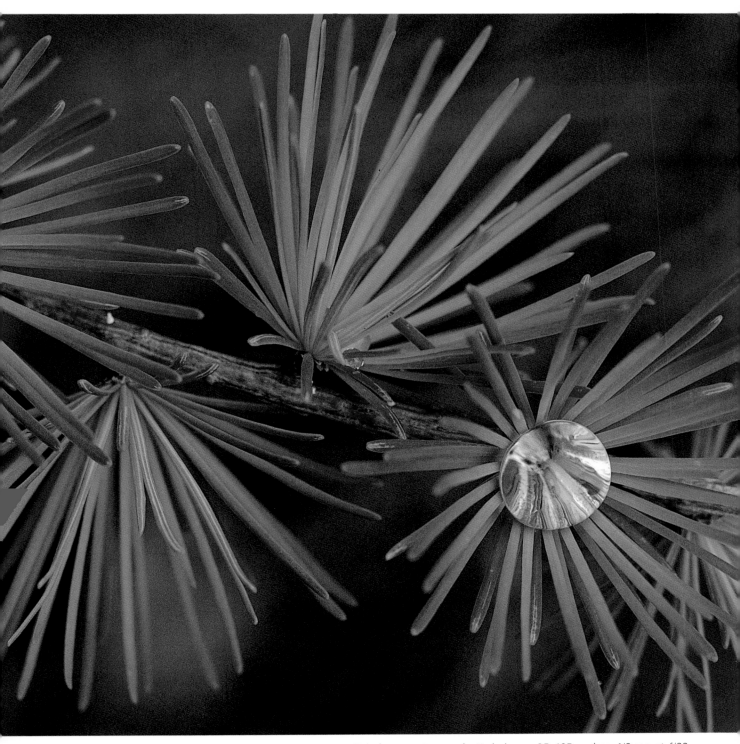

Raindrops on tamarack. *Kodachrome 25, 105mm lens, 1/2 sec. at f/22*

With my calibrated camera I carefully metered the middletoned green needles for this photo.

Metering

Once you have calibrated your meter to a middletone placement, you have to learn how to use it properly. Exposure meters do not think, but photographers do. Being a slave to your meter and taking its suggested exposure values literally is a sure way of turning your quality camera into a glorified box camera.

All through-the-lens meters are reflected-light meters; that is, they measure the light reflected from whatever subject you point them at. Reflected-light meters assign tonality to what you meter according to the tonality for which they have been calibrated. In other words, if you've calibrated your meter to a middletoned value and you photograph using an exposure that the meter suggests, then whatever you metered will be middletoned in the final slide.

So if your subject is middletoned, all you have to do is meter it directly and shoot. If the subject is not middletoned, there are several solutions to achieving proper exposure. One way is to intentionally meter something besides the subject. Find a middletoned area in the same light as your subject. Focus on your subject, then swing the camera to the middletoned area, and meter it without refocusing. Now return to your subject, but use the exposure settings you found from the middletoned area to take the picture. As long as there is a middletoned expanse in the same light as that illuminating your subject, this is probably the easiest way to obtain an exposure value.

What can you do if there is no middletone to read? You could carry a middletone with you by purchasing an 18-percent reflectance gray card. Then you simply meter the card in the same light as your subject. However,

The bear track in the top photo was fresh—*I watched and then photographed the bear as it walked past me in this freshly fallen snow. This shot was taken about five minutes later, after the bear literally went over the mountain. The exposure here is two-stops open from from that indicated by a direct meter reading of the snow. The exposure in the bottom photo is one-stop open from what the meter indicated.*

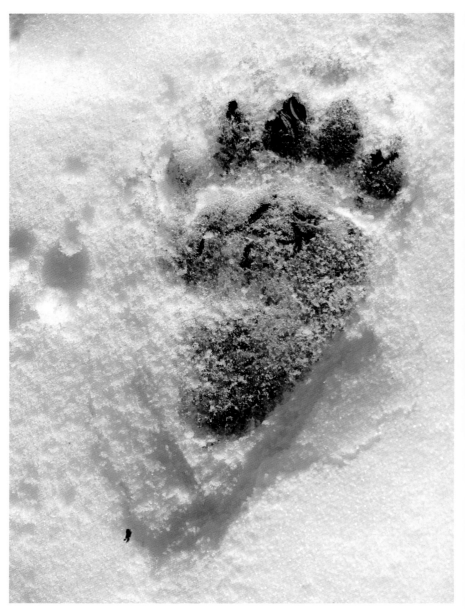

Grizzly bear track in snow. *Kodachrome 64, 55mm lens, 1/125 sec. at f/16*

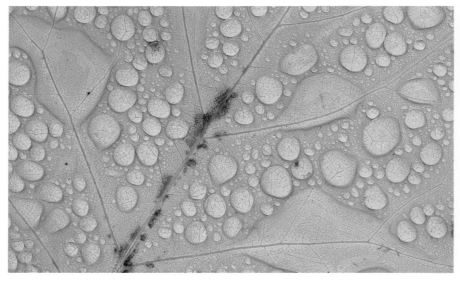

Raindrops on autumn tulip-tree leaf. *Fujichrome 50, 105mm lens, 1/4 sec. at f/11*

Silvercrown. *Kodachrome 25, 55mm lens, 1/2 sec. at f/22*

Winged sumac in autumn. *Kodachrome 25, 105mm lens, 1/4 sec. at f/22*

even the best gray cards have a little sheen to them and tend to be too reflective for metering. I would buy one to use as a visual reference point; I like the ones made by Unicolor (called *The Last Gray Cards* since you supposedly won't need to buy another) because they have a suede finish and are not so reflective.

Lacking a gray card, you can meter a known substitute. Find something such as your camera bag that you'll always have with you in the field. Meter it, and compare that reading with one from a middletoned subject in the same light. Let's say a reading from your camera bag is 1/15 sec. at *f*/8 and a reading from a middletoned area is 1/15 sec. at *f*/11. You now know that your bag is one-stop darker (yes, *darker* since the meter says the bag needs even more light to be placed as a middletone value) than middletone. To use this information in the field, focus on your subject and then meter your bag in the same light. Take the bag's meter reading, and stop down one stop to get back to a proper exposure for your subject.

One known substitute that is very handy, so to speak, is the palm of your hand. You'll always have it with you, and if you cannot find it, you probably shouldn't be out trying to photograph. The skin on most people's palms is about one stop lighter than middletone. To make sure of this, meter your palm, and compare it against a middletone reading. It will definitely be lighter than middletone. To take a picture, repeat the procedure with the camera bag, only this time open up from a reading off your palm. It might seem like you should stop down, but if you shoot at what the meter says, your palm would become middletoned in the final slide. It is not; it's lighter in value so you must add light. A little memory aid I learned may help: You have to open your hand to take a meter reading, so you have to open your lens. One hand, one stop.

You can meter anything you want as long as you know either what its tonality is—that is, how many stops it is away from middletone (as in the camera bag or your palm)—or more important, what tonality you want to

The silvercrown is exposed at the meter reading, and the sumac is one-stop down from what the meter indicated.

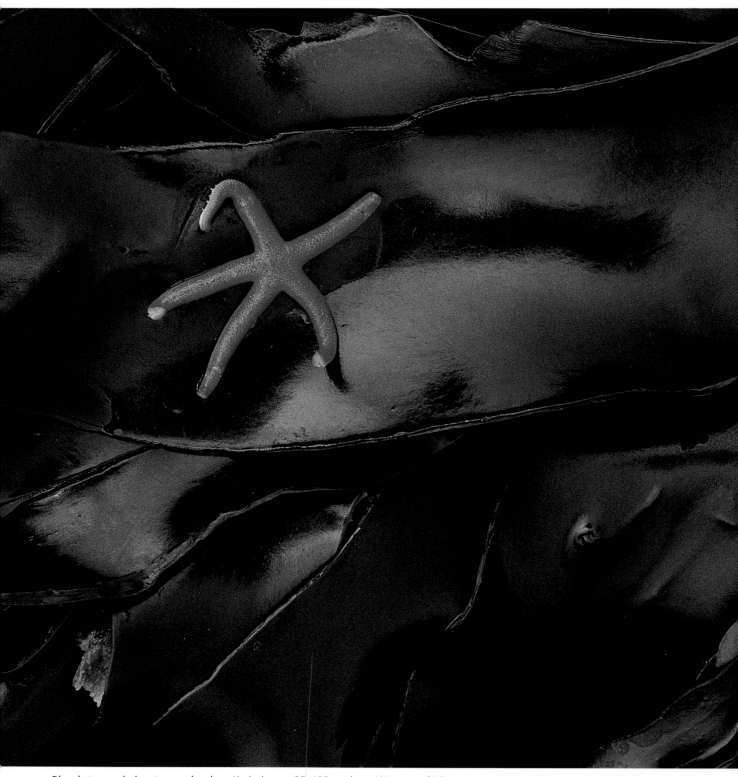

Blood star on kelp at ocean's edge. *Kodachrome 25, 105mm lens, 1/4 sec. at f/16*

This is two-stops down from what the meter indicated. I had time for only three frames before another wave washed the blood star away and left me with soaked boots.

make it *appear* in the final photo. The final photograph doesn't have to be a literal rendition of your subject; it can be an accurate representation of what you see, or it can be lighter or darker to create a particular mood. You don't have to reproduce colors exactly as you can see them, but you do want to reproduce them as you envision them.

Color slide film has a total exposure range of about five stops from textureless white to detailless black. Middletone falls halfway in between these two extremes. *Proper exposure* means that all the important parts of your photo are reproduced in the tones that you envisioned them to be, while improper exposure means that they are not. Correct exposure is a matter of your controlling the color rendition. The terms *overexposure* and *underexposure* simply mean that the important colors are either too light or too dark compared to what you wanted. These terms do not mean that you shot at an exposure value different from what your meter suggested, since you must often adjust a meter reading to reach your correct exposure. Remember, don't be a slave to your meter!

Whatever you meter with a reflected-light meter will become middletoned if you shoot at what the meter suggests (assuming it has been calibrated). I've heard lots of people say that a meter makes everything a middle gray. No, it makes everything a middletoned placement. If you meter a green area, it doesn't become middle gray in the final slide; it becomes middle green. The meter makes whatever color you meter into an average or medium value: for example, medium green, medium blue, medium red, or medium yellow. So what you have to do is decide what value you want a color to have in your photograph. Do you want that green area to be a dark green, a medium green, or a light green? Metering it would place it as a medium value, and you could

either open up from that meter reading to lighten the color or stop down to darken it.

If you work in stops, this becomes a lot easier. Color slide film has a tonal range of about five stops altogether, or two-and-one-half stops on either side of middletone. One stop open makes a color appear light, and two stops open makes it almost white. One stop down makes it a dark color, and two stops down makes it almost black. Half stops fall in between. For example, let's take green and see what values result as we open up in half stops from the meter's middletone:

Meter reading— medium green

½ stop open— dark light-green

1 stop open— light-green

1½ stops open—light light-green

2 stops open— whitish green

2½ stops open—burned-out, detailless whitish green

Now do the same but stop down:

Meter reading— medium green

½ stop down— light dark-green

1 stop down— dark green

1½ stops down— dark dark-green

2 stops down— blackish green

2½ stops down— blocked-up detailless blackish green

Of course this works with all colors. Now you can pick any portion of your frame and choose how you want it to appear in the photograph. Meter that area, and adjust in stops to reach the color rendition you want. Or you can compare areas to see how they will record by metering them and then comparing the readings. This, at last, is control.

Part II
EQUIPMENT AND FILM

A camera system

Closeup photography is one area in which the 35mm SLR truly excels. Its through-the-lens viewing allows you to see exactly what you're photographing, and its interchangeable lenses and accessories permit many different strategies in closeup work.

The first thing to realize is that equipment alone does not make a photograph. Good technique is far more important than anything else. The best equipment used sloppily won't produce pictures that are as good as those taken with mediocre equipment used precisely. Buying another lens does not necessarily mean there will be any improvement in the quality of your photographs, but using the equipment you already own to its fullest potential will make a difference. There are some factors to be considered in choosing camera bodies and lenses if you want to achieve the broadest utilization of your equipment.

Top quality closeup photos can be produced with any brand of 35mm SLR camera. I would suggest buying the best equipment that you can afford, especially when it comes to lenses, because your photographs will only be as good as the optics that create the images. The actual brand of camera is not so important as is its ruggedness, reliability, and range of accessories. If you're combining travel with photography, I might add replaceability to this list; being several hundred or thousand miles from the only dealer who offers a certain brand of equipment is not the best way to work. Otherwise, the following features are what I want on a camera:

Manual-exposure control, either a manually set camera or some sort of complete automatic-exposure override. I want to control how my photo appears, and I don't want to leave this choice up to the camera. If mistakes are going to be made, I want them to be my own mistakes; then the successes will be mine, too.

A complete range of shutter speeds. Almost all cameras now offer speeds from 1 sec. to 1/1000 sec. If a camera doesn't have at least this much range, don't buy it. You probably won't need the very fast speeds above 1/1000 sec.

which are now offered on many cameras, but having speeds slower than one sec. right on the shutter-speed dial is definitely useful. Many new cameras have shutter speeds that go down to 8 sec.

Depth-of-field preview. This is a means of manually stopping the lens down to your shooting aperture so that you can preview the depth of field in the final shot. You normally view through a wide-open lens, and can therefore see only the depth of field created by that wide open f-stop, not the depth of field of the f-stop you have chosen for your exposure. I think a depth-of-field preview provision is absolutely vital for all photography; I use it constantly in my work. Unfortunately, more and more manufacturers are removing this preview as a cost-cutting measure. If you have any choice in the matter, go with a camera body that has a depth-of-field preview. If you already own a camera without a preview, there is a trick that works with a few models. Examine your lenses to see if they stop down when they are off the camera and then open fully when you mount them onto the body. If so, you may be able to get them to stop down to your selected aperture by carefully starting to dismount them from the camera. This is a good way to drop a lens but is no real substitute for a built-in depth-of-field preview. Just be very careful.

Full range of lenses and accessories available. A range of lenses covering at least 24mm to 300mm should be available, along with some choice of maximum apertures. I would also choose a system that offers more macro lenses than just a 50/55mm macro lens; having one in the 100mm range is especially helpful. You may not want or need one right now, but it is better to have it available if someday you do want it. You will also need to have automatic-diaphragm extension tubes available, and, given a choice, through-the-lens flash is a worthwhile feature. In sum, you want a camera system, not a camera with only a few available options.

Mirror-lockup provision. Every 35mm SLR has a mirror that must swing up

out of the way before light can reach the film. When you trip the shutter, the mirror slaps up against the pentaprism and creates vibrations that make the image less sharp. A mirror lock is a mechanical way of moving the mirror up before you trip the shutter. Very few cameras today have this provision; in fact, the only ones that come to mind are the Nikon F3, the Pentax LX, the Olympus OM-1, and the Contax RTS. All other features being equal, a mirror lock is worth having, although I certainly wouldn't run out and trade camera bodies simply to get a mirror lock. The newest cameras have succeeded remarkably well in dampening mirror slap, so if you own a camera without a mirror lock, don't worry. But if you already have a camera with a lock, use it. It's such a habit with me to lock the mirror that even when I'm shooting with a 24mm lens at 1/500 sec., I find myself reaching over and flipping the mirror up. Of course, this only works with a tripod-mounted camera because you can no longer see through the lens once the mirror is up.

On some cameras, running the self timer flips the mirror up at the start of the timer sequence. For stationary subjects this yields a mirror lock. However, with movable subjects there seems to be a direct correlation between wind velocity and the timer—there will be a dead calm at the start of the sequence, but as the shutter trips, a gale often seems to arrive.

Interchangeable viewfinder screens. Precise focus is absolutely critical in closeup photography since you have so little depth of field to cover any discrepancy. I've heard suggestions about focusing one-third of the way into a subject, but I think that focusing on what you consider the most important element is more to the point. One problem that arises when most cameras are used for closeups is the blacking out of part of the split-image viewfinder screen. Consequently, knowing when you have reached the best focus is very difficult. The solution is to change the focusing screen in your camera. If you plan on doing a lot of closeup photography, being able to change viewfinder screens should

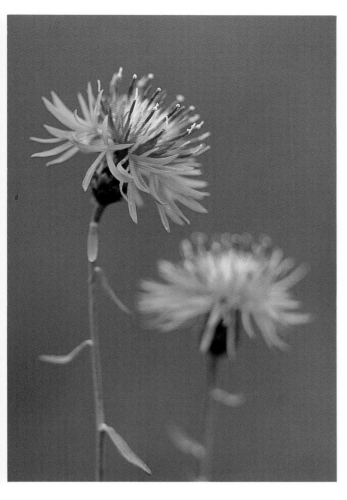
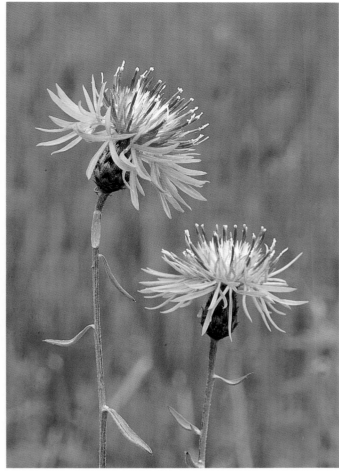

be a definite consideration in choosing a camera system. The best screens are the clear matte-Fresnel screens, either plain or with a grid overlay. In the Nikon line these are called the *B* and the *E* screens. Here are the equivalents for some other brands:

Nikon: B E

Canon: C D

Olympus: 1–4 1–10

Pentax: SE SG

Some of the screens may have a special designation for particular camera bodies, so check with your dealer before purchasing any. By the way, these screens are also perfect for general photography.

If you're photographing at twice life-size or at higher magnifications (especially when shooting in low light), you might consider using a special screen made for use at only these magnifications. It is called an aerial-image screen, and it yields the brightest viewfinder image possible. Here are the screens to consider:

Nikon: M

Canon: I

Olympus: 1–12

Pentax: SI

Once you have decided on a camera system, you must then pick your lens for any given subject. The focal length chosen controls several factors: the angle of view taken in; the image size, or area of coverage; and the working distance. The *angle of view* is how much the lens sees from side to side, or the angle of its vision. As the focal length decreases, the angle of view increases. Wide-angle lenses (as their name implies) see a very broad field, while telephoto lenses see a more narrow angle. If you're shooting from one location, you can change lenses to crop or expand the framing of your photograph.

Changing the focal length—and thus changing the angle of view— also means you are changing the *image size*, the apparent size of things as you look through the viewfinder. Working from any one spot, the

Compare the depth of field in this pair of pictures of the same star thistle shot at the same image size. The photo on the left was taken at f/4, and the photo on the right was taken at f/22. A 200mm lens was used.

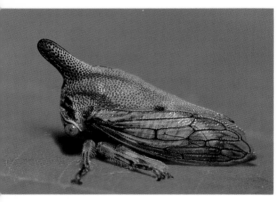

I was cooking a steak when I saw this treehopper in the morning glories growing along one side of my patio, next to my barbecue grill. I photographed the insect at twice life-size, on the top at f/4 and on the bottom at f/22. A 105mm short-mount lens was stacked on a 200mm lens to get to this image size (see Part V on stacked lenses for an explanation of this technique).

shorter the focal length of the lens you use, the smaller objects in the image will appear since you are covering more of an area, and vice versa. The size of an image varies directly with the focal length. If you change from a 100mm lens to a 200mm—that is, if you double the focal length—you double the image size; if you change from a 100mm to a 50mm lens, you halve the image size.

Working distance is also controlled by focal length and is the space between the front end of the lens and the subject. For much closeup work working distance is a primary concern. When you are in the field, having enough working distance is absolutely vital since you often cannot move your equipment without either disturbing the subject or encountering an environmental obstacle. This is particularly true when you're working low to the ground with a tripod-mounted camera; then you need extra room for extended tripod legs in addition to the normal space taken by the camera and lens.

Working distance is basically proportional to focal length, (although complex lens design may change this relationship somewhat). Think of the two as being directly proportional—it's the most useful and easiest way to work. If you have 4 inches of working distance with a 50mm lens, a 100mm lens with twice the focal length gives you twice the working distance, or 8 inches at the same image size. A 200mm yields twice that of the 100mm lens, or 16 inches.

Depth of field is how much looks sharp in a photograph, from near to far. Theoretically, of course, only one plane is in precise sharp focus, and that is the plane on which the lens is focused. However, there is a zone of relative sharpness on either side of the plane of absolute focus. In front of and behind this zone, the image is distinctly not sharp. This zone of sharpness is called the depth of field.

I've often heard it said that depth of field varies with focal length, for example that long focal-length lenses yield shallow depth of field and that wide-angle lenses give great depth.

That is not exactly true. The relationship between depth of field and focal length also involves the actual aperture used, the image size obtained, and the distance from the lens to the subject. There are four basic considerations about depth of field:

With any focal length lens, the depth of field obtained varies directly with the aperture; the smaller the aperture, the greater the depth of field, and the wider the aperture, the shallower the depth of field. As you stop down a lens from its widest to its smallest aperture, you go from shallow depth of field to great depth of field.

Regardless of the f-stop you use on any focal-length lens, the closer the lens is to the subject, the shallower the depth of field will be. As you gain magnification, you lose depth of field at any given f-stop. When a lens is focused at 10 feet, f/16 has quite a bit of depth of field, but when focused at 10 inches, f/16 has a lot less.

When photographing from any one location, the longer the focal length is, the shallower your depth of field will be at any focused distance. If you photograph a subject with a 50mm lens and then photograph it with a 100mm lens from the same working distance (with less of the subject area covered), you will have less depth of field.

If the image size and the aperture remain the same, all focal-length lenses give the same depth of field. Understanding this is very important for closeup photography. If you photograph a subject at life-size with a 50mm lens and then move back and photograph it again at life-size with a 200mm lens at the same f-stop, the depth of field will be the same. Photographs taken with a wide-angle lens and with a telephoto lens will have the same depth of field if the image size and f-stop used are the same. The backgrounds will look different due to angles of view on the various lenses, and the perspective will be different since the photos will be shot from two different locations, but the depth of field will be the same.

Tripods and heads

The best cameras and lenses are no guarantee of quality photographs if you handhold your equipment. It's as simple as that. To improve the technical quality of your photos, you should use a tripod whenever you're working with natural light. Unfortunately, most tripods are not designed to be used out-of-doors, and especially not with the camera close to the ground. For that matter, I would argue that most tripods aren't even designed for human use because they pinch fingers, are way too short, and their controls seem to be located for some other race's appendages.

Why bother with a tripod at all? Using a tripod enables you to repeat the sharpness and the composition of your successful photos. You can always soften up a photograph by either handholding the camera at slow shutter speeds or by bumping the tripod during the exposure. Whether you want to get an absolutely razor-sharp image or the chance sharpness of handheld images is the real question you need to answer for yourself.

There's an old rule of thumb that says to obtain acceptable sharpness, never handhold a camera at a shutter speed slower than the focal length of the lens being used. In other words, if you're using a 50mm lens, the slowest speed to use safely is 1/60 sec., while for a 105mm lens it's 1/125 sec., and for a 200mm it's 1/250 sec. This is for infinity focus. I *can* handhold a 50mm photo of a mountain at 1/60 sec., but I *cannot* get a sharp picture at this shutter speed when I'm shooting at life-size. Remember that when you're taking a closeup, you're magnifying the image, which simultaneously magnifies any problems such as movement.

If you want any consistent sharpness, handholding your camera will restrict you to using fast apertures, fast films, or very short focal-length lenses. But for closeup photography these three are all counter-productive. Wide-open apertures have little depth of field, fast films cannot record the fine detail of small subjects, and short lenses permit no working distance. The only solution is to use a tripod.

A tripod also helps with composition. Mounting a camera on a tripod slows you down and lets you study the image, which is almost impossible to

do when handholding the camera since you are always swaying a little. How can you carefully check the edges of the frame when the edges are always changing? And with your camera firmly mounted on a tripod, you can wait for a lull if it is windy and be already focused and composed, all set to trip the shutter.

Almost all tripods are designed to be used at eye level while erected on a flat, hard surface. Look for a tripod that comes to *your* eye level and has the least centerpost extension possible. My day-in-day-out tripod has a centerpost only 5 inches long. You should also find a tripod that goes as low as possible to permit ground-level work.

I've heard it said a million times that the way to work low to the ground is to invert the centerpost and hang the camera upside down. How can you possibly contort your body to fit between the tripod legs, work the camera controls upside down, and miss the third tripod leg with the lens since your body is occupying one of

the open sides? It doesn't work.

For the widest use in the field you need to find one tripod that suits all your photographic needs: scenics, wildlife shots, and closeups. Find a sturdy, well-made tripod that by spreading its legs out flat goes low to the ground so that you can work with the camera upright all the time. Now equip it with a quality tripod head. For closeup work I much prefer a three way pan-tilt head where movement in each axis—swiveling left and right, tilting forward and backward, and tilting sideways—is governed by a separate control. Ball-and-socket heads are all right until you mount large equipment on them; then the sheer bulk of the gear becomes unwieldy when you're trying to compose precisely. Shooting at 1/2 life-size with a 105mm lens on extension and trying to recompose only a fraction of an inch in one direction without changing any other alignment is impossible with a ball-and-socket head since one control loosens movements in *all* directions at once.

Knot detail with and without using a tripod. *Kodachrome 25, 105mm lens, 1/8 sec. at f/8*

Here is a knot in my patio deck. I photographed it at about 1/4 life-size first on the top left with a tripod and then on the top right by hand-holding the camera (the handheld shot is the

best one I got out of 8 frames shot by bracing my left arm across my tripod head). The detail pictures below them are sections of the originals blown up to show the sharpness or lack thereof.

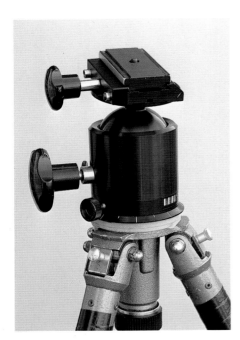

Arca-Swiss Monoball ball-and-socket head. This is the quick-release version with a very large ball head.

These tripods are the Slik M322 on left and the Gitzo 320 with a Bogen 3047 head on right. Both tripods offer low-level ground positioning. I've taped the legs of my Gitzo to keep my hands from getting so cold when I'm using it in the winter.

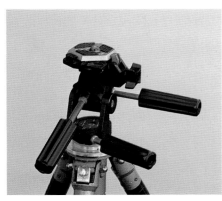

This is a Bogen 3047 three-way pan-tilt head with quick release.

Two other notes on tripod heads: most ball-and-socket heads commonly available are far too weak and vibration-prone to handle current 35mm SLR cameras, especially for closeup work. Balancing a 15-inch-long camera-and-lens combination on a 1/2-inch-wide ball so that the equipment is rock solid just cannot be done. Also, I've seen many people mount their cameras on pan-tilt heads 90 degrees in the wrong direction. Then they end up loosening the camera-locking screw in order to tilt down while in a vertical orientation. Almost all pan-tilt heads are constructed so that the control handle for tilting forward comes directly back toward the photographer, while the handle for vertical flopping sticks out to the right. If you have to loosen the camera screw to reposition your image, either you're doing something wrong or the head is poorly designed.

The sturdiest tripods have the fewest leg divisions possible. Each joint is a potential weak link. Check the smallest section; its strength will determine the strength of the whole tripod. Plus the fewer the sections, the faster the tripod can be set up and taken down.

There is no such thing as a lightweight sturdy tripod. A tripod designed to hold a complex assortment of equipment—for instance, a 200mm mounted on 50mm of extension tubes plus a camera body—has to be larger and bulkier than one which at most will support a camera and a 28–80mm zoom lens. To see how sturdy a tripod is, either mount a camera with a long lens on it and focus close or compose a closeup at about 1/2 life size. Now tap one of the tripod legs or the end of the lens while looking through the viewfinder. The image should not jump that much. A tripod that is too lightweight only adds to vibration and movement problems.

Here are my recommendations for good quality, sturdy tripods that work well in the field and permit low-level operation:

Gitzo 320, my standard tripod.

Gitzo 224, a little less heavy (as light as I would recommend). This is my backpacking tripod. Gitzo tripods are, in my opinion, the best made field tripods available. They come without heads, so you can mount the head of your choice. They are expensive tripods until you realize that the invest-

ment will last; you'll change cameras and lenses but still have the same Gitzo tripod. I've used the same Gitzo 320 tripod for ten years now. Gitzos come with a long centerpost that totally defeats their provision for low-level operation, so either buy their accessory short centerpost, or take a hacksaw or tubing cutter and make the long centerpost into a short one.

Slik M322, which comes complete with a good pan-tilt head. This is a good mid-range tripod. It has a unique grooved leg system that keeps the legs from twisting when you use the leg locks.

Bogen 3020, a very good flexible tripod for the money. It is a little short if you're 5'10" or taller.

Here are two good pan-tilt heads:

Bogen 3047, uses quick-release mounting plates.

Bogen 3025.

And finally, here are some ball-and-socket heads:

Bogen 3055, uses the same quick-release plates as the 3047 head.

Slik Pro-Ball, along with the Bogen 3055, the smallest ball-and-socket heads I would recommend.

Arca-Swiss Monoball, the best ball-and-socket head, but very expensive.

I was photographing flowers in the Texas hill country when a fellow saw me working with a tripod and came over to introduce himself as a photographer. He told me in very strong terms that the wind never stopped in Texas and that I should concentrate on photographing in midday when I could use fast shutter speeds. I didn't tell him that the evening before I had been shooting 8 sec. exposures. Yes, even on the Texas prairies the wind does drop to dead calm.

Texas spring wildflowers.

Kodachrome 25, 105mm lens, 1/4 sec. at f/32

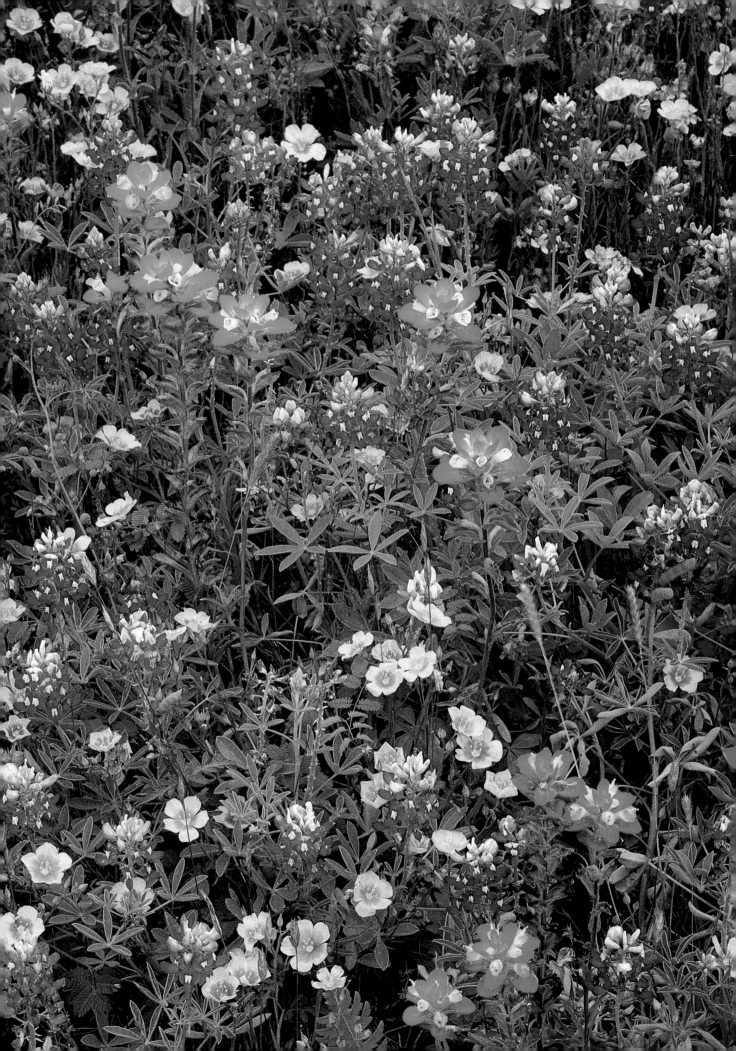

Focusing rails

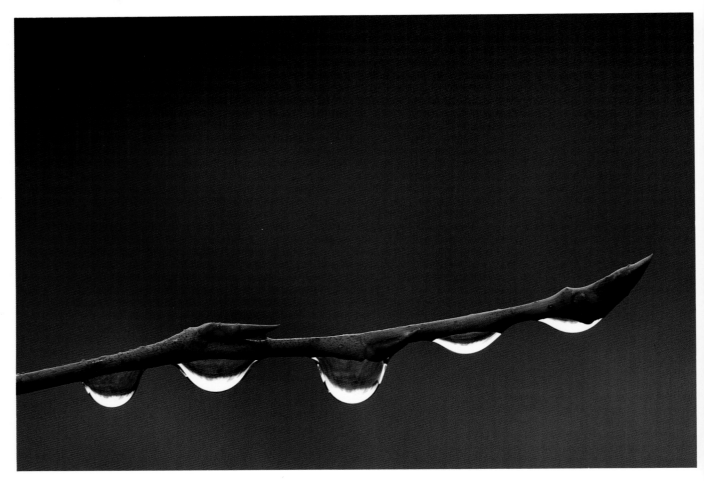

Raindrops. *Kodachrome 64, 105mm lens, 1/4 sec. at f/8*

When you are photographing at magnifications of 1X or higher, focusing becomes very difficult if you try to do it by using the helical focusing mount on a lens. The problem is that a combination of things are happening all at once. As you turn the focusing mount on a lens, what you are really doing is changing the extension of the lens (see Part IV on extension) and therefore changing the magnification being obtained. This means you are also changing the size of the area you are photographing and hence your composition when what you are really trying to accomplish is to focus the image sharply.

It is a lot easier to pick a desired magnification and then move the entire camera to bring the subject into focus. The most practical method is to set your lens for a given magnification (by simply looking at the subject and deciding on the size of the area you want to photograph, which in turn

gives you the magnification needed); then move the whole camera-and-lens assembly nearer to or farther from the subject. However, trying to slide a tripod back and forth is not very practical in the field.

The solution is to use a focusing rail, or rack-and-pinion rail, between the tripod head and the camera-and-lens assembly. Very few really good rails are available now. I've got an old, discontinued Minolta rail which was designed for use with their bellows attached. Novoflex still offers a well-made compact rail, as does Pentax. Of course, you don't need a Minolta camera to use a Minolta rail, or a Pentax for a Pentax rail—any camera should fit. All rails are just sliders with tripod sockets on the bottom and tripod screws on the top. A couple of rails won't work with motor drives because the rails don't provide enough clearance—I would avoid these models.

Several available rails offer move-

This was photographed just after a cold winter rain, a time when it is difficult enough to work without having to jockey the tripod around, but using my focusing rail saved the day.

This focusing rail is attached to a camera with a 105mm macro lens. Here the rail is centered over the tripod, allowing both forward and backward movement.

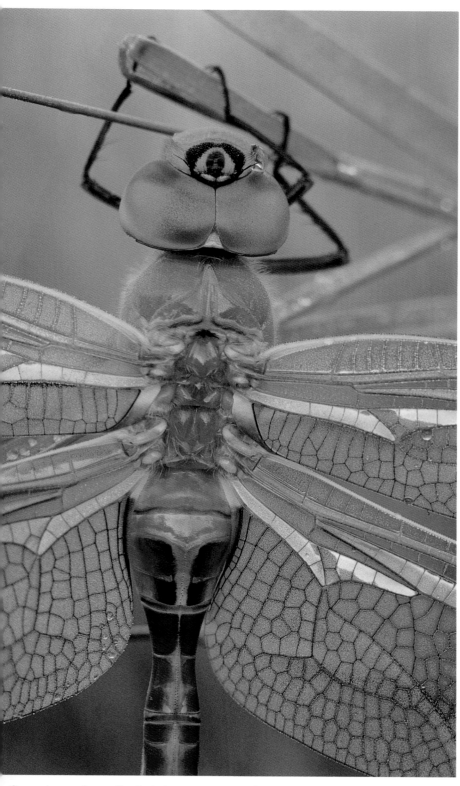

Green darner dragonfly. *Kodachrome 25, 105mm lens, 1 sec. at f/11*

ment in the forward-backward axis and the left-right axis. I don't recommend these at all, except for studio use. First of all, they tend to be very large, which will discourage you from carrying them in the field. And second, you will have trouble shooting a vertical picture if you have to mount your camera directly on the rail. Using a two-axis rail on a tripod means adding about 5 or 6 inches in height above the tripod head before you even get to the camera. Try flipping this whole assemblage to the side for a vertical—you had better have an extremely sturdy tripod!

To work with a rail, mount your camera on it so that the rail extends out under your lens. I'm always surprised at how many people do this backwards so the rail sticks out in their faces, which is a rather uncomfortable way to work. Use whatever extension you need for your desired magnification. Now use the rail to bring the image into focus and determine if your subject is too tight or too loose in the frame. If so, simply add or subtract a little extension and refocus with the rail. You might find it helpful to start off with the middle of the rail centered over the tripod head so that you have some movement in both directions.

You certainly don't need a rail if you're only interested in photographing fairly big subjects, such as the larger wildflowers. When you are backed away from a large subject and are working with a 105mm or 200mm lens, you can move your tripod around into the right position. After all, if you're working 20 inches from your subject, 1/2 inch either way is almost meaningless. However, the more you magnify an image, the more you will definitely need a rail. Above 1X magnification, a rail is almost a necessity.

This shot would have been almost impossible without the aid of a focusing rail. I was working as low as my tripod would go into the dew-covered grass early in the morning. Precise alignment was imperative, yet there was no way at this image size that I could get the exact framing I wanted by moving my tripod in and out. Using my focusing rail made the process much easier.

Filters

My advice on using filters is simple: don't use a filter unless you can verbalize a reason for doing so. Some photographers love filters and use them on almost every shot. I do not, because I much prefer to record the natural world as I see it, not with any added decorations. I believe the world is already spectacular enough without trying to add cross-stars, rainbow prisms, or other "spectacular" effects.

This is not to say I never use filters. When I photograph something, I am trying to record how it looks, and part of that appraisal lies within my experience as the one looking, as well as in the enveloping mood of the situation. Sometimes filters are necessary to bring out this ambience to the fullest. Although I don't want to change a subject's colors, I may want to emphasize the qualities already present in it. When I use filters to this end, I find that a subtle reinforcement is far better than an overwhelming alteration.

Consequently, my most used filter is not that strong; it emphasizes the warm colors already present in the scene. Overcast days yield perfect open lighting for many small subjects, especially flowers and vegetation. However, this light often tends to be cool and bluish. A warming filter—I recommend the pale amber tinted 81B—removes this coolness. I decide if I want to use this filter by holding it up and comparing how the scene looks with it and without it. I'm inclined to try it if the subject contains warm colors, the reds, oranges, yellows, and russets. However, some scenes and subjects should definitely be cool: frost, snow, and twilight are good examples. I've recently stopped using a warming filter on almost all my photos of dew-covered subjects because I've concluded that part of the feel of a dewy morning is the coolness of that time of day.

Another filter that I sometimes use, but not very often, is a pale magenta one. Very often the pale, pastel-pink flowers photograph as a washed out, dirty white. This is particularly true if they are growing under trees. The light coming down through the green foliage picks up a green cast that neutralizes the magenta pink of the flower. Green is exactly opposite

Autumn leaves. *Kodachrome 25, 55mm lens, 1/2 sec. at f/16.*

This pair illustrates the difference in photographs taken with and without an 81B warming filter. The picture on the top was made without one, and vice versa for the picture on the bottom.

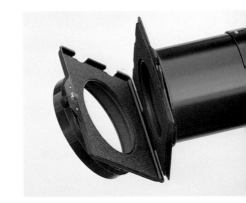

Here is the Nikon version of a gel-filter holder mounted on a 200mm lens. You can see that the holder opens like a book and the gel is then placed inside.

38

magenta on the color wheel. To replace this pale color, I use at most a 10CC magenta gelatin filter.

The CC filters are the color compensating filters available from Kodak and other suppliers in a variety of strengths in the six primary and complementary colors: magenta, yellow, cyan, red, green, and blue. The weakest version of these filters that you can usually find is a very pale 5CC value that contains just the faintest hint of color, while the strongest filter is 50CC, and it is quite distinctly pigmented. A 10CC filter adds a little emphasis, that's all.

Gelatin filters are, as the name suggests, very fragile. They are available in 3-inch squares, and in order to mount them on a lens, a gel-filter holder is necessary. Several manufacturers offer a hinged frame that holds the filter and then screws onto the lens.

I own quite a few gelatin filters because I once discovered a camera store that was selling out its entire stock for mere peanuts, and I couldn't refuse such a deal. But I rarely ever use the ones I bought; in fact, some I have never used at all.

I don't use a skylight or UV filter to "protect" my lens. Some photographers leave one on permanently and justify this by saying that the filter offers protection for the lens. I can never figure out exactly what it is protection against. I've always envisioned some sort of madman, the "one-armed filter claw," lurking out there in the swamps, waiting for nightfall so he can come skulking toward my unprotected lenses. In truth, better lens protection can be had by using a lens shade, especially a rubber one that acts as a bumper against knocks and bangs. I simply don't like leaving a filter permanently on the lens. I paid very good money for the best-quality lenses; I certainly don't want to degrade the image at all, and any filter placed in the light path will do so to some extent. I don't *always* leave a polarizing filter on, or *always* leave an 81B on, or *always* leave the lens cap on. Why then *always* leave a skylight filter on? So my advice is to use it when you can verbalize your reason out loud: for example, "I want to protect my lens from salt spray while I am photographing these barnacles."

Here is another comparison using the same composition to show the effects with an 81B filter on the left and without one on the right.

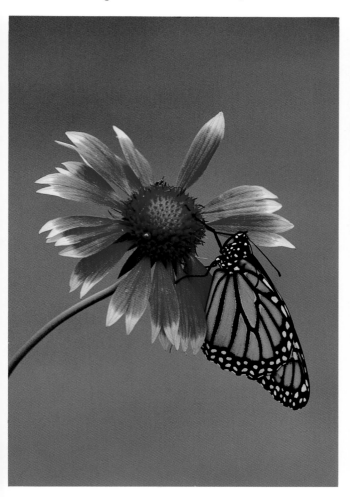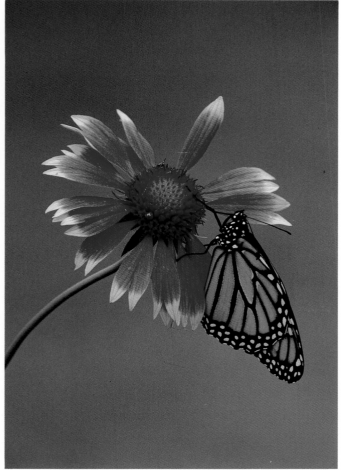

Monarch on firewheel. *Kodachrome 25, 80–200mm zoom lens, 1/8 sec. at f/8*

Films

Generally speaking, when you're shooting closeups you're usually interested in sharply rendering all the minute details present in your subject. The only way to do this is to use the best film available to you. As a rule, the slower the film speed, the sharper and more grain-free the image; so you should use the slowest speed film possible given your working conditions. It makes no sense to spend a lot of money for optics and then not be able to see the quality you paid for in the final image. Good lenses and good working techniques deserve good films.

As far as I'm concerned, the best results are obtained by shooting trans-parency, or slide, films. Slide film is sharper than print film and is the type of film used for publication on the printed page. Slide film makes better prints than print film makes slides, and best of all, the results are plainly visible when you look at a slide. Learning anything by checking a color negative is a mystery to me, and I've been a professional photographer for quite a while. Gaining photographic information from a color print is almost impossible, since compensations are automatically made by the machines that make the prints.

There's an old adage about the cost of the film being the photographer's least expense, and like many sayings there is a lot of truth to it. I would much rather overshoot a subject than undershoot it. Slides cost less per shot than prints, which helps. You will miss shots; we all do. Don't be afraid to edit your work ruthlessly, especially if you want to sell photographs to books and magazines. Check your slides by using a high quality loupe and a light box, and throw away any mistakes. One difference between an amateur and a professional photographer is that the professional has a larger wastebasket.

If you check the photo captions in this book, you will discover that my normal film is ISO 25 while my "super high-speed" film is a blazing ISO 64. I

This pair of photographs shows the differences between Kodachrome 25 on the left and Ektachrome 400 on the right. The K25 was shot at 1/2 sec., while the E400 was four-stops faster at 1/30 sec. Note the differences in color and sharpness.

Autumn leaves.
105mm lens, at f/16

must admit that recently I've seen less of a difference between the two Kodachromes (there used to be a distinct color difference), so I'm shooting more and more Kodachrome 64. Since I can have the same results as before but with a stop more speed, I'll gladly take it. And as of this writing, I'm experimenting with the Fujichromes.

Among wildlife and natural-history photographers, Kodachrome 64 is probably the most popular of all films, although Fujichrome 50 is gaining popularity. I urge you to try different films and pick the one, or at most two, that you like best. Then totally learn that film's characteristics so you know how to handle it in the field. What does it do at long exposures? How does it portray certain colors? Are the white areas in a scene neutral, or is there a predominant color cast to the film? I suggest choosing a film that is readily available wherever you plan to work. What if you're traveling and need more film? Can you purchase it locally, or must you send back home for more? If you can find it locally, is there enough of a turnover in the stock so that it is relatively fresh, or has it been sitting on a shelf for the last five years? I personally stick with Kodachrome and Fujichrome films for just these reasons; I can travel almost anywhere in the world knowing that I can find more consistently good film if I need it.

Here is the same subject shot on Kodachrome 25 on the left and Fuji 50 on the right. There is a distinct color difference between these two films. You must pick a film you like.

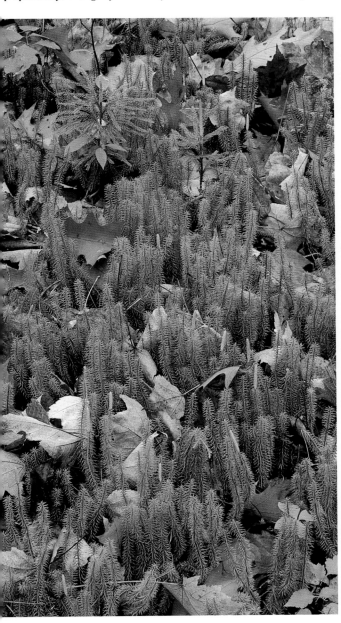
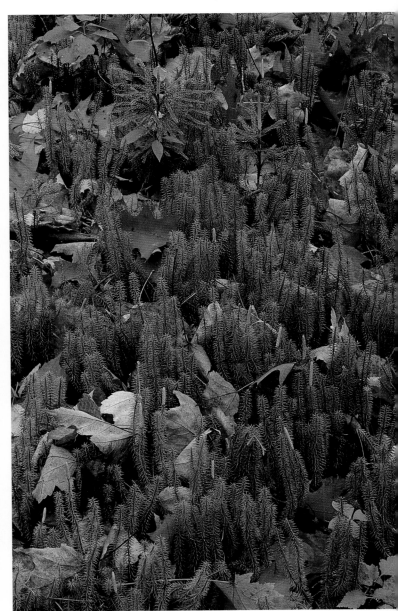

Stiff clubmoss. *105mm lens, at f/11*

Low light exposure and reciprocity failure

One problem you will face when shooting closeups with natural light, especially when you're using an extension-based system, is obtaining a meter reading in low light situations. Often you will be outside the sensitivity range of your built-in camera meter if you try to meter your subject at the f-stop at which you want to work. For example, say you're photographing some life-size images of sphagnum-moss patterns in a cedar and tamarack bog. You're shooting on an overcast day, and the tree canopy is cutting out a lot of the light. You've used the depth-of-field preview on your camera and have decided that you need at least f/22 to cover your subject, but when you turn on your meter, you cannot get a reading.

You can do one of several or a combination of things now. First, you don't have to meter at the actual f-stop you plan on using when you take the picture. Instead, take a reading with your lens wide open, and then figure out the shutter speed for the f-stop you actually want to use. Suppose you meter wide open at f/2.8 and get a reading of 1 sec. This equates with 2 sec. at f/5.6, 4 sec. at f/8, 8 sec. at f/11, 16 sec. at f/16, and 32 sec. at f/22. If you cannot get an initial reading at f/2.8, you could meter something lighter than middletone, something more reflective such as the palm of your hand. From the earlier discussion on metering you know that you have to open up one stop to take this lighter reading into account. Metering your palm would thus make the final exposure 64 sec. at f/22.

Forest floor.
Kodachrome 25, 105mm lens

This test sequence shows the effects of reciprocity failure. The top frame was exposed 1/2 sec. However, I needed more depth of field as the tips of the ferns are not in focus. In the middle frame I stopped down, and the shutter speed was 4 sec., but you can see that it is slightly underexposed compared to the first frame. Correcting for this by doubling the time to 8 sec. in the bottom frame, I went back to the exposure density of the 1/2 sec. shot but with the added depth of field from stopping down.

Theoretically, you could also set the ISO dial at a higher number. or a couple of stops faster than the film you're using. If you're shooting Kodachrome 25 and you adjust the ISO dial to 200, or three-stops faster, you must allow for this in your final answer. Start off with the meter reading of 1 sec. at $f/2.8$ and allow for three stops to 8 sec. at $f/2.8$. Now count stops over to $f/22$, and your shutter speed is 512 sec. If you had to do so, you could even change the ISO dial *and* meter off your palm. Combine a three-stop change in the ISO with metering off your palm, and the final answer would be 1024 sec.—17 minutes—at $f/22$. All that from a one sec. meter reading with the lens wide open!

To be honest I don't think you should ever have to do all this. I cannot think of any time when I have had to adjust my ISO in order to get a meter reading. I would be tempted not to do so anyway, since I know I would forget to reset the dial back to the correct number. At most, I am willing to meter a lighter-than-middletone area and calculate my exposure from there. If you need to take further measures, it's too dark to photograph; give up for the day or use flash. Besides, if your meter reading is 17 minutes at $f/22$, you probably cannot see to focus.

You will, however, discover that you do shoot quite often at speeds slower than 1 sec. I commonly use shutter speeds between 2 and 16 sec. If you shoot these exposures as calculated, you will discover that your slides are slightly underexposed because of *reciprocity failure*. Reciprocity is the relationship between shutter speed and aperture, wherein a change in one equals an equivalent but opposite change in the other. At very short or very long exposure times, this relationship breaks down. Quite simply, the film needs a little more light for correct exposure, the exact amount depending on the film and the shutter speed.

I would advise you to standardize the films you use, particularly when it comes to long exposures, so that you can learn exactly how reciprocity failure affects them. All film manufacturers give reciprocity-failure data for their films, but you should test this information yourself.

I use the Kodachromes for most of my work. My standard way of shooting long exposures with these films is to

Fringed polygala. *Kodachrome 25, 105mm lens, 8 seconds at $f/16$*

open the aperture 1/2 stop when I calculate a 1 or 2 second exposure. Beyond a 2 second exposure, I just double the time. If an exposure of 8 seconds is called for, I shoot at 16 seconds, and so on. I use this system because it's easy for me to remember. I must admit that I rarely shoot exposures longer than about 16 seconds; an exception is when I'm photographing star trails. (With either of the Kodachromes, start at an exposure of 1 hour at $f/2.8$ to record the apparent arcing movement of the stars. Increase the time for a longer arc, but don't stop down any more.)

This milkwort was photographed on a bright, sunny day, but I was working in the full shade of a cedar swamp. Even though the day was cloudless, at this location I still needed a full 8 sec. exposure to shoot at roughly 1/5 life-size using extension on this film at this aperture.

Running a test

Although testing equipment and procedures is not very glamorous, it is one of the most productive ways of learning about photography and about photographic technique. Too many photographers buy new lenses or learn about new ways of working, and then try to implement this new material when they are ready to shoot a subject in the field. This is absolutely the wrong time to experiment. You want to be confident of the results and not have to resort to a trial-and-error approach.

I am a great believer in testing out both equipment and working procedures. In fact, I take little information for granted until I've experimented with it the same way I work in the field. Some methods that I've heard touted as the best solutions to certain problems don't work for me at all, and other methods that seem ridiculous at first are the exact answers. But I only found this out by running some simple tests.

You don't need anything special to run a controlled test except control. Be logical and precise in your work, think out all the variables and change only one at a time, and keep careful notes. For example, let's say I want to compare two different ways of reaching the same image size, or the same magnification. First I find a subject to photograph, something I have around

my house that I can later compare directly to the test pictures. I want a subject that has sharply defined detail, and probably a variety of colors if I think my procedure might affect their rendition. Then I photograph the subject using both the new method and a tried-and-true way, using the same light source for all the test photos so that no change in lighting influences the results. I note all my exposure information along with such things as working distance. When I receive the resulting slides, I set up side-by-side comparisons that I can check with a loupe on my light table.

The two most important factors in running a test are using perfect technique and keeping careful and complete notes. Sloppy technique invalidates all the resulting information. Unless your efforts are diligent, how will you know whether the picture isn't sharp because the equipment doesn't work as you thought it should, or because you were handholding the camera? Be sure to use a sturdy tripod with the controls locked solidly. Is the color different in the two shots because the sun was out for only one? Then you should use flash for both, or make sure the natural light will be consistent when you shoot.

Too often we think we will be able to remember how we shot a picture, and consequently, we neglect to write

down the pertinent information. Believe me, you won't remember it. Keep the best notes you can, as thoroughly as you can. Correlating your notes with your pictures can be a problem when you get all your film back from processing. A solution is to place as much information as possible right in the frame when you shoot. I've always used small pressure-sensitive labels stuck on one corner of the subject. If I lose my notes, or if a couple of years from now I want to review my tests, the information is still available.

One place I don't use labels within the frame, however, is in film comparisons. I'm aware that I bring my own prejudices to the way I look at pictures and determine what is good color and what looks sharp, and any information within the frame might call up these prejudices. I can hear myself saying, "Why, that can't be any good since it's Superchrome!" I shoot film comparisons side by side, same camera, same lens, same light, same composition. Then I compare the shots without checking the slide mounts as to film type.

The cost of testing is minimal: the price of a roll of film and some of your time. The results are worth far more as you evaluate the quality of a given lens or procedure. Now you can concentrate on achieving your best while working in the field.

I used a cereal box to make this test shot. It is a good example of how I test out equipment. In this case, it was a 200mm lens on a large extension tube. Note the information on the small label.

200 on PN-11 K25
1/15 f16 WD = 38

In this exposure-test sequence I was checking the exposure latitude of Kodachrome 25 by working with an entirely middletoned subject. The sequence is in stops, from 2 stops open to 2 stops down from my meter reading.

Part III

IN THE FIELD

Paralleling the subject

As you gain magnification, precise camera positioning becomes more and more critical. Positioning your camera for closeups is quite different from photographing a mountain, for instance, where moving closer, farther, or side-to-side by several feet is entirely meaningless. The camera position doesn't change enough relative to the mountain to make a difference, and the depth of field at $f/16$ is measured in yards. However, if you're photographing up close, being out of position by an inch is a gross discrepancy. Depth of field at $f/16$ is now measured in inches or fractions of an inch. At 1/10X magnification the depth of field at $f/16$ is roughly 4¼ inches, at 1/2X it is ¼ inch, and at 1X it is only ¹⁄₁₆ inch.

You must maximize the effectiveness of whatever depth of field you have. To do this, carefully align the film plane (the back of the camera) with the most important subject plane so that they are parallel. Choosing this important subject plane is an arbitrary decision on your part; you pick the aspect of your subject that you want to emphasize. Look at your subject and decide what is important and therefore has to be sharply in focus in your photograph.

I cannot stress enough the importance of precise camera placement. In fact, for closeup work it is the *most* important factor, since you simply cannot stop down enough to cover imprecise placement. Two tricks will help you in positioning your equipment. First, look at the subject and determine the plane of importance. Now reach out and place your flat, open hand parallel to this plane and as close to it as possible. Bring your hand back toward the camera position and align the film plane with the angle of your hand. Then once you've positioned the camera, step to the side and look at it. It's easier to check whether the film plane is really parallel to the subject plane when you're looking at the side of the equipment. Quality closeup photography is worth spending a great deal of extra care and time in positioning your camera properly.

Leaf veination of chestnut oak. *Fujichrome 50, 105mm lens, 1/8 sec. at f/8*

In the top photo I carefully aligned the camera back so that it was parallel with the leaf, thus giving me the sharpest focus possible. When I made the second photo, the camera was about 20 degrees off the perpendicular. Both edges are out-of-focus, even though I used the same f-stop and focused in the same place, the center of the frame.

Due to a persistent breeze, this was the slowest shutter speed I dared to use. I was parallel to the iris and the lone long-spurred violet blossom when I made the photo below, which gave me enough depth of field to keep all the flowers in focus. In the photo at left I was at an angle to my subjects, and the depth of field provided by this aperture wasn't adequate to compensate for not being in alignment, so I lost sharpness in the rear blossoms.

Crested Dwarf iris. *Fujichrome 50, 105mm lens, 1/30 sec. at f/8*

Backgrounds and focal length

There are two ways to control the appearance of the background behind your subject. One is to control the lighting of the subject and the background by manipulating the natural light (this is covered in the next section). Many photographers don't realize there is another way, and that is by changing focal lengths. The lens you pick to photograph a subject will influence not only how the subject appears, but also how the background looks.

A lens's angle of view is the angle it sees, how much it takes in from side to side. The longer the focal length of the lens is, the narrower the angle of view is; and the narrower the angle of view, the less coverage *behind* a subject. The solution to working with a confusing background is often to back away from it with a longer lens, keeping the image size of the subject the same but taking in less of the background.

One real advantage of using long focal lengths for closeups is that you can often pick the tonality of the background simply by shifting your shooting position a little. With a short focal-length lens you sweep in a lot of material behind the subject, whether or not you want it. Moving your vantage point doesn't change what is behind the subject because so much is back there. With a long lens—especially 200mm lens or longer—you can pick and choose exactly what in the scene you want to appear in the image.

In this case it is not shallow depth of field that isolates a subject. All lenses that are focused at the same image size (the subject is the same size in the frame) and the same *f*-stop have the same depth of field. What isolates a subject against a posterlike background is using a long focal length because it sees so little background behind the subject.

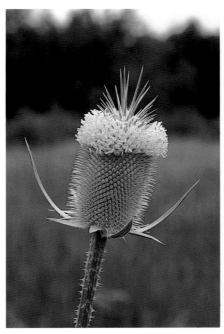

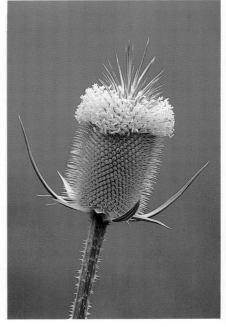

Teasel. *Kodachrome 25, 50mm lens, 1/8 sec. at f/11*

Teasel. *Kodachrome 25, 200mm lens, 1/8 sec. at f/11*

With a fairly short lens I have included the field, the far distant line of trees, and part of a blank sky in the background.

By switching to a 200mm lens I can eliminate the background confusion. Now the teasel is isolated against the out-of-focus field.

Coneflower. *Kodachrome 25, 300mm lens, 1/4 sec. at f/8*

The only difference between these two pictures is the location from which I shot the two frames. The long lens let me pick and choose the background. In one frame the flower is against the

deeply shadowed woods; in the other it is against an open field. I moved my camera position less than one foot to get this change in background, but that created a strong emotional difference.

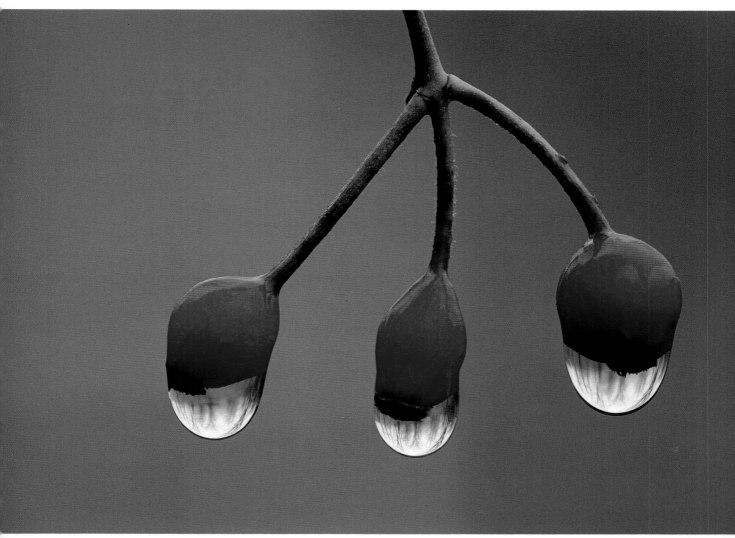

Multiflora rose hips and raindrops. *Kodachrome 25, 200mm lens, 1/8 sec. at ƒ/11*

By using a long focal-length lens, I isolated these rose hips against a posterlike green background, making them stand out sharply.

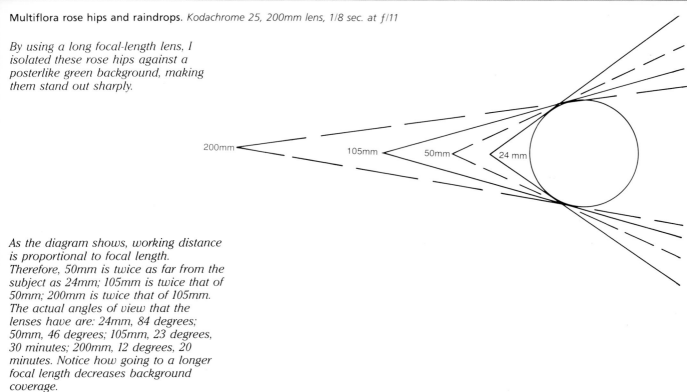

200mm 105mm 50mm 24 mm

As the diagram shows, working distance is proportional to focal length. Therefore, 50mm is twice as far from the subject as 24mm; 105mm is twice that of 50mm; 200mm is twice that of 105mm. The actual angles of view that the lenses have are: 24mm, 84 degrees; 50mm, 46 degrees; 105mm, 23 degrees, 30 minutes; 200mm, 12 degrees, 20 minutes. Notice how going to a longer focal length decreases background coverage.

Controlling natural light

Dewy damselfly. *Kodachrome 25, 105mm lens, 1/15 sec. at f/11*

In both shots the damselfly is lit by early morning sunlight. I wanted to modify the background created by the straight natural light shown in the shot on the left, so I diffused the light with my white umbrella for the second frame. After I took these photos, I packed my gear, turned around, and neatly trampled a nest of yellow jackets. I definitely paid for my photos that day.

Controlling the natural light falling on a subject is one of the most important aspects of closeup photography. Film cannot record the contrast range that the human eye can see, so photographers must often compress the range of lighting contrasts falling on a subject. Transparency film has a usable range of roughly five stops maximum, from pure detailless white to pure detailless black, two-and-a-half stops on either side of where a middletone exposure falls. If the shadows or the highlights are within this tonal range, they will record; otherwise, shadow areas block up into pure black or detail is lost in burned-out highlights. When you meter both your subject and shadow areas, you can compare meter readings and learn what contrast you have.

Compressing the contrast range may be done several ways. One good method is to shoot in low-contrast lighting. Too often we think that the time to photograph is on a sunny, cloudless day. The reality is that for most closeup photography, this is the worst lighting possible. You're trying to record all the minute details of a

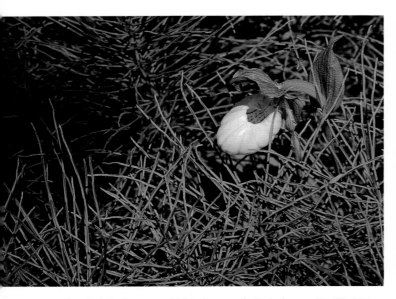 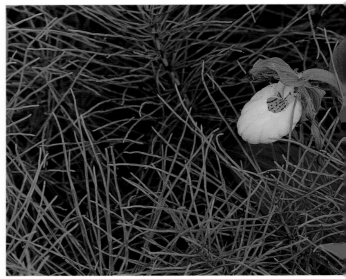

Yellow lady's slipper orchid in horsetail. *Kodachrome 25, 80–200mm zoom lens*

The direct sunlight was too harsh for this subject. The shadow details were lost in the horsetail, and the highlights were burning on the blossom. I shaded the entire area with my white diffusing umbrella for the second shot, which gave my subject a far more open light. Note also the difference in color temperature between the two photos. By the way, that day I had the most helpful accessory possible along with me: another person to hold the umbrella.

subject, but the harsh lighting hides many of these very details in shadow or washed-out areas. But if you shoot on an overcast day, details pop out, colors come alive, and subtleties return. On a day with high overcast, the entire sky acts as a giant diffused light source.

Obviously it is impossible to shoot only on overcast days, so you must learn to control the natural light, whatever its level. Several accessories help in this process, the simplest being reflectors, diffusers, and shades.

The best reflectors I know of are made by covering cardboard—I've always used the white side of a gray card—with aluminum foil that has been crumpled and then partially smoothed out again. Wad up some foil, carefully spread it back out, and rubber cement it onto the board. This makes a surface that reflects an open, diffused light. You can change the intensity of the reflected light by how much you crumple the foil. To achieve a spotlight effect, don't crumple it at all but use it straight from the box. You can also change the color balance by using a colored foil. If you want a warmer light, make a reflector covered with gold foil (foil wrapping paper is a good source here).

If you want direct highlights without quite as much contrast as sunlight, make a diffusing screen. I used to do this with several layers of cheesecloth sandwiched into a cardboard picture-framelike cutout. Cheesecloth snags on everything in the field, however, so I found a much better substitute in silkscreen material, available from art-supply stores.

My most-used lighting accessory is ready made—I carry a standard folding rain umbrella. Actually, I have two of them; a white one that I use as an open diffuser, and a black one that I use for a shade. I utilize them mainly to shade the subject along with a reflector card that throws some highlights back or to shade the background. Frequently, we get so caught up in looking at a subject that we forget about the background. Out-of-focus highlights behind the subject record as hot spots, and these can ruin a photograph. One trick I've learned is to carefully check around the edges of my viewfinder frame, searching for hot spots along the edges. If I find one, I shade whatever is

causing the hot spot with an umbrella.

To hold an umbrella in place I usually prop it on the ground or cram it into the branches of a nearby shrub or tree. If I'm quite close to my car, I use an old lightweight tripod with a standard studio umbrella clamp. I keep this old tripod around just as a stand; it's not much as a tripod—it's way too

flimsy for that—but it makes the best outdoor stand I know. Regular light-stands are made for flat, hard-surfaced floors. Take one outside, and it immediately falls over. But tripods are made with adjustable-leg lengths, an invaluable feature on an outdoor stand that might have to be planted on a mountainside!

Bunchberry in reindeer lichen. *Kodachrome 25, 105mm lens*

When I found this bunchberry, it was half in shade, half in sunlight. I used my black umbrella to shade the entire area by propping the umbrella several feet to the side of the plant.

Composition

Good composition is good composition, regardless of the size of the subject. There really is no difference between shooting scenics and shooting closeups except for the element of scale. Metering and exposure are the same, tripods and films are the same, and composition is the same; and good technique is good technique, notwithstanding subject size.

The first step in composing a photograph is defining your subject. I've often heard photographers say, "Isn't that a great subject?" but when asked what specifically they were talking about, they were unable to answer except in the broadest of terms. Vague feelings are not enough. The more you can specify your subject matter, the better. One aid is to verbalize out loud exactly what you're interested in photographing, then include only the material that fits your definition within the viewfinder. Simplification is always a good compositional tool. Keeping only one visual center of interest within a picture tends to unify it, whereas including many centers of interest tends to pull the frame apart.

Once you have decided on a specific subject, you still have to make two major decisions: how to frame the subject, and where to place the subject within that frame. Framing involves deciding how tight to crop the image, how much space to include on the sides and in the background, and also whether to shoot a vertical or a horizontal. The format of the frame definitely affects the emotional impact of the photo. Although a 35mm camera is not particularly designed for shooting handheld verticals, using a tripod solves that problem as well as adding stability. A tripod is probably one of the best compositional aids available because it allows you to study the image precisely. Noting where the frame's edges fall, you can make the minute adjustments necessary for achieving the fullest impact in your final image.

Notice the use of a rule-of-thirds placement in these first two photos, one in a vertical format, the other in a horizontal.

Tufted phlox and moss. *Kodachrome 25, 105mm lens, 1/2 sec. at f/22*

Sycamore leaf and dew. *Kodachrome 25, 50–135mm zoom lens, 1/4 sec. at f/11*

When you have decided how much of your subject to frame and whether to use a vertical or horizontal format, then the issue of placement arises. Placement is the arrangement of important subject elements within the rectangular 35mm frame. What you want to create is a visually interesting and moving arrangement; you don't want a dull, static picture that looks frozen into place. Placing your subject dead center in the frame is generally not a good idea since a bull's-eye placement allows for no movement or implied movement. A dead-centered subject tends to sit there like a lump, not going anywhere.

If you cannot decide on how to arrange the elements of form, color, and line within the frame, an artificial but useful starting point is offered by the traditional "rule of thirds." Draw a tic-tac-toe grid across the 35mm frame, dividing it into thirds horizontally and vertically. The intersections are very strong points at which to position the important components of your subject. You have eight of these intersections: four in a horizontal format, and four in a vertical. Although you certainly won't want to compose every photograph with placements right on these points, the rule of thirds can be helpful for viewing a subject if you're unsure about composition.

When you find a subject, I would urge you not to mount your camera on your tripod immediately. Doing that sometimes gives a false importance to wherever the tripod happens to be positioned, so that you end up shooting from that location regardless. Mount the lens you want to use, hand-hold the camera, and view your subject. This way you can move around easily, trying new positions and slightly different perspectives. Then, once you find roughly the perspective you want to photograph, set up your tripod and compose carefully.

Here is exactly the same shot but in both formats. I prefer the horizontal composition where the ground squirrel's eye falls on a thirds placement, and there is more room in the direction of the implied action.

Thirteen-lined ground squirrel. Kodachrome 64, 400mm lens, 1/500 sec. at f/5.6

Part IV

EXTENSION

Closeups with extension

All lenses focus closer as you "extend" the optics away from the film plane, or in other words, as you physically move them away from the camera. Most normal lenses focus closer by means of extension; when you turn the focusing mount, the lenses physically grow longer. All that is happening is that you're using the extension built into the lens's focusing mount. Most lenses incorporate some sort of extension in order to focus closer, and for field work, extension is one of the most practical ways of working with magnifications down to about 1X.

The total amount of extension you need in order to get to any given magnification depends on the focal length of the lens you are using. Notice that I say "total" extension; it does not matter how you gain the extension—some could be added by using extension tubes, some could be in the focusing mount of the lens—since the entire amount being used is what is important. A basic formula gives approximate magnification rates:

Total extension used/Focal length used = Magnification

If you want to photograph at 1/2X with a 50mm lens, you can see that you need 25mm of total extension. But on a 100mm lens, the same 25mm total extension yields only 1/4X, and on a 200mm lens it yields 1/8X. Any given amount of extension yields less magnification when used with a longer focal-length lens.

When working with a very long focal length, extension becomes an unwieldy means of shooting at higher magnifications. Consider what happens when using a 200mm lens in the field. Add 25mm of extension for 1/8X (an 8 × 12-inch subject size), and the equipment is very manageable. Go to 50mm total extension for 1/4X (4 × 6-inch coverage), and immediately the combination starts to demand more care in handling. Go to 1X, and the equipment is definitely awkward if not hopelessly vibration prone. Adding 200mm of extension, which is roughly 8 inches, to the lens and the camera body creates quite a package. Just out of curiosity, I put my standard 200mm F4 Nikkor lens on 200mm of extension—a 27.5mm tube plus a 52.5mm tube plus 120mm of bellows extension—and measured the total size from the front element to the camera back, which came to a total of 15 inches. If you work this way, you'll need to have some means of mounting the extension on the tripod (see page 72), rather than hanging all the weight on the camera and mounting it on the tripod. Obviously, the real limit to adding extension is one of practicality. Imagine trying to shoot at 2X using extension with a 500mm lens— you would need one meter, 1000mm, of added extension. Try to carry that in the field, let alone support it!

Air bubbles in ice on stream. *Kodachrome 25, 180mm lens, 1/2 sec. at f/16*

Extension is extension is extension. Speaking in terms of the results, there is no difference between an extension tube and a bellows—they are both ways of getting extension. However, in actual practice there is a great difference between these two kinds of extension, and a great difference as to their practicality in the field.

Extension tubes are fixed-length amounts of extension that fit between the camera body and any lens, permitting that lens to focus closer. Very few sets of extension tubes are available anymore; but check with your camera manufacturer to see what they offer. Several different lengths can usually be obtained. Nikon, for example, offers individual tubes for purchase separately in the following lengths: 8mm, 14mm, 27.5mm, and 52.5mm. When you're using these tubes, they may be combined in any order you want; they are just different lengths of extension. And there is nothing special about these lengths, either. If your camera manufacturer offers entirely different lengths, well and good. Extension is extension is extension.

Before you buy extension tubes, there are a couple of features worth checking. Almost all tubes today are meter-coupled and diaphragm-coupled. This means that the tube allows the meter to work just as it does when the lens is attached normally, and that the lens remains wide open until the shutter is released (then the lens stops down to the preselected aperture and reopens after the shot). Very few uncoupled, or manual, tubes are offered today, and for field work I wouldn't purchase the few that are available. Above all, you want diaphragm-coupled tubes so that you can compose, focus, and shoot with the lens initially wide open. By the way, when you add extension you will lose any f-stops displayed in the viewfinder. Don't worry about it—your through-the-lens meter will still work correctly.

A bellows is nominally a variable extension tube. However, it is a lot larger and far more fragile, and it is rarely meter-coupled or diaphragm-coupled. For field work, these factors are all major drawbacks. Their bulk alone is enough to rule out carrying most bellows into the field unless you're working very close to your car. Because bellows are not meter-coupled, you have to take stopped-down meter readings, which is an inconve-

nience but workable. Being non-diaphragm-coupled, though, is a disaster for field work.

Many bellows solve this problem—or at least their ads say they do—by using a double-cable-release system. This is a cable release with two cables connected to one handle. One cable screws into the front standard of the bellows, the other into the cable-release socket on the camera. When you press the plunger, the lens stops down before the shutter releases. In other words, you have a mechanical diaphragm-actuating device. Unfortunately, the double cable is one more item to carry and one more item to lose. And without it, you're right back to a manual-diaphragm system. (By the way, never walk around with a cable release of any sort connected to the camera. I often walk with my camera mounted on my tripod, but I always take the cable release off. I once saw a double-cable release catch on a branch as a photographer was ducking under a tree, and it jerked the top shutter assembly out of the camera.)

One big problem with most bellows is that when they are closed down all the way, they still yield a significant amount of extension. I measured several different makes of bellows—a Nikon, a Canon, and a Novoflex—and their average length when closed was 45mm. This is the minimum extension available! If you need a smaller amount of extension, you must use a tube. So owning a bellows means you will also own at least one small tube. This is especially true if you want to add extension to short focal lengths. Roughly 45mm of extension on a 50mm lens means that you're starting out at almost 1X, with nothing in between this magnification and the minimum focus of the lens alone, and that's a big jump. Even on a 200mm lens, you're almost at 1/4X.

A small tube is also needed if you want to make a long lens focus just a little closer, such as when you're shooting birds at the nest. Adding a bellows to a 400mm lens is not very practical—although it can be done—because it results in a very unwieldy outfit that probably doesn't have an automatic diaphragm. A small tube, 10–15mm or so, is perfect. Having at least two tubes, a large one and a small one is helpful, even if you have a bellows. But if you already have enough extension to shoot most of the subjects you want to photograph, I

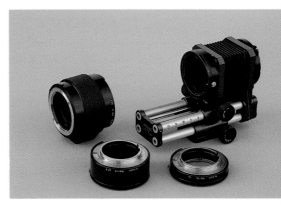

Here are three Nikon extension tubes of various sizes, including the PN-11 tube on the left that has a rotating tripod collar. The Novoflex bellows shown here is a form of variable extension. Note that this one has a built-in focusing rail.

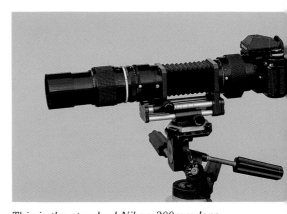

This is the standard Nikon 200mm lens plus 120mm of bellows extension plus the Nikon PK-13 and PN-11 tubes, which together add up to a total of 200mm of extension. You can see that this length is definitely getting awkward.

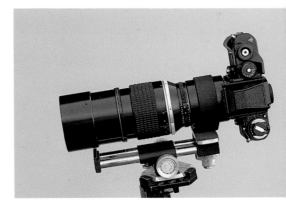

This 180mm lens on a Nikon PN-11 extension tube that has been mounted on focusing rail is one of my favorite combinations for creating adequate working distance.

would urge you to think long and hard before you purchase a bellows since it is basically not for field use.

Many bellows do offer two conveniences: First, they let the camera rotate on the back standard for a vertical or a horizontal placement without flopping the tripod head, which means that the weight of the unit remains centered over the tripod. Second, they have a focusing rail built-in as part of the bellows. This greatly adds to their usefulness, both in the studio and in the field. In fact, if I were to purchase a bellows, I would not consider one without this second feature. Some bellows are made so that you must buy the bellows and the rail separately, then hook the two units together. Make sure you do this.

One last note on extension: Nikon makes a special extension tube that I highly recommend for Nikon owners, the 52.5mm long PN-11 tube. If you need this much extension, the feature that distinguishes this tube is that it has a rotating tripod collar that can be used to mount the entire camera assembly on the tripod. To shoot vertically, you simply loosen the collar and rotate the camera; you don't have to flip the tripod head to the side. By rotating the tube, the weight of the camera and the lens remains above the tripod axis, and there is less vibration than when the bulk of the equipment is cantilevered out to the side. Why other manufacturers don't offer such an extension tube is beyond me.

Interrupted fern. *Kodachrome 25, 105mm lens, 1 sec. at f/11*

Here the dark background is caused by shooting into the deeply shadowed forest.

Indian paintbrush and fir. *Kodachrome 25, 180mm lens, 1/8 sec. at f/11*

Short lenses

You will rarely, if ever, add extension to short focal-length lenses, unless you are reversing a lens for high-magnification studio work (see Part VII on reversing a lens). With the lens facing the subject in a normal position, any amount of extension added to a 24mm, 28mm, or even a 35mm lens immediately cuts the free working distance so severely that the lens almost touches the subject. The shortest tubes you can purchase are about 8mm long. When you add one to a 24mm lens with the focusing mount set at infinity, the magnification is immediately 1/3X. That makes your working distance less than 2 inches, and that's with the least extension possible. If you go to life-size with this combination, the working distance is minuscule; the subject almost touches the front element of the lens, which is totally impractical for any field work. Applying the question "How close can I get?" to working with short lenses does have some validity. The question should be reversed, however, to "How far can I stay away?"

Luckily most short lenses focus very close all by themselves. For example, in the Nikon line the 24mm *F*2, the 28mm *F*2, and the 35mm *F*2 lenses all focus to a working distance of approximately 8 inches. Check the close-focusing range of any new lens you might be considering; all else being equal, buy the one that focuses closest. Even if you don't plan on using it up close, the ability to do so is there if you need it.

The top photo was made with a 24mm lens at a focusing distance of 1 foot—that means there were roughly 8 inches between the end of the lens and the front dandelions. The foreground emphasis in this shot and in the sycamore leaf photo is typical of a wide-angle lens used up close to a subject.

The bottom photo was taken with the 35mm lens set at a focusing distance of one foot. The camera was as low to the ground as I could get my tripod.

Dandelions. *Kodachrome 64, 24mm lens, 1/30 sec. at f/22*

Sycamore leaf and sugar maple leaf. *Kodachrome 64, 35mm lens, 1/8 sec. at f/16*

Zooms covering the short focal lengths usually don't offer the equivalent close focusing at their wide-angle end. This is especially true as the zoom ratio increases. The Nikon 28–50mm *F*3.5 at minimum focus has about 2 feet of working distance at the 28mm end. The Kiron 28–210mm *F*4–5.6 focuses down to an 8-foot working distance at 28mm. Compare this to the Nikon 28mm *F*2 that focuses down to about 8 inches. Obviously, there is an incredible difference in coverage between these three working distances. If you're planning on using a short lens up close to the subject, then I would suggest that a fixed-focal-length lens is the answer.

When I want to convey a feeling of being almost inside the subject, I like to use a short lens very close to it.

Frost on autumn blueberry. *Kodachrome 25, 24mm lens, 1/8 sec. at f/22*

Normal lenses

I rarely use normal 50mm or 55mm lenses for closeup work. As with wide-angle lenses, the free working distance with normal lenses is very limited, although there are times when the available working distance is restricted due to tight quarters, which might dictate using a normal lens for closeups.

Using a normal focal-length lens for closeups does have a few advantages. First of all, you may already own a lens in this focal length since the odds are one came with your camera. By definition, if you already own it, it's good until you discover some extremely convincing arguments to the contrary. Second, their superior optics make 50mm lenses some of the best lenses available; their results on film can be spectacular. And third, normal lenses need a very reasonable amount of extension to produce any given magnification, making a small, easily

carried package for field work. Only 50mm of total extension, or about 2 inches, is needed with a 50mm lens to get to 1X. What you have to decide is whether you can live with the limited working distance and the background coverage of this focal length.

Many of the fast 50mm lenses, such as the F1.2s or F1.4s, don't have f-stops smaller than f/16, but at the same time, such a lens would almost never be used wide open for closeup work. Therefore, if I didn't own any lens in this focal length nor had a zoom that covered it, I would consider buying a 50mm or 55mm macro lens. This would give me coverage in the normal focal length, convenient close focusing if needed, and the smaller f-stops. However, if I did own a lens that covered 50mm, I would use it before purchasing anything else in this focal length. There are lots more convenient lenses for working closeup in the field than a normal 50mm lens.

Ostrich plume moss and spruce needles on top of stump
Kodachrome 25, 55mm lens, 1/4 sec. at f/16

Golden barrel cactus.
Kodachrome 25, 55mm lens, 1/8 sec. at f/22

In both these photos I didn't have a lot of space available, so I made good use of the shorter working distance of my 55mm lens. For example, the moss was growing on top of a stump; I could not get high enough above it to use any longer focal length. And cactus can make a pointed impression on a careless photographer.

Short telephoto lenses

One of the most practical focal-length ranges for closeup field photography employing extension includes the short telephoto lenses between 85mm and 135mm. Within this range falls my most-used lens, the 105mm focal length that is my bread-and-butter lens as a professional photographer.

There are many good short telephoto lenses available, and most are quite compact in size (which translates into easy handling in the field) and offer relatively fast maximum apertures to aid in focusing. Without resorting to unwieldy, impractical lengths of tubes or bellows, lenses in this focal-length range are about as long as can be used with extension in order to get to 1X.

By comparison with short and normal lenses, the free working distance offered by short telephoto lenses finally approaches an acceptable amount. Now there is some room for positioning the tripod without bumping the subject with either the tripod or your hands, the curse of shorter lenses (or is it that shorter focal lengths bring out curses?) Try to work a tripod into the right position when you're using a 50mm lens on sections of a dew-covered spiderweb. You either hit the web itself while trying to adjust the tripod legs, or you bump the supports from which the web is hung. In this situation, focusing a short lens often results in wet web on hands. However, a large and a medium extension tube, with a 105mm lens, and the morning suddenly goes smoother.

The short telephoto is often called a "portrait lens" since this focal length is frequently used to photograph people. Its working distance yields a pleasing perspective. I also use it for portraits, although my portraits are closeups of small subjects, of flowers or dew-covered butterflies.

Stonecrop leaves in moss. *Kodachrome 25, 105mm lens, 1/2 sec. at f/22*

European skipper on black-eyed Susan.
Kodachrome 25, 105mm lens, 1 sec. at f/11

The stonecrop in the top photo was growing on an angled, mossy, rock face. I needed all the flexibility of my tripod to work it into place. The short telephoto gave me just enough working room; moving farther back with a longer lens would have meant changing my shooting angle, which I did not want to do. I metered off the neutral moss, recomposed, and shot.

A 105mm lens coupled with a focusing rail is perfect for the kind of subject on the left. You're far enough away to have room to work without hitting the subject, yet close enough to notice any slight movements of the long-stalked flower.

Stream violet and roundleaf trillium.
Kodachrome 25, 105mm lens, 1/4 sec. at f/16

This illustrates the high quality obtainable with a short telephoto, good film, and a sturdy tripod. As always, exposure was a compromise between the depth of field I needed and a shutter speed fast enough to stop wind movement.

200mm lenses

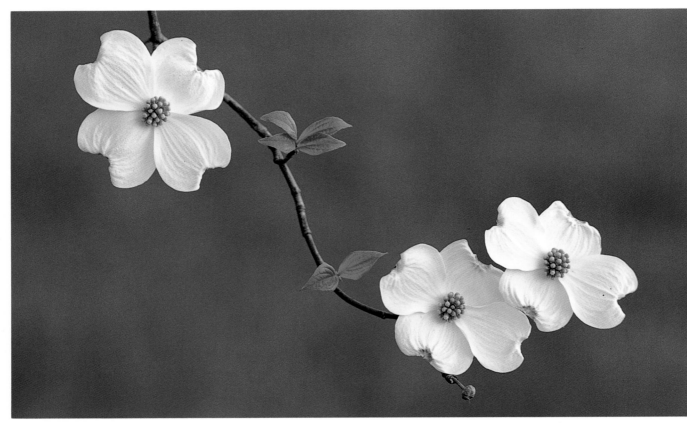

When you start to consider shooting closeups with a 200mm lens, you are primarily doing so for two reasons: The long focal length yields a considerable amount of working distance, while the narrow angle of view restricts background coverage and thereby eliminates distracting elements behind the subject. These two factors go hand in hand, and they govern lens selection.

You won't use this focal length on extension for magnifications greater than 1/2X simply because too much extension is needed. As long as you restrict yourself to shooting subjects that don't demand so much extension, handling is not too difficult. I mainly use this focal length coupled with a 25mm extension tube for as much working distance as possible, or I mount it on Nikon's PN-11 tube that is 52.5mm long and has a rotating tripod collar. The 200mm lens is my favorite for making flower portraits because the lens' narrow angle of view isolates blossoms against a posterlike background.

There are many high-quality 200mm lenses available, and some of the most popular zooms cover this focal length. The most common maximum aperture is about $f/4$, which is still fast enough to focus even when some light is lost to extension. As a side benefit, most standard 200mm lenses use the same filter sizes as normal lenses, which means fewer items to carry in the field. Beyond 200mm, almost all lenses jump a filter size or two.

I always seem to reach for my 200mm lens when I have to shoot close to ground level but looking parallel with the surface. Even with a tripod that permits extremely low-level work, I still have to contend with the height of the tripod head and centerpost connection, a small but significant height when dealing with short subject matter. The 200mm focal length lets me shoot at a much less acute angle since I can back off and use all the working distance to my advantage. When I photograph a small woodland flower, for instance, the 200mm lens lets me look flat into it at a right angle to its upright stem, rather than looking slightly down at it as I would be with a shorter focal length.

Flowering dogwood. *Kodachrome 64, 200mm lens, 1/30 sec. at f/11*

Good subjects are everywhere. I made the top photograph in my backyard one overcast spring day. I used my 200mm lens to narrow down selectively the background coverage.

Opossum. *Kodachrome 64, 200mm lens, 1/60 sec. at f/4*

Getting close to this young opossum was no problem, but any lens shorter than my 200mm picked up parts of the blank sky. I made this photograph early in the morning, and because of the relatively low light level, I shot wide open using all the speed I could have.

300-400mm lenses

Stonecrop. *Kodachrome 25, 300mm lens, 1/15 sec. at f/16*

I photographed this flower in Olympic National Park. I had to use my 300mm lens because of the flower's location. I was looking downhill, and with any shorter lens I ended up seeing over the tops of the downhill trees, thereby causing a strip of blank sky to appear across the top of the frame. The 300mm lens had such a narrow angle of view it included only the distant vegetation.

Wine cup mallow. *Kodachrome 25, 300mm lens, 1/125 sec. at f/5.6*

I used my 300mm lens to photograph this Texas wildflower in order to narrow down the background coverage. I shot almost wide open to keep my shutter speed fast, which was a necessity in the almost constant prairie wind.

Using any lens longer than 200mm for closeup work takes you into another sphere of operations. You definitely won't use much extension with very long lenses because then vibration becomes an overwhelming problem. Attached to long tubes, a lens this long tends to teeter-totter back and forth on top of the tripod head no matter how tightly you wrench down the controls. The size of the outfit comes into play, acting like a sail, and the slightest breeze will move the lens.

Although you don't buy a 300mm or 400mm lens specifically for closeup work, you can use it at its minimum focusing distance or a little closer when you need the reach. I quite often add my 14mm extension tube to either my 300mm or my 400mm lens, especially when I'm shooting small, ani-

mated creatures, such as chipmunks. The small tube gives me several feet of closer focus, and though I cannot focus out to infinity, the tube is so little extension that I maintain focus out to a distance of 25 feet or so. In this way I can cover a broad range of the animal's activities by shooting close-ups but being instantly ready if a longer shot reveals itself.

Given any choice whatsoever in a long lens, consider buying one with internal focusing (IF). These lenses focus by moving the optical elements around inside the lens barrel, not by changing the built-in extension as with the normal, helical-focusing mount of most lenses. What this means is that IF lenses stay the same physical length whether focused at infinity or at minimum distance.

Since they do not use extension to focus, there is no light lost to extension over their own focusing range. The exposure remains constant throughout the field of focus as long as the subject stays in the same light and regardless if it moves closer or farther away. When you add extension, the base exposure changes in fixed amounts. For example, adding a Nikon PK-12 tube to my 300mm IF lens means a ½-stop exposure change from my previous reading.

Because of their design, IF lenses focus very easily and rapidly. And without all that helical mount filling up the working distance, they can also focus much closer all by themselves than normal lenses. The standard version of the Nikon 300mm *F*4.5 focuses down to a working distance of 12 feet from the front of the lens, while the IF version of the same lens ends up at 7 feet. When I add my 14mm tube, I can focus my 300mm IF lens to a working distance of 5½ feet at a magnification of 1/5X.

I needed the entire reach of my 400mm lens to photograph the constantly moving chukar. A small extension tube on the lens permitted me a little more close focusing.

Chukar. *Kodachrome 64, 400mm lens, 1/250 sec. at f/5.6*

I wanted to move in as close as possible to the ground squirrel on the right. Working in the fresh snow at the squirrel's eye level was wet and cold but well worth doing.

Arctic ground squirrel. *Kodachrome 64, 400mm lens, 1/500 sec. at f/5.6*

Extending zoom lenses

Extension added to *any* lens will permit that lens to focus closer. This is as true with zooms as with other lenses. However, adding extension to a zoom lens is not the handiest way to work, although it certainly can be done. The problem you'll run into is that you can no longer zoom and stay in focus simultaneously, which you can normally do when working with the zoom. Indeed, the ability to change focal lengths by zooming while remaining in focus is one of the great joys of working with a zoom lens. But when you add extension behind the zoom, other factors come into play.

Any given amount of extension added to a given focal length results in a given magnification. A 25mm extension tube added to a 75mm lens yields 1/3X. The same tube added to a 200mm lens gives 1/8X. This, of course, is exactly what you are doing with a zoom lens—you are changing the focal length of the lens on the extension when you zoom. Since working distance is proportional to focal length, with a zoom lens on extension you must either refocus every time you zoom or physically move the camera position forward and backward to maintain the image size.

Icicles on maple leaf. *Kodachrome 25, 80–200mm zoom lens, 1/8 sec. at f/11*

Frost on old nest. *Kodachrome 64, 80–200mm zoom lens, 1/15 sec. at f/8*

This sounds harder than it really is. If you're working on inanimate subjects such as wildflowers, adding extension to a zoom is not a great problem. However, if you're shooting a moving creature, zooming while you quickly change focus is a hassle since any zoom movement creates quite a twist in the focusing mount. Luckily, there are better ways to use a zoom closeup (see Part IV on zooms with diopters).

Another problem arises if you're using a large, heavy zoom lens, such as the larger 70–120mm, 80–200mm, or 100–300mm lens. Very few of these lenses have tripod collars on them. This means that the camera body it-self must be mounted to the tripod with all the extension and the lens strung out in front. Flipping your camera for a vertical sometimes becomes almost impossible—all that weight slowly twists on the tripod head, and the lens ends up pointing down. This problem can be compounded if you're using a motor drive.

A possible solution is to make a small plate with a lip to catch the camera body on one end and with another lip on the other end to catch the tripod head. I normally use a Bogen head with quick release plates, and I've simply added to them a small stop that snugs up against my motor so nothing can twist.

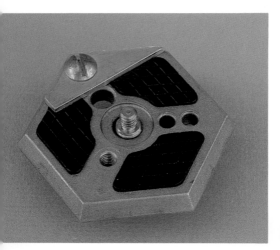

This Bogen quick release plate has an added lip to catch against the motor drive. The plate is an odd shape, with one end cut off, because I made it to fit the motor drives for both the F3 and FE2 Nikons.

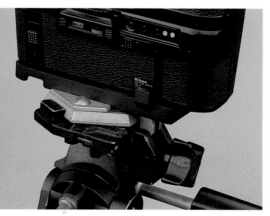

Here is the Bogen quick release plate in use. See how the added lip catches the bottom of the motor.

Swamp rose and marsh fern. *Kodachrome 25, 80–200 zoom lens, 1/4 sec. at f/22*

Macro lenses

Many photographers starting to do closeup work think that they must purchase a macro lens, since they've been led to believe that macro lenses are the only lenses that will work up close. Let me give a broad definition of a "macro" lens as the term is normally used. A macro lens close focuses all by itself. That's all there is to it. A macro does not have any special properties except for its ability to close focus without adding any accessories. It is true that macros are optically optimized for maximum sharpness and flatness of field in the closeup range, but in practical field terms, all lenses will work fine for closeups if your photographic technique is good.

Most macro lenses are available in two focal lengths: 50mm or 55mm, and 100mm or 105mm. And Canon and Nikon offer 200mm macro lenses. Most macros focus down to 1/2X all by themselves, while a few go all the way down to life-size. With the exception of the two 200mm lenses, all are based on adding extension, although the newest lenses also incorporate a "floating element" design that slightly reduces the amount of extension needed.

Let's assume you have a 50mm macro lens that focuses to 1/2X. That means that built into its focusing mount is 25mm of extension. Sure enough, as you focus, the mount just keeps turning and turning, and the lens gets about 1 inch longer. A 100mm macro that focuses to the same magnification has 50mm of extension built in, and grows almost two inches longer as you turn the focusing mount to its closest focus. To gain more magnification, just add more extension. Indeed, many macros come with "life-size adapters" which is just another name for the extension tube that lens needs to get to 1X.

Some manufacturers, including Nikon offer these tubes as part of their standard accessory line. Nikon's PK-13

I photographed this maple leaf in the rain. I don't take any particular precautions for working in the rain as long as it's not pouring. I keep the camera under wraps until it's time to set up the tripod. If I have my camera out and I'm not actually shooting, I cover it with what I consider the perfectly designed camera rain-cover—an old-fashioned shower cap. It is waterproof, easily accommodates a camera with extension tubes and lens, and has an elastic band that secures it.

Milkweed seed caught in goldenrod. *Kodachrome 64, 200mm macro lens, 1/60 sec. at f/8*

Maple leaf caught in spruce. *Kodachrome 64, 105mm macro lens, 1/8 sec. at f/8*

tube, for example, is an odd length: 27.5mm long. Why? It's the extension needed to bring their 55mm macro (Nikon calls their macro lenses "micro" lenses; don't worry—there is no difference except for the spelling) from 1/2X to 1X. Since the Nikon 55mm macro goes to 1/2X all by itself, it has 27.5mm (half of 55mm) of extension built into the lens. Now it needs another 27.5mm to get to 1X. In the same manner Nikon offers a PN-11 tube that is 52.5mm long; this makes their 105mm macro focus to life size. Of course these are all just extension tubes and any lens can be mounted on them. (The 105mm *F*-2.8 Nikon macro lens used on the PN-11 tube yields a little more than life-size at full extension. This is because the lens, due to its optical design, focuses a little over 1/2X. The older *F*4 version went to 1/2X.)

Macro lenses are more corrected for flat-field reproduction than normal lenses. If you're planning to do document copy work, then by all means invest in a macro lens. However, for normal field photography, this feature is not particularly advantageous. Outdoors you generally don't shoot anything that fills the frame, edge to edge, in a flat field.

A macro lens does not make a closeup or any photo shot with it look different. The focal length of the lens used, and only the focal length, determines the "look" of a photo. Why then even consider buying a macro? The answer is simple: convenience. You won't have to add or remove tubes for many closeup subjects. The range of photographic subjects between infinity focus and 1/2X is staggering.

I've heard people object that macro lenses are only good for closeup work; they say that to photograph at normal distances, a standard lens is needed. This is not true at all. Macro lenses tend to be some of the most highly corrected lenses made and are extremely good for photographing subjects at any distance. For that matter, I would definitely *not* own both a normal 50mm lens and a 50mm macro, since what they do in terms of an image is identical; the 50mm macro just focuses closer. Granted that the standard 50mm lens probably has a faster wide-open aperture, but do you ever use the lens at that aperture? If not, why double up on focal lengths? The latest macro lenses are also increasing their maximum aper-

ture. An aperture of *F*2.8 is now common, and Olympus has a 90mm *F*2 out. The speed difference is disappearing. While I'm on the subject I might as well admit that I have never owned a normal 50mm or 55mm lens. My lens in this focal length has been, and still is, an old 55mm *F*3.5 Nikon macro lens I purchased in 1970.

Macro lenses generally do have smaller minimum *f*-stops than normal lenses. Almost all macros stop down to *f*/32. Though you certainly wouldn't use that *f*-stop all the time, it is an advantage to have it if you need it (but be careful when using the small *f*-stops—see Part VII on diffraction).

If you don't own any lenses in the macro focal lengths, consider them again. For closeup work, I wouldn't pick the 50mm or 55mm focal length since working distance is so limited at this focal length. I would suggest buying the 100mm or 105mm macro lens. By the way, most macros come with all sorts of scales engraved on their lens barrels. For field work, this information is basically useless. Trying to read a scale while photographing a free-flying butterfly is a quick lesson in what is important.

What then of the 200mm macros? Nikon and Canon make models with a maximum aperture of *F*4, and they both come with detachable rotating tripod collars, but beyond that they differ. Let's look at Nikon's Micro Nikkor lens first. It goes to 1/2X by internal focusing, or by moving the elements around in the manner of a zoom lens, rather than by adding extension. This gives the brightest image by which to focus, but to get equivalent depth of field of any given aperture, the lens must be stopped down to an equivalent *f*-stop. For example, let's take a standard 200mm lens and set it up on extension at 1/2X. It has "lost" about one stop of light to extension; that is, the marked *f*-stops are no longer valid but are effectively smaller. The aperture marked *f*/4 is now effective *f*/5.6, one-stop smaller, and it gives the depth of field of *f*/5.6. With the Nikkor 200mm Micro lens, however, the aperture marked *f*/4 remains *f*/4; to get *f*/5.6, you must physically set the lens at *f*/5.6.

The Nikkor 200mm Micro also changes its effective focal length as you close focus. (This seems to be true of all "internal focusing" lenses,

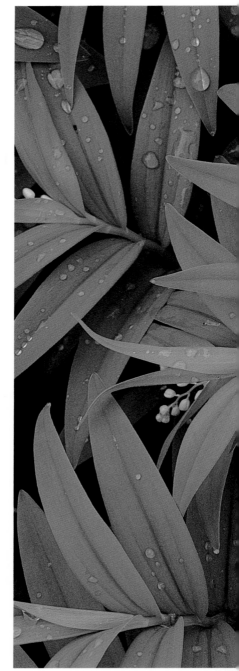

although most do not focus close enough for the change to be apparent. The 300mm *F*4.5 ED-IF Nikkor, for example, is a 300mm lens at infinity focus, but at its closest focusing distance of 7 feet from the front of the lens, it is effectively about 280mm. That's not enough to be concerned about.) At infinity focus it is a 200mm lens, but at 1/2X its effective focal length is 150mm. You can demonstrate the effects of this to yourself by focusing with the lens at 1/2X and noting your free working distance: about 19 inches between subject and lens.

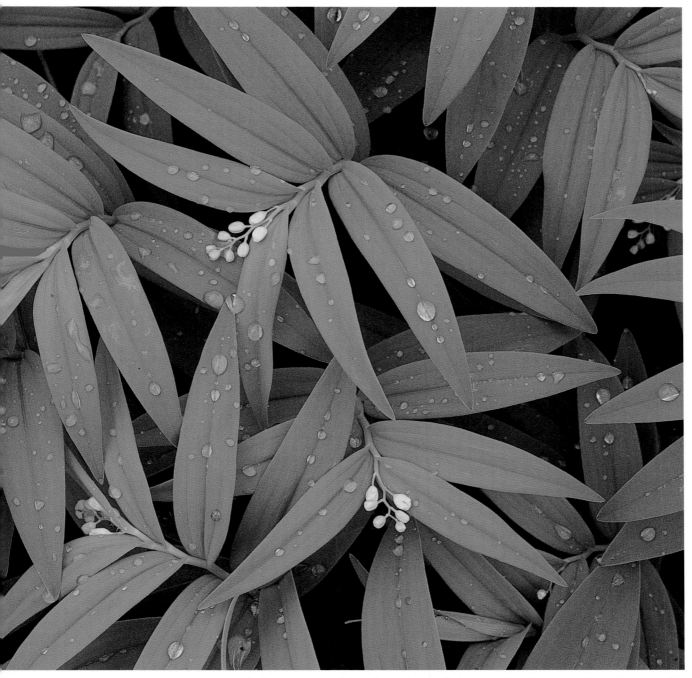

Raindrops on starry false solomon's seal. *Kodachrome 25, 55mm macro lens, 1/4 sec. at f/22*

Now leave the lens at infinity focus and add extension to get to 1/2X and the working distance is 21 inches.

In the field, if you need more working distance than the lens itself offers, adding extension is exactly what you should do. In fact, if working distance is your prime concern you can most likely gain even more by using a standard 200mm lens on extension. The normal Nikkor 200mm *F*4 lens on extension at 1/2X yields 29½ inches of free working distance and the Nikkor 180mm *F*2.8 lens at 1/2X has 24½ inches. Of course, with those lenses

you're back to carrying around a lot of additional extension. By the way, be very careful as you focus the Nikkor 200mm Micro lens—since its focusing mount covers such a large range, a slight movement can cause a gross discrepancy in where it is focused.

The Canon 200mm Macro lens uses a combination of extension and internal focusing to go to 1X all by itself. At first glance, it appears to be much larger than the Nikon lens because of the Canon's large tripod collar, but at 7³⁄₁₆ inches long and a weight of 1 pound 12 ounces, it is almost exactly

the same. It takes 58mm filters, so for field work you will have to carry two sets of filters, which is a bother.

Since it moves the optics around as well as using extension, the Canon 200mm macro does not lose light as expected. At 1X magnification it has grown 1½ inches as a result of its own built-in extension, far less than the almost 8 inches a normal 200mm would need. Its total light loss at 1X is only one stop, which permits the lens to be very bright for focusing. Its working distance at 1/2X is 20 inches, while at 1X it is 12 inches.

Using a hand meter for extension closeups

One advantage of a through-the-lens exposure meter is that it takes into account any light lost to extension or to filters. At times, though, taking a hand-meter reading is a more convenient way to work. If you're using extension or filters, you must subtract the amount of lost light from the hand-meter reading to get back to correct exposure. Although filter factors are constant and are given to you by the manufacturer (for example, an 81B warming filter costs 1/3 stop of light) the amount of light lost with any given extension depends on the lens to which you add the extension.

For instance, a 25mm extension tube on a 50mm lens yields 1/2X magnification and costs about one stop of light. The same tube on a 300mm lens gives 1/12X and takes roughly only one-third stop of light.

You might have run across tables that give all sorts of "extension factors" for different lenses. These tables are not really of much use (for that matter, no complicated table is of *any* use during field work) since they are only correct for symmetrical lenses. Lenses are symmetrical if, when you look into them from both the front and the rear, they appear to have the same size aperture at any given *f*-stop. Most lenses today are not symmetrical at all. Macro lenses are as close to symmetrical as any other lenses, and the latest versions of most macros are not even very symmetrical.

The easiest way to note the light lost due to extension on any lens is to meter TTL with and without the extension. The difference in stops is the amount of light the extension costs on that lens. Here's how to do it.

Set whatever lens you want to use at infinity focus. Without adding any extension, take a meter reading of an evenly lit subject in unchanging light. An easy subject to meter is an evenly lit wall in your house. Pick a shutter speed that gives you an *f*-stop in the middle of your aperture ring. Then

British soldier lichen melting through ice. *Kodachrome 25, 105mm lens, 1/4 sec. at f/16*

Here I had to correct for the extension as well as for the white subject.

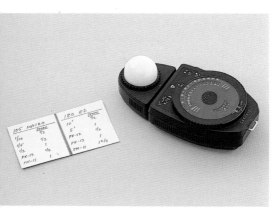

This is my normal incident-light meter. You must calibrate hand meters just as you do camera meters. On this particular meter I get a correct reading for ISO 25 with the dial set at ISO 32.

add the extension, and take another meter reading. Change the aperture on the *f*-stop ring to get back to correct exposure. Do not change the focus setting at all during this procedure. Now note the difference in stops between the two readings. This is the amount of light in stops used by that extension on that lens. Do this for all the extensions you plan on using with this particular lens. When you are in the field, add the total number of stops for whatever extensions you're using and open up this number of stops from a hand-meter reading to get the correct exposure.

You might also want to try this using only the built-in extension in a lens mount. Focus and meter with the lens set at infinity, and then rack the lens out to its closest focusing distance and take another meter reading. You now know the amount of light that the lens loses in its own focusing mount.

I've made a little chart for my most used lens and extension combinations, which I carry in my wallet. This way I can compare a TTL-meter reading with a hand-meter reading if I want. Or I can take a hand-meter reading, and without even taking a TTL reading I can compute the correct closeup exposure. For example, on my chart I've noted that my 180mm lens loses one full stop of light between infinity focus and its closest distance (it loses a half stop getting to a focused distance of 10 feet, and another between there and the closest distance of 5 feet). A Nikon PK-13 extension tube (27.5mm long) on that lens costs one stop. So if I'm shooting a flower blossom and the lens is focused at a marked 10 feet but it is mounted on the PK-13 tube, I know I have a total of one-and-a-half stops of light loss. If my hand meter tells me that correct exposure is 1/8 sec. at *f*/8, I open up one-and-a-half stops, which is 1/8 sec. at *f*/4–5.6 or any equivalent exposure.

There are hand meters available that read the light reflected from your subject (just as your TTL camera meter does) or the light falling on your subject. The latter is called an incident-light meter and is my pick for a hand meter. Either one, however, will work for closeup calculations as long as you know the starting point from which to work. With a reflected-light hand meter, you still have to take into account the tonality of the area at which you point the meter. It meters

an area the same way your camera meter does, making whatever you point it at a middletone value, so you must first work in stops for a correct exposure and then make any corrections for light lost to extension or filters. An incident meter eliminates one step in this process; it automatically

places values where they occur so you generally don't have to worry about the reflectance of the subject unless it is very light or very dark. Just hold the incident meter in the same light as the subject, take a reading, and calculate the correction for using extension and filters.

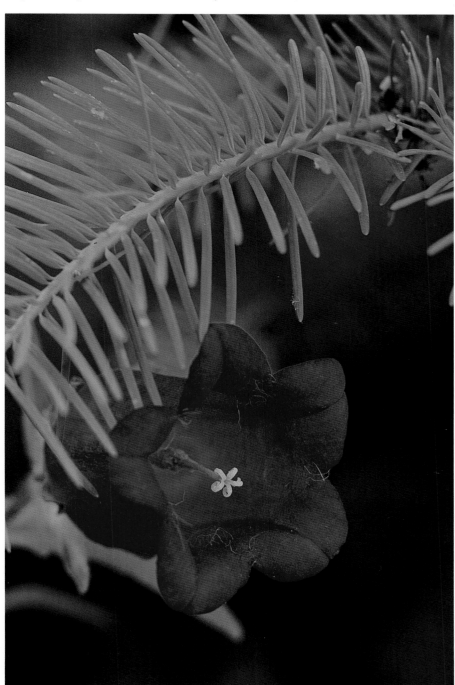

Canterbury bell and fir. *Kodachrome 25, 180mm lens 1/8 sec. at f/8*

After taking an incident reading, I noted the extension I was using and opened up an appropriate number of stops.

Part V
ELECTRONIC FLASH

Flash theory

Most of the time I prefer to work outdoors with natural light, especially when I'm shooting such subjects as flowers, dew-covered butterflies, or ferns. I much prefer to photograph in the moody light of early morning or twilight, or in the soft light of an overcast day—times when I can work in what I call the "sweet light." Sometimes, however, I must resort to flash, either because the subject is in motion and I need the action-stopping capability of a short flash duration, or because handholding the camera is the only practical way to work. At times I need more depth of field for closeups but the natural light is so low that the required exposure times would be impractical. And sometimes it's just plain dark outside. Flash is the answer.

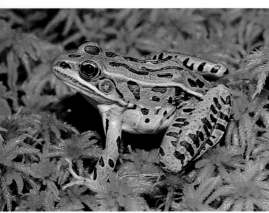

This pair of photos of a leopard frog on moss illustrates why flash is necessary. The natural-light shot on the top was done at 1/8 sec. at f/4, while the flash shot on the bottom was done at 1/60 sec. at f/11. Both were made with a 105mm lens on Kodachrome 25, and the camera was handheld for both.

Learning to control flash is very important if you want to control the photographic process. Can you repeat your success when you want to do so, or is the whole process a matter of chance? This is a crucial question. The more conscious control you the photographer have, the more the resulting photograph will portray the image you have in your mind's eye. Using flash is too often a matter of hit-or-miss bracketing, of leaving all exposure choices up to the sensor of an autoflash, or of relying on through-the-lens flash metering to yield good exposures. The more you consciously understand how light works, the more you can control your use of flash.

The best way to think about flash (or any artificial lighting) is in terms of stop values. Indeed, as I said earlier, everything about photography works in stop values. Flash is no different.

Light falls off, or diminishes, in relation to the square of the distance it travels from its source. With artificial lighting your concern is not where the camera is located but where the flash is located. Flash-to-subject distance, and this alone, regulates the intensity of the light falling on a subject. Obviously, if a flash is mounted in a hot shoe on the camera, then camera-to-subject distance will be the same as flash-to-subject distance. Go to Niagara Falls any summer night and witness the irony of someone popping off pictures of the Falls with a flashcube, while directly behind him are huge floodlights barely able to light the Falls at such a distance. The problem is strictly one of distance. If that fellow could magically place the flashcube up close to the Falls, at least one small section of it would be correctly lit by the flash.

When you take the flash unit off-camera, you must run a long cord between the two to synchronize the flash with the shutter. Exposure is then determined by where you place the flash. For any given *f*-stop, the flash must be placed a certain distance from the subject to have proper exposure. In order to explain flash exposure most clearly, I'm going to first describe how to determine exposure with a manual flash; I'll discuss through-the-lens flash in a separate

chapter. (Understanding the principles of flash will help even with TTL.) Let's learn flash theory for normal working distances, and then we can turn to flash for closeups.

The standard method of determining flash exposures is by using guide numbers (GN):

GN = Aperture × Flash-to-subject distance.

The Guide Numbers supplied by flash manufacturers are based on suggested indoor exposures for a room of average reflectiveness. Working outside, you will discover that these recommended exposures are usually too dark because there is no light reflected back on your subject from walls and ceilings. Therefore, run a test to determine the true outdoor GN of your flash. Set up a middletoned subject (anything will do) at a measured distance from your flash and, making sure your flash is set on manual, shoot several frames at different *f*-stops. A starting point would be the *f*-stop suggested by the manufacturer's GN. For example, suppose you have a flash that has a GN of 40 for ISO 25 film. Set it at a measured 5 feet from a subject. If the GN of 40 is correct, then *f*/8 should supply the proper exposure, not taking into account any lens extension or light lost to filters. Remove all filters and leave the lens at infinity focus; it doesn't matter if the resulting test shots are in focus or not, we just want to determine the right exposure.

Run a series of exposures around *f*/8. Bracket by half stops from about two-stops open to about one-stop down; in other words, from *f*/4 to *f*/11 by half stops. Make sure you do this test with slide film. Critique the slides on a light box, and pick the one that you consider properly exposed. (Trying to critique projected slides is counter-productive, since it doesn't allow you to compare two shots side-by-side. You cannot carefully evaluate exposures, especially on the underexposure side; your eyes adjust to different light levels and as long as the exposure is not grossly off, the slide looks OK. But if you use a light table, the exposure differences are readily apparent.) That *f*-stop multiplied by the measured distance equals your

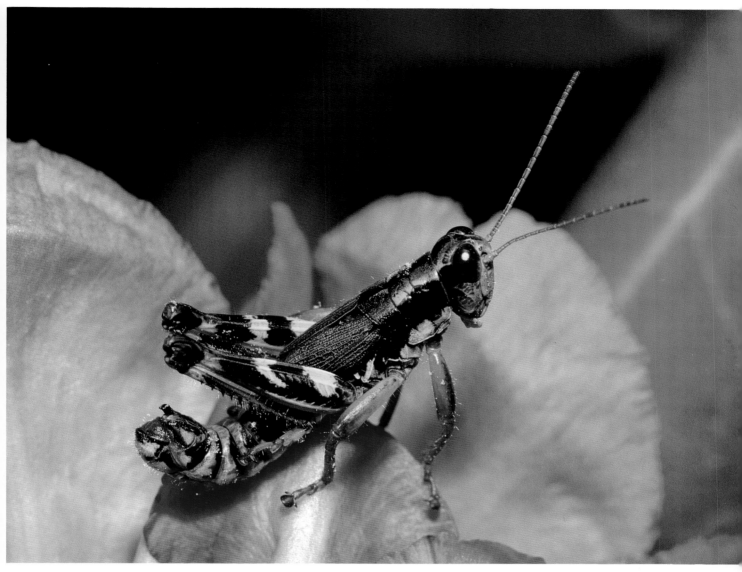

Grasshopper on rhododendron. *Kodachrome 25, 105mm lens, 1/60 sec. at f/11, one flash*

true outdoor GN. Let's assume that f/5.6 turned out to be right. The outdoor GN is f/5.6 × 5 feet, or 28. Now that you know that, the f-stop you want to use will dictate the flash distance, or vice versa.

What if you change film and use something other than what you tested? Do you have to do another test? No, not if you work in stops. You could use a formula to arrive at a new GN mathematically: GN (new film) = GN (known film) × the square root of the known film's ISO divided by the new film's ISO. I can just imagine trying to work with that formula in the field! But if you work in stops, calculating new guide numbers is easy. Just count the number of stops between the ISO ratings of the two films. Using the f-stop series of numbers, start at the known film's GN and now

move by the number of stops. For example, your tested GN for ISO 25 turned out to be 28. What is the GN for ISO 100 film? There are two stops of speed between these films. Start at f/28, roughly halfway between f/22 and f/32. Since ISO 100 is a faster film, stop down two stops and you arrive at half-way between f/45 and f/64, roughly GN55. You could do this even easier if you move powers of 10 around, by starting at f/2.8 and counting over two stops to f/5.6. Shift the decimal, and there it is, GN56. The difference between GN55 and GN56 is absolutely meaningless. You don't really have to be very precise; a one stop difference in this case would be a GN of 40 on one side or a GN of 80 on the other.

Working in stops is also useful when you have to move a light closer

to or farther from your subject in order to change exposure. Pretend the f-stop series of numbers is a distance scale in whatever units you want to use (feet, inches, whatever—it doesn't matter what units you use as long as you are consistent). Move the light in the increments of the f-stops, and you are changing light intensity in one-stop values. Let's say you have a light 8 feet from a subject and want to increase its intensity by one stop. Move it closer to the subject by one f-stop, to 5.6 feet. You've gained one stop of light, so from whatever exposure you were shooting with the light at 8 feet, you now stop your lens down one stop. If you want to weaken the light, move the light source away from the subject to 11 feet, and open your lens one stop from your established exposure at 8 feet.

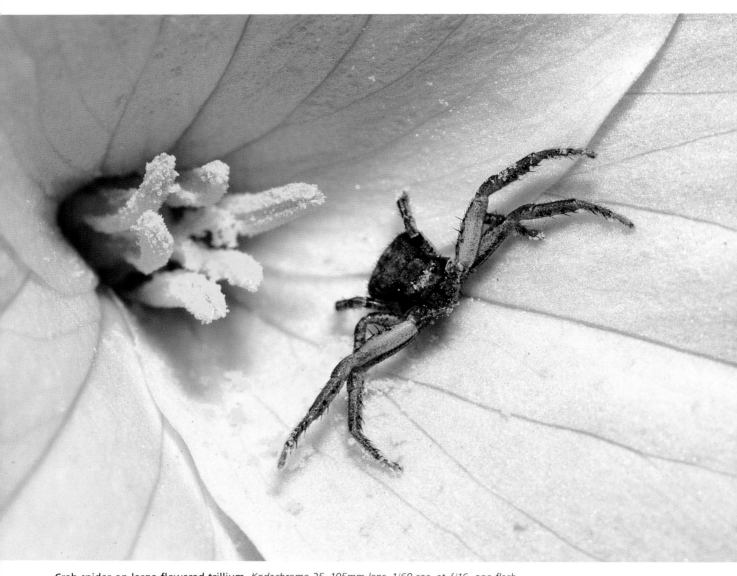

Crab spider on large-flowered trillium. *Kodachrome 25, 105mm lens, 1/60 sec. at f/16, one flash*

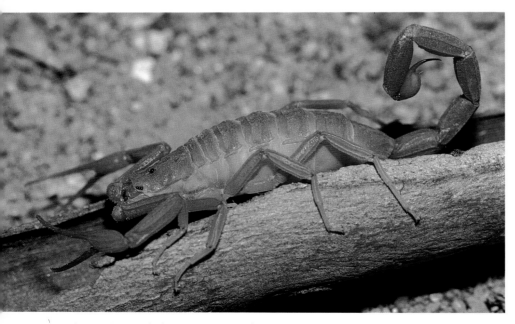

This species of scorpion has the most potent venom of all American species. I actually found this one in a friend's woodpile, after which we were more than careful when carrying in an armload of wood for his stove.

Bark scorpion. *Kodachrome 25, 105mm lens 1/60 sec. at f/11–16, one flash*

Let's try this with some numbers. You're using Kodachrome 25 with a flash that is 8 feet from the subject and that is giving you $f/4$ (if you just figured out that here the flash has a GN of 32, you're right!). By using your depth-of-field preview you determine that $f/4$ doesn't yield enough depth of field; you need $f/11$, three stops more. To gain light move your flash three-stops closer to 2.8 feet from the subject, and you're all set.

What if you also wanted to shoot some Fujichrome 100 film, which is two-stops faster than the K25? Now that the light is at 2.8 feet, the exposure for ISO 100 is two-stops down from the K25 exposure, or $f/22$. But now let's say you again use your depth-of-field preview and decide that $f/22$ gives you too much depth; $f/11$ was right after all. Just move the light back two stops to 5.6 feet from the subject, and you're right back to correct exposure.

If you need to use multiple lights, it is definitely easiest to use flash units of the same output. This simplifies any stop calculations you might have to do. For example, a typical use for a second flash is lighting the background. If you work in stop values in terms of flash-to-subject distance and flash-to-background (which is the subject for the second light) distance, multiple flash becomes easy. If your main light is 2.8 feet from your subject and you want to light a background to the same intensity, place a second flash 2.8 feet from the background. If you want the background a stop darker, move the background flash back one stop to 4 feet. A stop lighter than the subject would mean the background flash is 2 feet from the background.

What if the background is already lighter or darker than the subject? Again, work in stops. Let's assume your subject is middletoned, but the background is one-stop darker than the subject. However, you want them to appear to be the same intensity in your photograph. The solution is to lighten up the background by one stop until it is the same intensity as the subject. Whatever exposure your subject flash yields, place the background flash one-stop closer to the background and the values are balanced.

You can use GNs for closeup work if you work in stops. First, determine in stops how much light is lost to exten-sion, then subtract that amount from your GN exposure. For example, you have a flash with a GN of 56. You want to photograph a subject at $f/16$ at 1/2X magnification. You've determined previously that your lens loses one stop of light at 1/2X. Where do you place the flash?

Let's find the answer by trying two methods—and I hope we get the same answer both ways. (1) Take the normal GN of 56 and reduce it by the one stop of light loss to GN 40. Now $f/16$ would call for a flash-to-subject distance of 2.5. Or (2) figure out the flash distance for $f/16$ with a GN of 56, which would be 3.5, and then move the flash closer by one stop to com-pensate for the light loss to 2.5. It works!

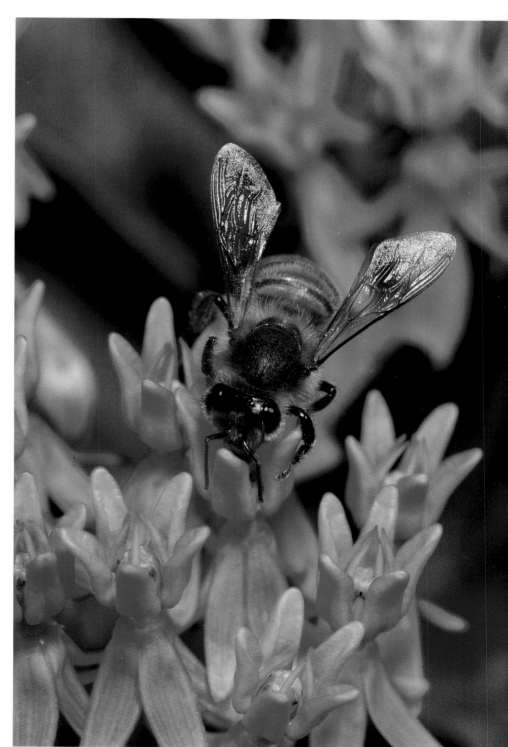

Honey bee on orange milkweed. *Kodachrome 25, 105mm lens, 1/60 sec. at $f/16$, one flash*

Black backgrounds and lens selections

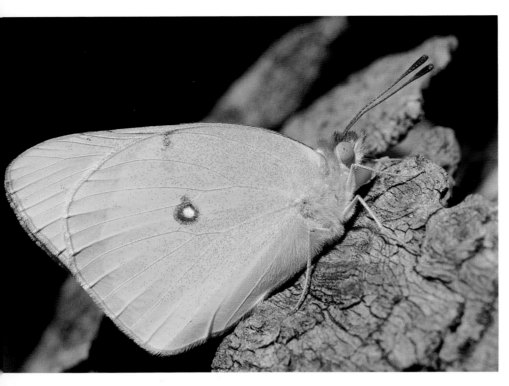

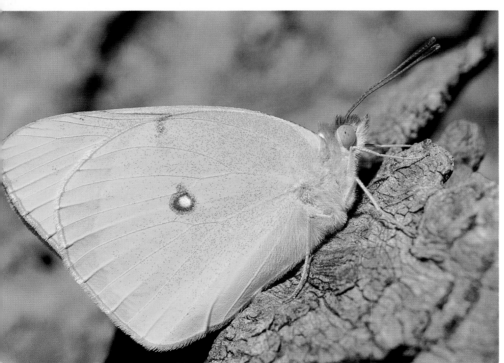

Pink-edged sulphur. *Kodachrome 25, 105mm lens, 1/60 sec. at f/16*

The butterfly is resting on an old stump. However, the background behind the butterfly in the top photo is not solid, so portions of the frame are going black. If there is nothing there on which the light can fall, you'll get black backgrounds regardless of what you do.

After I took the first frame, I carefully and very slowly slipped a piece of old bark behind the butterfly without disturbing it. Then, in the bottom photo, my single flash lit the background.

One thing I particularly dislike about some photographs taken with flash is the black, unlit backgrounds behind the subjects. I've heard people call this dramatic; maybe it is the first time, but after looking at a number of photos with black backgrounds, it quickly becomes boring. Besides, and this is my major objection, how often do you look at flowers, insects, or other closeup subjects at night with a flashlight? That is the effect the black background suggests.

There are several ways to avoid this. Regardless of what you shoot, there must be something behind the subject for light to fall on. How far behind is the real question.

Let's start off with one light. If you work in stops, you can easily determine how dark any given background will be, since light falls off in the f-stop series of numbers. For example, suppose you're photographing a flower and the flash is 16 inches from the flower. What intensity will a mid-dletoned background located 16 inches behind the subject be? Work in stops. The flash-to-subject distance is 16, while the flash-to-background distance is 32 (16 to subject plus 16 subject-to-background). The difference between 16 and 32 is two stops, so the background will be lit two-stops darker since it's farther away from the light than the subject.

What color will this background be rendered on the film? Remember that color-transparency film has a contrast range of about two-and-a-half stops on either side of middletone. If your background is two-stops darker than middletone, it will be almost tex-tureless black.

One obvious solution is to add a second flash aimed at the background. Place it the same distance from the background as the main flash is from the subject, in this case 16 inches, and the two will be lit to the same intensity. Move the background flash in stop values, and you can control how light or dark you make the background. Firing the second flash with a slave unit—a remote triggering device that requires no cords running between flash units—is the easiest way to work. Some slaves will trigger if the ambient light level is high enough,

such as in direct sunlight. Others located in high ambient light will keep the flash from recharging. I've had good luck with the Vivitar SL2, or the Rollei Foto-Eye. If you're having problems with a slave unit, make a hood for it by placing it inside a cardboard tube.

If you don't have another flash, you could lighten the background another way. Move the main flash farther away from the subject. This, of course, means you will be shooting at a more open f-stop, although the camera can stay in the same position. In the example above, let's say you move the flash back to 32 inches from the subject. That's two stops less exposure on the subject, so you must compensate by opening your lens two stops. What about the background? Now the flash-to-subject distance is 32 inches, while the flash-to-background distance is 48 inches (32 plus 16). The difference between $f/32$ and $f/48$ is just a smidgen over one stop. Now the background will have some color in it.

This has a great bearing on lens selection if the flash is mounted on-camera, either in the hot shoe or on a bracket. Consider a 50mm macro lens. At 1/2X magnification, the hot shoe of the camera is about 8 inches from the subject. A background only 8 inches behind the subject will be lit two-full-stops darker. Move back with a 100mm lens that is set for the same magnification of 1/2X, and working distance is doubled to 16 inches. Now that same background is lighter, only one-stop darker than the subject.

This also means that the closer you place your flash to your subject, the more critical that placement becomes. If your flash-to-subject distance is 3 inches, being an inch off either way is horrendous since it would change your exposure by two full stops $(3-1=2; 3+1=4; 2$ to 4 is two stops). Work with the flash farther away, the way working with a longer focal length lens might permit, and an inch either way in placement becomes meaningless. Consider what happens when the flash is back at 11 inches. Being off an inch either way would mean the difference between $f/10$ and $f/12$, about a half stop total.

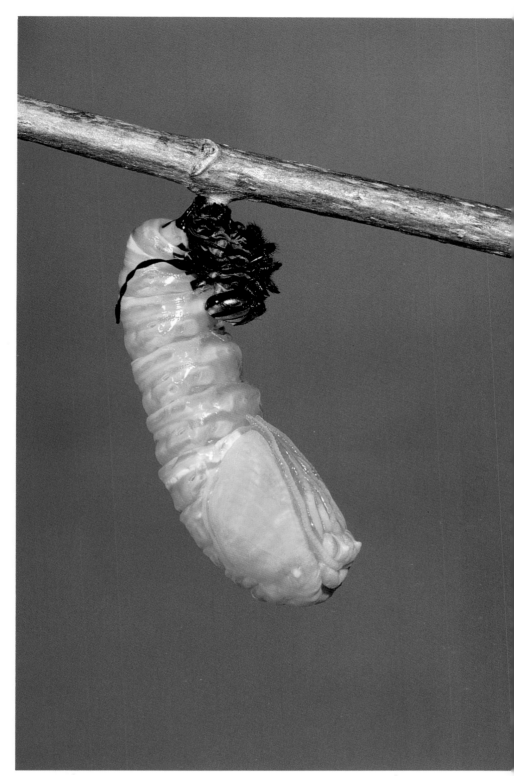

Monarch butterfly larva pupating. *Kodachrome 25, 105mm lens, 1/60 sec., f/11–16*

I needed a background to light, so I used some foliage that was several feet behind the subject (so far back that it is totally out of focus). I slaved a second light on the background, lighting it to the same intensity as the monarch.

Handheld flash in the field

I generally use flash with a handheld camera for closeups when I am working two kinds of subjects: small, highly animate creatures, or minute subjects where impractical natural-light-exposure times combine with the difficulty of working a tripod into position. These two types of subjects are related to each other. In general, as you shoot small subjects you want to record all their fine details. This dictates the quality of a slow-speed film. You need a small aperture to gain some depth of field, but the light lost to extension in getting the right image size means very slow shutter speeds. For example, the proper bright sunlight exposure for Kodachrome 25 is 1/30 sec. at f/16, but this is at infinity focus. Add extension to get to life-size, and about two stops of light are lost. You still need f/16 because as you gain magnification you lose depth of field, so you have to slow the shutter speed to 1/8 sec. A

tripod is the obvious answer here, but what if the subject won't hold still while you position it? Restraining the subject is not an answer. And I disagree with advice to refrigerate small animate subjects. A good naturalist can spot pictures of refrigerated subjects every time. Imagine refrigerating your kids until they could not move and then photographing them— surely you could tell that they didn't look right in the resulting photo.

There are three simple ways to photograph with a handheld camera and flash. The first way is what I call *inverse-square flash*. This involves using a lens plus extension to shoot closeups, and determining your flash exposure by where you position the flash (see page 95). The second method I call *TTL flash*, or using any means of gaining magnification while metering your flash TTL to determine exposure (see page 98). The third way is *zoom flash* (see page 109). What

you gain with all three methods is total mobility. Being able to move around a subject, to position yourself anywhere, is vital, and in order to have this you must handhold both the camera and the flash.

When you photograph closeups with a handheld camera, one major problem is focus. As magnifications increase it is hard enough to even find the subject in the viewfinder, let alone bring it into sharp focus. Trying to focus by turning the focusing mount on the lens is disastrous; your body is moving while at the same time you're turning the focusing mount. What you

This kind of subject demands a handheld camera. Trying to work a tripod into this scene in order to shoot with natural light at this image size is hopeless.

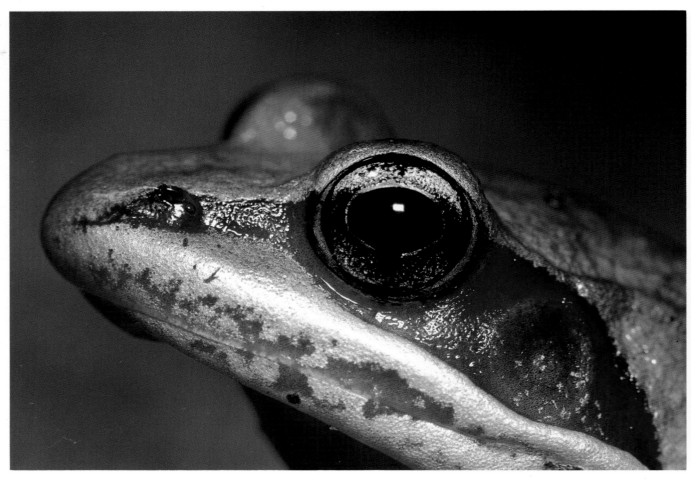

Wood frog. *Kodachrome 25, 105mm lens, 1/60 sec. at f/11–16*

should do is set the lens roughly at the magnification you need, then look through the viewfinder and lean in and out until you hit focus. You're basically using yourself as a focusing rail. If you need more or less magnification, reset your lens and do it all over again.

Brace yourself as much as possible. Trying to focus by freeholding a camera even on a fairly large subject such as a monarch butterfly is not easy. Tuck your elbows into your sides, with your left hand under the front of the lens, and with your right hand gripping the camera body ready to push the shutter when the image comes into focus. If there is anything to lean on to brace yourself, use it. For small subjects that are slow moving or inanimate I carry my tripod, not for mounting the camera but for bracing my left forearm.

The shutter speed you set doesn't regulate the flash exposure at all, as long as it is the synchronization speed or slower. You can use any speed up to the synch speed but none faster. The shutter speed governs the ambient-light exposure. Given a choice, you want a camera with the fastest synch speed possible, not that you would always shoot flash with the camera set on that speed. Suppose you want to photograph at 1/2X using Fujichrome 100 at f/16 with flash in bright sun, and you have a camera that synchs flash at 1/60 sec. The correct bright sun exposure for Fuji 100 is 1/125 sec. at f/16 at infinity focus. If you use an extension closeup system, you'll lose about one stop at 1/2X, which would drop the shutter speed one stop to 1/60 sec., the top synch speed. In this case the natural light exposure and the flash exposure are identical; double images, one from the flash and one from the ambient light, are assured. So here the only solution is to use a slower film such as Kodachrome 25, which is two stops slower, or to change to a camera that offers a higher synch speed.

Even with such a camera, there are times you'll want to shoot at a shutter speed slower than the top synch speed. For example, assume you're working on a flower that is shaded, but there is a sunlit background. You could balance a flash exposure on the blossom with a natural-light exposure on the background. Here's how: Determine the f-stop you're going to use on the flower, then focus on the blossom to figure out your extension factors, and then take a TTL meter reading of the background without refocusing. Find the shutter speed that will give the correct exposure at the f-stop you'll get with the flash. Shoot at this speed, and the two will be balanced. You can lighten or darken the background in stop values by changing the shutter speed. For example, you want to do the flower on K25 at f/11. After focusing on the flower, you meter the background and determine that 1/15 sec. would give you f/11. But you want the background to be one stop darker in relation to the flower, so you actually shoot at 1/30 sec. at f/11.

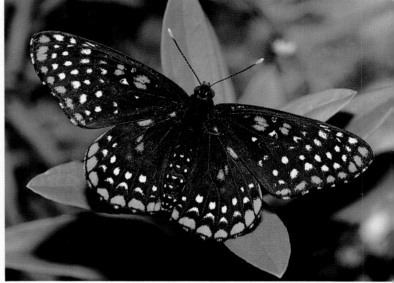

Baltimore checkerspot. *Kodachrome 25, 105mm lens, 1/60 sec. at f/11*

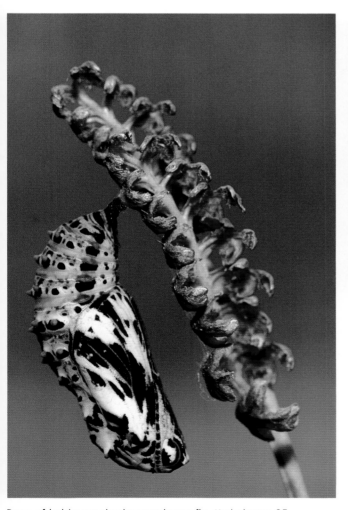

Pupa of baltimore checkerspot butterfly. *Kodachrome 25, 105mm lens, 1/15 sec. at f/16*

In the situation on the left I didn't shoot with my camera at sync speed. The pupa is on an old fertile frond of sensitive fern in a shaded area. The background is a distant sunlit area of marsh plants. I metered the background, then slowed the shutter speed to balance the natural-light background exposure with the flash exposure.

I checked the same area later for adult baltimore checkerspots and found many flying. To make the top photo I definitely needed the flexibility of a handheld camera plus the action-stopping capability of flash.

What size flash?

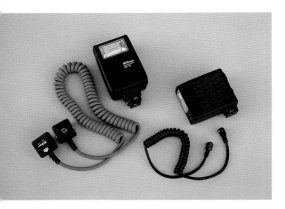

Here are two flash units with cords. On the left is the small Nikon SB-18 TTL flash and its TTL cord. On the right is the long discontinued Vivitar 102 with its PC cord.

There are basically two types of flash units you can purchase, small, low-output ones or large, powerful ones. For most closeup work, I would consider the small units.

Putting a small flash very close to a subject will illuminate it with the same amount of light as putting a large flash at a distance from it. A large flash then effectively becomes a point source of light, casting black, hard-edged shadows. The sun is a very large light source, but it is a long distance away, so we end up with high-contrast light on a bright, sunny day. A small light source gives far more open, even, lower-contrast light since it must be used up close to the subject. Even a small flash has a relatively large reflector, and used at a distance of 8 inches from a small subject, the lighting effect is that of a bare flashtube bounced from an umbrella. If you're photographing small subjects, your flash source is often probably at least as big as your subject, if

not bigger. With such an open light source, only one light from the front is usually necessary.

Physically large flashes such as the big Vivitars, Sunpaks, or Nikons have another *big* drawback—they're too big and heavy for field use. Remember that you have to carry all this equipment; although Vivitar 5600s are good flashes, a couple of them add up to a lot of bulk. I've noticed that a lot of these large units don't put out much more light when they're used up close to a subject. Their reflectors are designed to be most effective at a more normal working distance. I've got a Vivitar 4600, and used at a working distance of one foot, it puts out only about a half-stop more light than my normal flashes, although at a distance of 8 feet it throws out about one-and-a-half stops more. My normal closeup flash units are the discontinued Vivitar 102 models that were once the very bottom of the Vivitar line. They are small, compact, and take four AA

Honey bee on poppy. *Kodachrome 25, 105mm lens, 1/60 sec. at f/16*

batteries, so their recycling times are fast. For closeup TTL flash I use Nikon's equivalent small flashes, the SB-18s that also take four AAs.

I never use a ring light, which is a flash that encircles the lens and is made for medical photography. It produces a flat, shadowless lighting that comes from above, from below, and from both sides of the subject simultaneously—a lighting not found anywhere in our known universe.

All three of these photos were taken using one single flash; in fact, I used the same small flash for all three. Even with the largest of the subjects, the anise butterfly, I'm covering an area only about four times larger that the flash itself. With the smallest, the jumping spider, the flash reflector is several times larger than the subject. The hardest part of photographing jumping spiders is keeping them from jumping away. This one jumped right onto the front element of the lens while I was trying to focus.

Anise swallowtail. *Kodachrome 25, 105mm lens, 1/60 sec. f/16*

Jumping spider and prey. *Kodachrome 25, 105mm lens, 1/60 sec. at f/16*

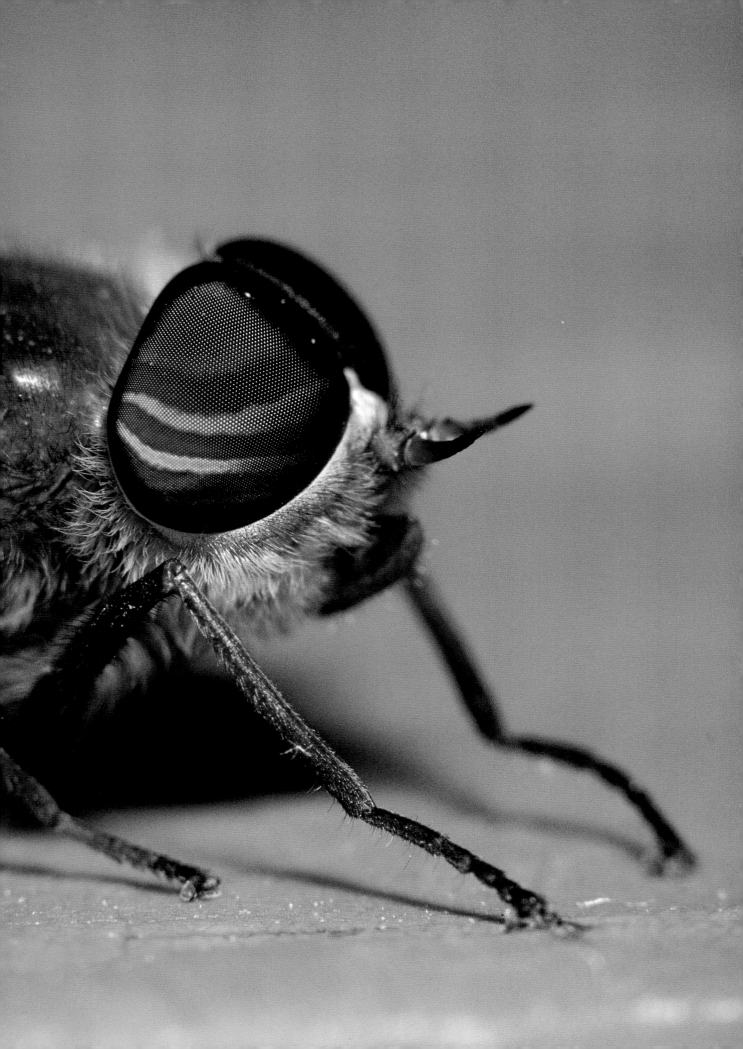

The butterfly bracket

If you're going to work with closeup flash on animate subjects, you'll definitely want to handhold the camera for maximum flexibility. The problem is where to mount the flash. If you use the hot shoe on your camera, you will run into some real difficulties. First of all, the flash probably cannot be aimed at your subject due to a parallax problem—the lens is looking at one thing, while the flash is aimed at another. Even if your flash can tip down, the light will probably not clear the end of the lens or the lenshade, and you'll end up shadowing your subject. What about shooting verticals? Tilt the camera and flash over, and you now have straight sidelighting, which only occurs twice a day, at sunrise and sunset. You need a third hand to hold your flash.

There are a number of brackets available commercially. They are usually either over-engineered and far more complex than necessary, or under-engineered and far too flimsy and lightweight. One commercial bracket is an 8-inch-long cantilevered arm that slides into the hot shoe. Imagine hanging the weight of a flash on the end on that—the top of the camera would be bent before long. Another bracket is a ring that screws into the end of the lens like a filter and holds a flash right next to the lens. This yields a very flat lighting, and since the flash position cannot be changed, the lighting is always the same.

You can make a bracket for yourself that is far better than anything on the market. I call my homemade model a "butterfly bracket" since I often use it to photograph butterflies. It is made out of some nuts and bolts and a 1-inch-wide, 1/8-inch-thick aluminum strap that I purchased at a hardware store, plus a flash shoe, a small ball-and-socket head, and a couple of

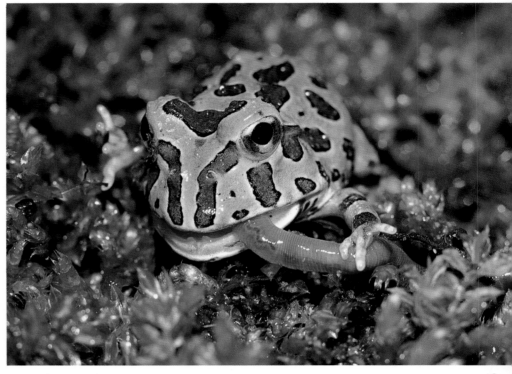

Ceratophrys spp. frog. *Kodachrome 25, 105mm lens, 1/60 sec. at f/11–16*

Horsefly portrait. Kodachrome 25, 105mm lens, 1/60 sec. at f/16

A subject as active as a horsefly could never be photographed with a tripod-mounted camera. The flexibility of a bracket-mounted flash frees me to concentrate on my subject matter, rather than on moving equipment around.

knobs with threaded shafts, all from my local camera store.

There is no significance to the shape of this bracket. It is only a third hand, a means of positioning a flash. You want to make something that clears all the camera controls and still permits you to comfortably hold the camera body.

A design that seems to work well with most cameras is to take a piece of strap about 1 foot long and drill two holes in it, about 1 inch from either end. One hole is for the knob that will mount the bracket to the baseplate of the camera, the other is where the ball-and-socket will mount. Your ball-and-socket should be the simplest available, with a tapped hole in the bottom and a threaded shaft on the ball end. Bend one end of the strap at a right angle about 1/2 inch in from the hole to make a little tab for the ball-and-socket to mount on with a 1/2-inch bolt. Then make another right-angle bend. To determine where, line up the baseplate hole in the strap with the baseplate hole in the camera with the strap running parallel along the camera's bottom. Add about an inch or so past the camera, and that's where to bend the strap. If you want to

A moment's action—this frog eating—and a handheld camera with flash can capture it as quickly as it happens.

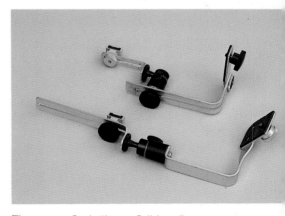

These two flash "butterfly" brackets have a slightly different design. Remember that the actual shape of a bracket is meaningless—it's simply a third hand to hold a flash.

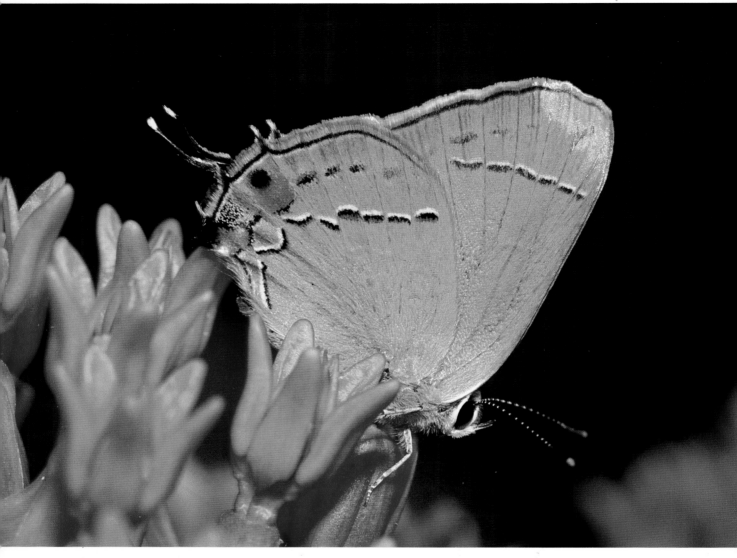

Gray hairstreak on orange milkweed. *Kodachrome 25, 105mm lens, 1/60 sec. at f/16*

Hairstreaks are extremely active little butterflies, twisting and turning constantly as they feed. Only with a totally mobile handheld camera and flash combination can you follow and photograph them in the wild.

do a neat job, put the strap and a short piece of 1-inch pipe in a vice and bend the strap around the pipe. You now have an *L* shaped piece. If you want, twist the strap so that the ball-and-socket end tilts forward in the same direction as the lens points. To do this, place the baseplate section of the strap in a vice, leaving about 1 inch at the bend sticking out of the jaws. Use a crescent wrench, or Vice-grips, and twist the strap about 45 degrees. Now you might want to cover

the part of the strap that actually touches the camera when they are fastened together. I've always used baseboard vinyl molding from a carpet store; cut a piece to size, and glue it on.

Now make an arm to fasten onto the ball-and-socket's threaded shaft, and on which you will mount a flash shoe. Take another piece of strap, about 8 inches long, and drill a hole about 1/2 inch in from one end. Come in another 1/2 inch and make a right-angle bend, forming another little tab where the arm mounts onto the ball-and-socket. Fasten it to the ball-and-socket using a lock washer and nut on the threaded shaft of the ball. Drill a series of holes along the rest of the arm where you can mount a flash shoe, a

basic shoe with a tapped hole in the bottom. This is not a hot shoe; the flash must still be connected to the camera with a cord. You can mount the shoe at any hole along the arm, permitting you to position the flash at any point.

In the field when you add extension, your reference point gets farther from the camera body. Tip the ball-and-socket forward and reposition the flash over the reference point, moving to another hole if need be.

As I said, this design is not special. Any shape will work as long as you can move the position of the flash. You could actually hold the flash in one hand and the camera in the other, but it's not a very practical or comfortable way to work.

Positioning the flash

Positioning the flash relative to the subject is obviously critical to the appearance of the final photograph, yet there is no absolutely right or wrong flash location. Although there is no substitute for experience, trying to learn flash positioning while working on hard-to-approach subjects in the field leads only to frustration. The best learning exercise I know is to assemble small household objects and light them from different angles while keeping careful notes. Mount your camera on a tripod, and use a high-intensity desk lamp to light the objects; this will yield a small direct source of light similar to a flash. Move the lamp around the object while you study the lighting effects through the viewfinder. Try to duplicate both pleasing and not-so-pleasing lighting by replacing the lamp with your flash. Be very critical of the results.

Many flashlit photographs of small subjects are overlit. This can be corrected by using fewer lights. Always use the least number of flashes possible; generally that number is one. Problems arise when you position the main light to the side. Many photo guides suggest that you should always light a subject from the head end. Aside from its impracticality for field work, (I know the writers of those guides have never stood chest-deep in a pond at night and worried about whether they were lighting the head end of a singing frog), lighting from the side results in a hard shadow.

In reality, however, you do want some shadows. Shadows delineate subjects and create the appearance of sharpness, and rendering sharpness is why you bought that expensive lens. You need shadows, but you must control where they fall.

For practical results in the field, a good starting point is to position the flash in what I call the "high-basic" location. Keep the flash vertically on an axis a few inches above the lens, regardless of the camera's orientation. You are lighting the subject from about 30 degrees directly above the lens. Portrait photographers often call this "butterfly lighting," because it casts a small butterfly-shaped shadow under the human nose. With a high-basic flash position, you'll get good lighting regardless of which way your subject faces. And, as a bonus, most of the shadows will fall behind the subject.

Keep the light in this same high-basic position even when you shoot vertical photos. If you're using the butterfly bracket, mount the flash toward the end of the arm, loosen the ball-and-socket, and flop the arm over 90 degrees to the side so that the flash is again in its high-basic position over the reference point.

This photo was made with one light mounted on a bracket.

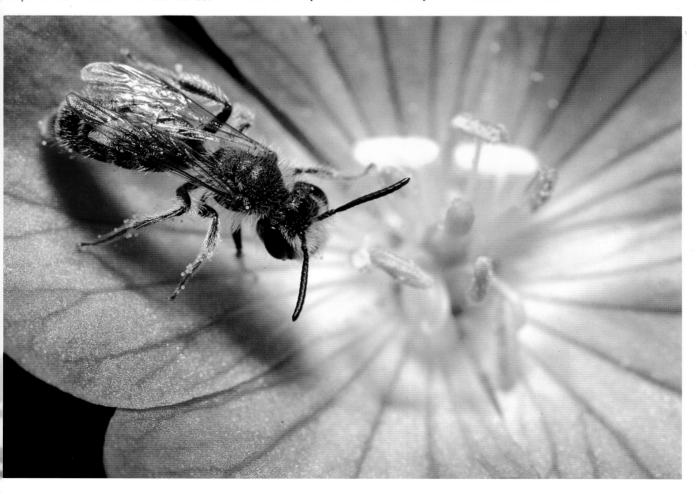

Bee on wild geranium. *Kodachrome 25, 105mm lens, 1/60 sec. at f/16*

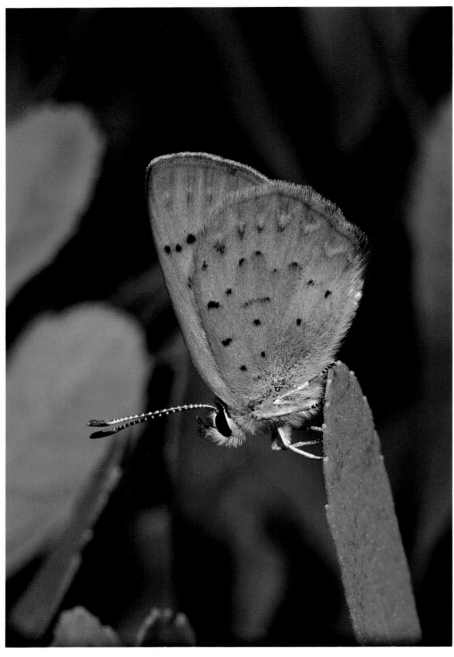

With a few lenses you can flip the camera body in order to make shooting vertical photos even easier. If you have a Nikon or Canon 200mm macro lens, make a flash bracket that mounts on the lens's rotating tripod collar. Then loosen the collar and swing the camera into vertical orientation. The Nikon PN-11 extension tube also has a collar that permits rotation. The drawback is that the tube is so long, 52.5mm, that with many lenses you'll·start off with too much magnification. For example, if you use the tube with a 105mm lens, you start at 1/2X covering a subject just 2×3 inches in size.

Avoid using two lights in front of the subject if at all possible. Two lights mean twice as many specular highlights and double catchlights in the eyes (not often found naturally on our planet since we only have one sun!). If the subject is extremely complex, you may have to resort to two frontal lights, but usually one light will suffice. A second light can be useful, however, if you want some extra light on the background. Make an additional bracket, possibly extending from the·camera opposite the first bracket, in order to hold the second light. Aim the second flash at the background, so that only a little light spills onto the subject. Work in stops to determine its intensity compared to the main light. If you're using manual or automatic flash, you can slave this second light. If you're running TTL flashes, you will have to use a special connecting cord so that both flashes are read by the camera sensor.

Keeping your main-subject flash at about a 30-degree angle to the lens works most of the time, but this is not a hard-and-fast rule. If you need the light closer to the lens to drive it back into what would otherwise be shadowed areas, by all means reposition the flash. On the other hand, moving it farther off axis results in a light that reveals more surface detail. When you move a light off axis, remember to keep it radially the same distance from the subject as before if you want to keep the same contrast in the lighting and the same exposure.

For closeup work it doesn't matter how the rectangular flashtube is oriented compared to the rectangular film image. Most small flashes throw out enough light to cover at least a 35mm lens's angle of view, and a long lens sees only the center of the light.

Purplish copper butterfly. *Kodachrome 25, 105mm lens, 1/60 sec. at f/16*

Here's an example of a shot with the flash positioned vertically above the lens. If I had left the flash in the position it was in when I was working on horizontal shots, I would have ended up with straight sidelighting here. Note that I kept the film plane parallel with the butterfly's wings.

This flash bracket has a flash mounted over my reference point, the front of the lens (or the rear of the lens shade, depending on how you look at it).

Extension and inverse-square exposure

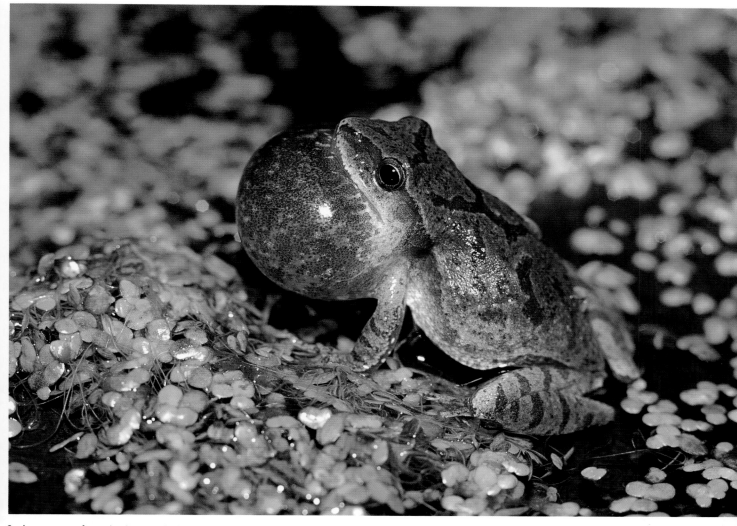

Spring peeper frog singing. *Kodachrome 25, 105mm lens, 1/60 sec. at f/11–16*

My most-used method of photographing such small, animate creatures as butterflies or bees is with what I call inverse-square flash exposure. This is a system based on positioning the flash over a reference point on the lens.

Determining the correct exposure for closeup flash has always been a problem. Many methods have been suggested. I've heard of recalculating guide numbers into so-called nature numbers, which is totally impractical if you are photographing a moving subject. (Nature Number = (focal length of lens × GN of flash) divided by (f-stop to be used × 3). Take the result and divide it by the total extension used to determine flash-to-subject distance. Now that's real handy for field work!) With guide numbers you must set a flash at a measured distance from a subject, which is pretty hard to do if that distance is always changing. Other methods I've run across include holding little rulers in the frame next to the subject to indicate magnification rates; I would love to watch the ruler maker when he photographs rattlesnake portraits.

Inverse-square flash does away with all this. It's a fast, easy way to determine correct exposures for field work when you are using an extension-based closeup outfit and a manual flash. As you add extension to a lens, that is, as the magnification increases, you need more light for correct exposure. At the same time, however, you must move the lens closer to the subject in order to focus. If your flash moves closer to the subject

I shot this frog at my normal middle-toned exposure; this exposure is correct only for this lens, film, and flash combination. Change any one of the three variables and another pretested exposure must be used.

along with the lens, you get more light. Believe me, in photography that is a miracle—you need more light and you get more light! Simply keep the flash and the lens in the same position relative to each other and move them closer or farther from the subject.

You must determine a starting point for your exposures by running an exposure test with a middletoned subject. Set up your equipment with extension to cover any magnification between roughly 1/6X and 1/2X. Pick a

short telephoto lens, somewhere between 85mm and 135mm. It doesn't really matter what you use, so long as you gain or lose magnification by changing the extension. You can use a fixed-focal-length lens plus extension tubes, a short-mount lens on a bellows, or a zoom on extension. If you do use a zoom, set it at one focal length, and vary the magnification by changing the extension, *not* by zooming. (I use my 105mm macro lens which goes to 1/2 life-size mounted on a Nikon PK-13 tube (27.5mm long) because the combination is so convenient. With the lens set at infinity focus, that is with only the tube as extension, I'm at about 1/4X, while with the lens racked all the way out I'm at 3/4X. Many of the subjects I want to photograph fall right in this magnification range; if I need more magnification, I can add another extension tube.)

Arbitrarily pick a reference point (I use the front end of the lens since I can always find it) in front of the extension. Position the flash over this point, about 3 or 4 inches above the lens, and aim it at your middletoned test subject. Make sure the flash is a manual one, or is set on manual output if it's an auto-flash. Without changing anything but the *f*-stops, run an exposure test by photographing in half stops from *f*/11 to your smallest stop. Shoot at *f*/11, halfway between *f*/11 and *f*/16, *f*/16, halfway between *f*/16 and *f*/22, *f*/22, halfway between *f*/22 and *f*/32, and *f*/32. Keep careful records on what you're doing and be sure to use slide film for this test. When you get the film back, carefully evaluate the shots on a lightbox and pick out the exposure you like best. This is now your exposure for a middletoned subject. Almost all small flashes seem to put out the same amount of light, and for a 105mm lens and Kodachrome 64, your base exposure will be roughly between *f*/16 and *f*/22. K25 is a one-stop-slower film, so its neutral exposure will be between *f*/11 and *f*/16, and Fuji 100 will be roughly at *f*/22.

This is a test series to determine correct exposure. Here is a middletoned frog on a middletoned background. These exposures vary by one f-stop (a normal series would include several more frames varying by 1/2 stops). After you shoot a test series of exposures, you simply pick the one you like best.

Sequence of spring peeper frog on leaf. *Kodachrome 25, 105mm lens, 1/60 sec.*

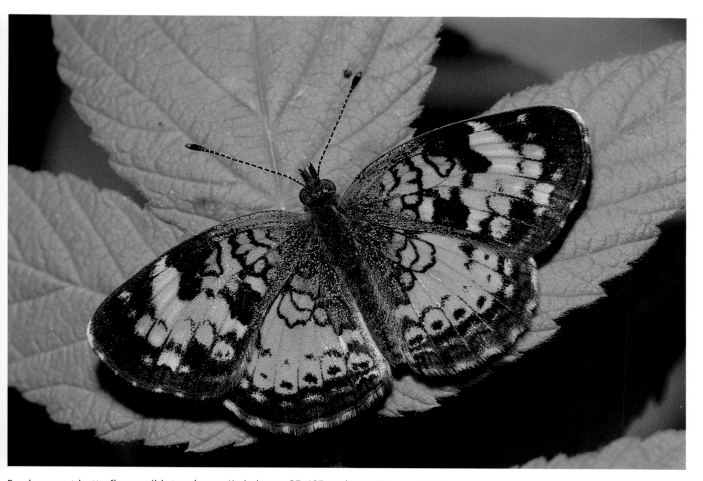

Pearl crescent butterfly on wild strawberry. *Kodachrome 25, 105mm lens, 1/60 sec. at f/16*

You can change the extension behind the lens to change image size by adding more tubes or by racking out the focusing mount of the lens. As long as you position the flash back over your reference point and keep it aimed at the subject, you will still use the same *f*-stop. As you add more and more extension, however, the flash should get a little closer to the lens. Start off with your flash and lens about 12 inches from a subject, with the flash about 4 inches above the lens. The flash and the lens form an angle, converging on the subject. Preserve this angle as you move closer, as you gain magnification. Basically, you are keeping the flash the same distance from the subject as the reference point.

You change exposure only when the subject is not middletoned. In those situations, you must stop down for light objects and open up for dark ones, starting from your basic middletoned exposure. Luckily, there are only a few variables. Keep careful notes on your first few rolls of film and you can fine-tune your exposures to your own taste. After a while you will

know instantly what *f*-stop to use on field subjects. The variations are:

Small, bright subjects, such as a little brightly colored butterfly—stop down 1/2 stop.

Small, bright subjects on snow or light sand, or white subjects—stop down 3/4 stop.

Large objects, swallowtail-butterfly size—open 1/2 stop.

Large, dark objects, swallowtail-butterfly size—open 1 full stop.

You can see that this system limits you to using only one *f*-stop for any given subject. While this sounds like a definite drawback, in reality it is not. It's generally difficult enough to see your object through the viewfinder, let alone worry about the *f*-stop. This inverse-square system will create quality pictures for you.

If you simply must use a different *f*-stop, you can do so by working in stops. First of all, you could use a different film. If you're using K25 and shooting at *f*/11, switching to Fuji 50 will gain you one stop to *f*/16. An ISO

This is photographed at 1/2 stop down from my middletoned subject exposure, since it is a small, bright subject. If middletone is f/11–16, this is therefore correctly exposed at f/16. The wild strawberry leaves are lightened 1/2 stop. In reality, they are a darker green, but I correctly exposed for the butterfly and let the background fall where it may.

100 film would give you another stop to *f*/22. If you don't want to switch film, you can gain stops by moving your flash in closer to the subject in stop increments. For example, you're photographing with K25 at *f*/16. Measure the flash-to-subject distance, which should be the same as your reference-point-to-subject distance. Assume this is 11 inches. Move the flash closer to the subject a one stop distance, to 8 inches, and you can shoot at *f*/22, one stop down from where you were. All you're doing is finding a new reference point. My normal point is the front of the flash over the front of the lens; perhaps it then changes to the back of the flash over the front of the lens shade.

TTL flash

Over the past few years almost all camera manufacturers have introduced at least one body that incorporates through-the-lens (TTL) or off-the-film (OTF) flash metering. (I'll call both of these TTL since their end result is the same.) If I were buying a new camera body and expected to do much flash photography, having TTL-flash metering would be a primary concern. Couple this with the fast synchronization speed—1/250 sec.—of the latest cameras, and you can shoot flash under a wide range of conditions.

With TTL flash the exposure is controlled by a sensor in the camera, which means that the sensor's angle of view changes according to the focal length being used. Remember, though, that the sensor probably reads the light in the same pattern as the TTL exposure meter. If your camera has a heavily center-weighted metering pattern, it will read this area with TTL flash also, but if the subject is not centered, problems can arise. You must be very aware of the area that the sensor will read.
TTL flash metering, though, is no

guarantee of correct exposure. Like all metering systems, it makes everything come out the same tonality to which it has been calibrated, and since you've calibrated your camera to a middletone, everything becomes middletoned. Just as you must interpret an exposure reading when metering a non-neutral area for natural light, so too with TTL flash. However,

Here is an easy subject for TTL flash—it's all middletoned. No compensation was dialed in.

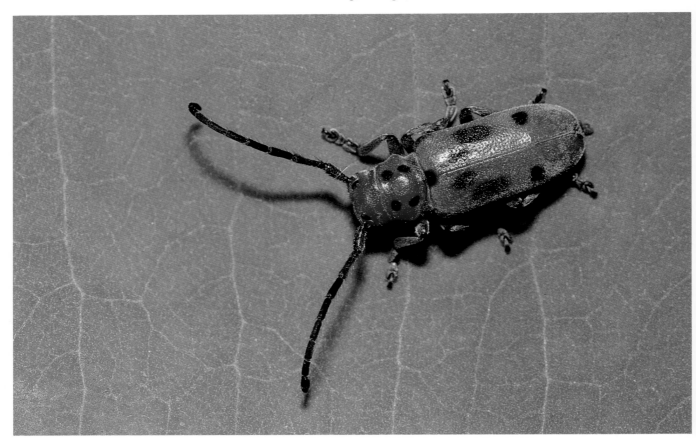

Milkweed longhorn beetle. *Kodachrome 25, 105mm lens, 1/60 sec. at f/16*

since the sensor is measuring the light from behind the lens, no compensation is necessary for light lost to extension or filters—this is taken care of automatically.

You cannot control exposure with TTL flash by changing the *f*-stops on the lens. The flash will automatically compensate for any change. Instead, you must use the exposure compensation dial, the + and − dial marked in 1/3 stop exposure changes.

To determine exposure with TTL flash, you have to think in stops from a middletone placement. Look at your subject and decide what tonality you want to make it. If it is middletoned, and that's what you want, go ahead and shoot. Suppose, though, it is a rich yellow autumn leaf. This is about the tonality of the palm of your hand, one-stop lighter than middletone. Set your compensation dial to +1 and then photograph. Remember to reset the dial when you're finished or else all your subsequent shots will also be one-stop lighter.

The instructions that come with many TTL flashes seem to suggest that you cannot use a TTL flash positioned closer than two feet or so from your subject. This is only partially true; it depends on the effective *f*-stop you're using. If you're working fairly wide open, at effective *f*/8 or even more open, you will get overexposed photos. The flashes cannot turn themselves off fast enough. Work at smaller effective *f*-stops, though, and all is well.

One aspect of TTL flash that I particularly like is the fact that I don't have to worry about precise measurement of flash distances. The flash reads the light coming through the lens and quenches itself when a certain level is met, regardless of flash-to-subject distance. As long as the flash is positioned somewhere within its output range, it will throw out a precisely measured light level.

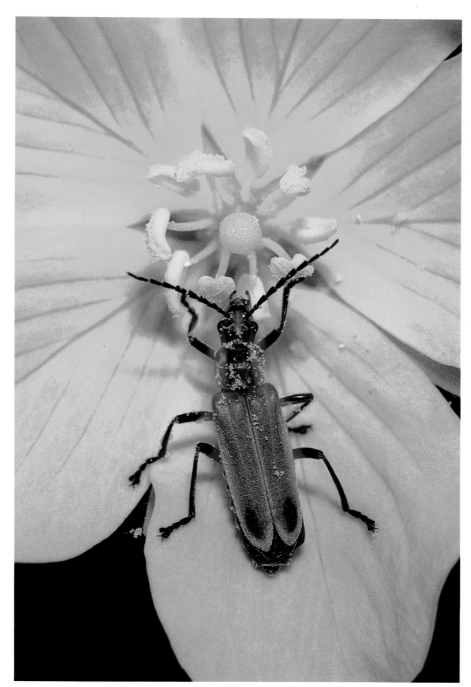

Soldier beetle on primrose-willow. *Kodachrome 25, 105mm lens, 1/125 sec. at f/16*

Because of the great expanse of bright yellow behind the middletoned beetle, I dialed in a +1/2-stop compensation.

This test sequence shows how important it is to learn how the TTL sensor in your camera reads a subject. I am photographing part of a Fuji film box; the subject area contains a bright white and a medium green. Look at what happens to the rendition of these colors as the compensation dial is changed. The reading is greatly influenced by all the white, yet the green also plays a role in determining the final exposure. The sequence is in stop values: −2, −1, 0, +1, +2.

Part VI
SUPPLEMENTARIES AND TELECONVERTERS

Supplementary lenses

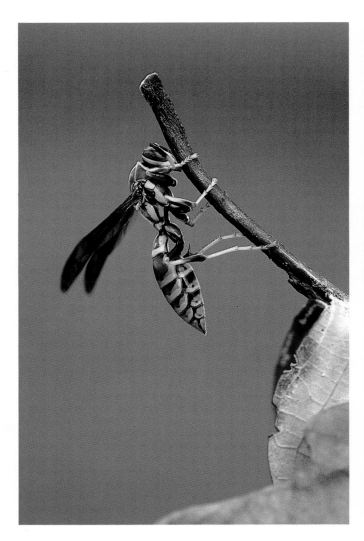
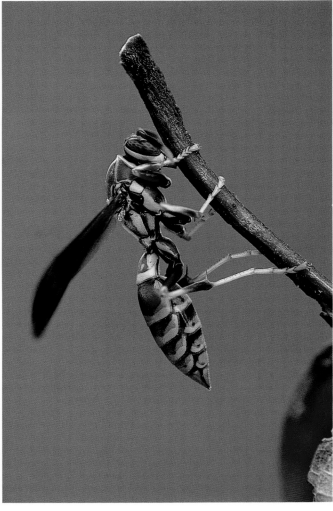

You are probably familiar with supplementary lenses, the so-called "closeup lenses" or "plus lenses" or "plus diopters." They are simple, single element lenses that attach to your lenses the same way filters do; indeed, they look just like filters and are most readily available in standard filter sizes. Attaching a supplementary to a prime lens allows it to focus in the closeup range. The working distance and coverage you end up with depend on the power of the supplementary and the focal length of the prime lens.

Supplementaries come in different strengths that are measured in diopters such as +1, +2, +3, and so on. The higher the diopter number is, the greater the supplementary's strength or the more magnification it yields compared to other supplementaries on the same prime lens. You can actu-

ally take photos with the diopter itself since it is a lens. Determine its focal length, place it on the end of enough extension, and shoot. All by itself, a diopter yields very soft images, but it's fun to play around with it.

Closeup supplementaries have some definite good points and bad points. Their low cost and easy portability are major advantages. In fact, few other closeup accessories approach their usefulness in such a small size for so little cost. And since adding one to a lens doesn't change the extension in any way, there is no change in the amount of light coming through the lens. This means there is no exposure change and no loss of focusing light. You can still focus using the brightest image and shoot with the most light available.

However, there are also some definite drawbacks to supplementaries.

This pair of photos of a wasp on a leaf stem was taken with a 200mm lens and a diopter. I used the Nikon 3T diopter for the one on the left, and the other, more magnified photo was taken with the 4T diopter. Both shots were made on Kodachrome 25 with an exposure of 1/8 sec. at f/16. These two photos show the difference in image size obtained with the two diopters used on the same lens. Both yield fine results, although I like the less-magnified shot better. The wasp had spent the night clinging to the leaf steam.

First of all, there is a loss of optical quality. Most diopters are simple, single-element lenses, and their optical quality leaves a lot to be desired. If you use one with your prime lens wide open, there will be a noticeable loss of sharpness, especially around the edges of the picture. You can either stop the prime lens down at least halfway, or you can compose your image so that the important parts are in the central portion of the frame. Diopters also give you a limited range of magnifications. The normal +1 to +3 lenses used on 50mm to 200mm lenses offer magnifications up to about 1/2X. Although there are stronger diopters available, their image quality quickly deteriorates as the power goes up. You can gain some magnification power by stacking diopters together. A +2 and a +3 yield a +5. Place the stronger of the diopters next to your prime lens, and don't stack more than two.

These closeup lenses work by shortening the effective focal length of the lens on which they are used. A formula for determining the actual focal length you end up with is:

Combined focal length =

$$\frac{1000}{(1000/\text{FL prime lens}) + \text{diopter power}}$$

Let's assume that you have a +3 diopter lens. Add it to a 24mm lens, and you end up with an effective 22.4mm lens. Add the same +3 to a 50mm lens and you get a 43.5mm lens. On a 105mm lens a +3 diopter creates an effective 80mm lens, and on a 200mm lens, a 125mm effective focal length. Adding one to a short focal-length lens doesn't do much since the more the effective focal length changes, the more the image size changes.

All closeup diopters make whatever lenses they are added to focus at the same working distance, if the prime lenses are set at the same focusing distance. In other words, if all the lenses are set at infinity focus, they will all be at the same working distance when used with a closeup lens. When a 50mm, a 105mm, and a 200mm lens are used with +3 diopter closeup lenses, they will all be focused at the same distance. At infinity focus on the prime lens, this working distance will be roughly 1 meter divided by the diopter power of the closeup lens. With all lenses set on infinity focus, a +1 diopter will

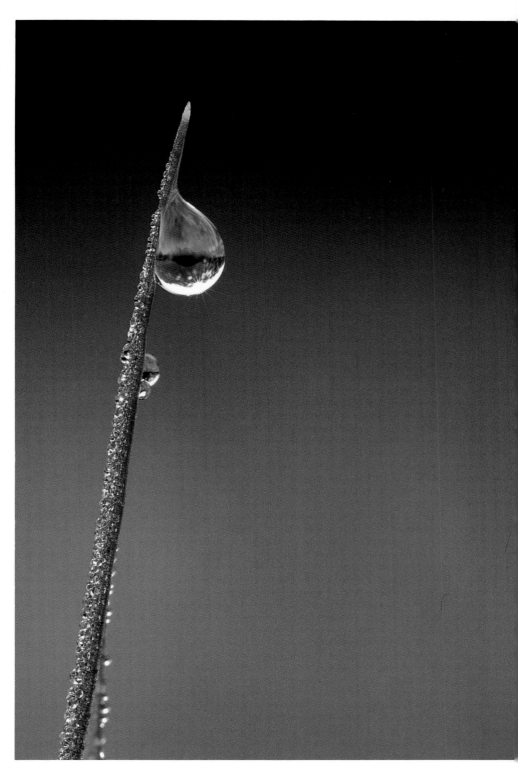

Dew drop on grass blade. *Kodachrome 25, 105mm macro lens plus 4T diopter, 1 sec. at f/22*

The early morning light was so low that a long shutter speed was required. I was worried about wind movement, so I wanted to use the fastest speed I could, yet at the same time I needed enough magnification for the image size. Adding a diopter, not adding more extension, solved my problem. The camera was then mounted on a focusing rail because precise placement was very important.

Here is the Nikon 4T two-element diopter mounted on a 200mm lens. I would always use this diopter with a lens shade.

make all lenses focus at 1 meter. A +2 diopter yields 1/2 meter, or about 19½ inches; a +3 diopter gives 1/3 meter, or just over 13 inches. Of course, you can still use the focusing mount of the lens to add some extension and gain some magnification.

If all the lenses will be in focus at the same working distance, it follows that the longer your prime focal length is the more magnification you'll get. But here's the problem: Almost all standard single-element closeup diopters are optically designed for use on 50mm focal-length lenses. Use a standard +3 diopter on your 200mm lens, and you'll definitely have sharpness and flare problems even if you stop down part way. You might be tempted to add a diopter to your 300mm or 400mm to gain image size, but I wouldn't recommend it. If you still decide to try it, use the weakest diopter you can find, a +1 at the most. Very few manufacturers offer diopters in large filter sizes anyway, although Minolta and Spiratone do.

The actual magnification (M) you obtain can be computed with a formula. Divide the focal length (FL) of the camera lens by the focal length of the diopter lens (not the diopter power). A diopter's focal length in millimeters is found by dividing 1,000mm by the diopter power. Therefore:

$$M = \frac{FL \text{ prime lens}}{FL \text{ of diopter}}$$

A +3 diopter has a focal length of 333mm (1 meter/3). Used on a 50mm lens, it gives 50mm/333mm, or .15X, roughly 1/7X. Used on a 105mm it gives 105mm/333mm, or .3X, about 1/3X. Another way of figuring this out is to multiply the diopter power by the focal length of the lens in meters:

$$M = \frac{\text{Diopter}}{\text{power}} \times \frac{FL \text{ of lens}}{\text{in meters}}$$

Actually, it's a lot easier to just stick a diopter on a lens and look through it; you'll soon discover which ones will yield what coverage. I don't like formulas for field work.

The major problem with using diopters on short lenses comes back to the original problem of shooting closeups with short focal-length lenses. Let's look at some figures. To achieve the same image size, or the same magni-

fication, you need a stronger diopter on a short lens than on a long lens. To get to 1/2X, you need a +10 diopter on a 50mm lens, but only a +2.5 diopter on a 200mm lens. If you choose the 50mm lens (which is now an effective 33.3mm lens), you start running into the problems common to all short lenses used up close: lack of working distance and increased background coverage. In other words, using short lenses with diopters for field work often compounds the very problems you're trying to eliminate.

What if someone made multi-element closeup lenses that were capable of high-quality flat-field reproduction and were optically designed for the longer focal lengths so useful for gaining working distance? Luckily there are some available. Nikon offers two different diopters in two filter sizes. These two-element designs are far better corrected than the single-element diopters. Other manufacturers also offer two-element diopters but, as far as I know, they are all optimized for 50mm lenses except for the Nikon diopters. Of course, you don't need to own a Nikon to use Nikon diopters; they are just like filters and will work on any lens on which you mount them. They come in +1.5 diopter and +2.9 diopter (let's call that +3 for convenience). They are available in 52mm and 62mm filter sizes. Here are Nikon's names for them:

	1.5 diopter	3 diopter
52mm	3T	4T
62mm	5T	6T

These diopters are optically designed for lenses with focal lengths between 80mm and 200mm, exactly the focal lengths most suited for using diopters. And they are relatively inexpensive. At a retail cost of about thirty-five dollars, they are more costly than single-element diopters, but they offer markedly better quality. You probably don't need both strengths; figure out the magnifications you want to cover and which lenses you will use most often, and that should give you some idea about which diopter to purchase. If you are considering stacking diopters, I would definitely pick up these two-element versions because paired together, their quality is quite high.

Using zooms with diopters

My first choice for closeup work with a zoom is adding a two-element diopter to the zoom. With this combination you can zoom and stay in focus simultaneously, and the two-element diopter yields very good results.

Many zooms have a so-called "macro" feature on them. This feature can have some drawbacks. Often it requires that the zoom be set to its shortest focal length, which means limited working distance. Also the quality of the "macro" mode is usually not that good.

Putting a closeup diopter on the same zoom offers far more flexibility and better resolution. The weaker of Nikon's two-element lenses, the 3T or 5T, are best with zoom lenses since

they are already so optically complex. However, with very good technique you can use either of the closeup diopters or stack them together for higher magnifications.

With a diopter on a zoom, you benefit from the effect of using a focusing rail without actually having to use one. Start off with your lens midway in its zoom range and you can zoom to change cropping. The convenience is incredible. Imagine hiking up a mountain to photograph mountain goats. You would probably carry a long lens for portraits and a zoom for scenes including animals. On such a climb you would never carry your closeup equipment, but with a two-element diopter in your pocket, taking

This photograph was made in the middle of the lens' zoom range. Sometimes you cannot see photographic possibilities because you lock in on only one subject. I was concentrating on photographing big game in Alaska when I found this tundra section literally next to my boots as I ate lunch one day.

Alaskan tundra in autumn color. *Kodachrome 64, 80–200mm zoom with 5T diopter, 1/15 sec. at f/16*

up no more space than a filter, you have a complete closeup system along with you. Now if you climb up the mountain and discover a fantastic closeup, you can work on it. When I'm on long big-game photo trips, my entire closeup outfit is a zoom with a two-element diopter. I've published many double-page spreads that were photographed this way—for that matter, I also shot the cover of a well-known natural-history magazine exactly like this.

The coverage you actually get depends on the close-focusing limit of the zoom and the range of focal lengths. If you add the 5T +1.5 diopter to the Nikon 80–200mm *F*4 lens, you'll get some astonishing results, as you can see from the accompanying chart.

If you are working with a Nikon 80-200mm F4 lens, look at the range of closeup work you can cover simply by adding a filter-sized diopter. With a +1.5 diopter on this lens, you can shoot from 1/8X to over 1/2X merely by zooming and turning the focusing mount.

These figures are only rough approximations. Use them only for guidelines. When the diopter is added, the actual focal length of the 80-200mm zoom becomes 71.4-153.8mm; however, for convenience I have continued to refer to it as an 80-200mm. The working distance is measured from the front of the lens assembly.

Adding a +1.5 diopter to a zoom lens

80-200mm lens by itself, at closest-focusing distance

Working distance: 38½ inches

Magnification obtained: at 80mm = 1/12X
 at 200mm = 1/4X

Subject area covered: at 80mm = 12 × 16 inches
 at 200mm = 4 × 6 inches

80-200mm lens with +1.5 Nikon 5T diopter added, at infinity-focusing distance

Working distance: 26 inches

Magnification obtained: at 80mm = 1/8X
 at 200mm = 1/3X

Subject area covered: at 80mm = 8⅜ × 12½ inches
 at 200mm = 3⅛ × 4¾ inches

80-200mm lens with +1.5 Nikon 5T diopter added, lens set at closest-focusing distance

Working distance: 15 inches

Magnification obtained: at 80mm = 1/4X
 at 200mm = 3/5X

Subject area covered: at 80mm = 4⅛ × 6¼ inches
 at 200mm = 1⅝ × 2½ inches

New England aster and dew. *Kodachrome 25, 80–200mm zoom with 5T diopter, 1/8 sec. at f/8*

I would have liked to have stopped down a little more, but a slight and persistent breeze kept me from using any slower shutter speed.

Adding flash to zooms with diopters

You can photograph in the field with the "butterfly bracket" using a zoom and a two-element closeup diopter, although you should first run some tests. When you work using diopters on a zoom, you can change image size by zooming but still remain at the same working distance.

Pick a zoom lens and diopter combination that gives you coverage from about 1/4X to 3/4X since most subject matter falls in this range. You might need two diopters to cover the entire magnification rate, but it's fairly easy to take one off and add the other while you're working in the field. A zoom focal length of about 75–150mm or 80–200mm is a good starting lens. Don't use a short zoom or you'll end up with too little working distance.

Mount the diopter on the lens, and set the zoom to any working distance you want. It's easiest to use the closest-focusing distance because this will help avoid ambient-light ghost images—getting one image from the

I used a TTL flash to make this photo. It was very important to keep the film plane absolutely parallel with the plane of the butterfly's wings.

flash and another from the daylight—since your flash will also be close to the subject and will overpower the ambient light. Work at this fixed distance from the subject, and simply zoom to change the cropping.

Figuring out exposure depends on the flash system you use. For TTL flash (my personal choice of flash for use with a zoom and diopter combination), pick an *f*-stop and control your exposure with the auto-compensation dial. For an auto flash, pick the smallest *f*-stop setting that the flash lets you use. You can lighten or darken the exposure from this stop by opening up or stopping down the lens. An auto flash makes everything middletoned, so to compensate you must work in stops if your subject has a different tonality. If your subject is lighter than middletone, and you want it to appear on the film as it does in reality, open the aperture; and vice versa for darker subjects. An auto-flash sensor reads a very broad area, so the actual exposure is not necessarily most influenced by your subject. You must be aware of the tonality of the surrounding area, too.

With manual flash you will have to run an exposure test. Set up a middle-

toned subject and focus on it with your zoom lens and diopter combination. Use the closest-focusing distance of the lens. Arbitrarily pick a reference point on the lens and position the flash over this point; you must always keep the flash at this reference position. Now run a test series of exposures by half stops to determine your middletoned subject starting exposure. You can do this for another working distance if you want, and you'll get another *f*-stop for that distance. At each working distance, since the flash is moving in tandem with the lens, there is one base *f*-stop. You open up or stop down the lens to vary the exposure depending on the tonality of the subject.

When you use manual flash, you have to compensate for nonneutral subjects by doing the reverse of what you do with TTL or autoflash. For those two systems, the flash controls the amount of light emitted and consistently makes the subject middletoned; for light-toned subjects you open up the compensation dial or the lens aperture, and for dark-toned subjects you stop down. A manual-flash closeup system reverses that process—the flash emits the same amount of light regardless of the tonality of the subject. Now you must stop down to keep from overexposing light-toned subjects, and open up to keep from underexposing dark ones (see Part V on inverse-square exposure).

Getting ambient-light ghost images is the biggest problem with zoom and diopter flash combinations. Auto flash can be used with this lens configuration because most zooms don't lose light to their own extension, a fact that you can easily check by metering an evenly lit surface in unchanging light with your zoom. Take a meter reading with the lens at infinity focus and another at the closest focus; there probably will be no difference. If there is no light loss to extension, the flash and the natural light exposures may be roughly the same, resulting in double images. Depending on the camera and flash you use, you must definitely be aware of the ambient-light level.

Hackberry butterfly. *Kodachrome 25, 80–200mm zoom plus T5 diopter, 1/125 sec. at f/16*

Suppose you're shooting Kodachrome 64 in a brightly lit area with a zoom and diopter combination, using TTL flash at $f/16$. Natural light exposure for this film is 1/60 sec. at $f/16$. You need to be a couple of stops away from this exposure in order to be sure you won't get double images. Since there is no light lost to the zoom's extension and you are not adding any extension, a camera that syncs at 1/60 sec. won't work. Use a slower film or a camera body that syncs at a higher speed, or as a last resort work only in shaded areas.

Using the f-stops recommended by the flash is rather difficult because most auto flashes won't let you use small f-stops. If your auto flash requires $f/8$, you will need all the help you can get—1/250 sec. sync speed and Kodachrome 25—to stay away from the ambient-light exposure by only one stop in bright sun. To compound this problem, when an auto flash is used at a short flash-to-subject distance and a fairly wide f-stop, the flash usually cannot turn itself off fast enough, and you end up with overexposed images.

With a few flashes there is a way around this problem. Most auto flashes have a scale for setting the ISO of your film. Decide how many stops you need over the smallest offered by the auto flash's f-stop range, and reset this scale that number of stops over the actual speed of your film. For example, assume you're shooting Kodachrome 25 at an auto f-stop of $f/8$, but you want to use $f/16$ which is two stops down. Set the ISO scale for a two-stop faster film; in other words, set the scale at ISO 100. You're fooling the flash. A few off-camera connecting cords, such as the Nikon SC-14 for the F3, have ISO dials on the cords that must also be reset. Definitely test this with your flash to see if it works before trying it in the field.

I used one small manual flash to take the top photo. The flash was not very powerful, so $f/11$ was as much as I could stop down. My exposure was determined from previous tests at three different image sizes. With this flash at this coverage, I knew that $f/11$ was correct for an average subject.

A single TTL flash was used to light this photo of a mantidfly. Since the subject is predominantly middletoned, I didn't change the compensation dial at all.

Gray tree frog clinging to stalk. *Kodachrome 25, 80–200mm zoom with T5 diopter, 1/60 sec. at $f/11$*

Mantidfly on milkweed leaf. *Kodachrome 25, 80–200mm zoom plus T5 diopter, 1/250 sec. at $f/16$*

Teleconverters for closeups

Teleconverters are optical devices that magnify whatever you put in front of them. They come in various powers, the common strengths being 1.4 power and 2 power, but 3 power ones are available, too. They superficially look like extension tubes, but they contain glass, whereas extension tubes are only hollow spacers. In order to distinguish them from extension tubes, I refer to teleconverters as "multipliers," since that is what they do: they multiply whatever you put in front of them from the same working distance.

Multipliers are generally thought of in terms of making a long lens into a

Here is an example of multiplying focal length: a 105mm lens with Nikon 1.4X multiplier behind it to make roughly a 150mm lens, with a PN-11 52.5mm extension tube behind that. The final magnification is about 1/3 life-size.

Here is an example of multiplying magnification: a 105mm lens with PN-11 extension tube behind it to give 1/2 life-size, and a 1.4X multiplier added behind extension tube. The final magnification is about 7/10 life-size.

longer focal length. For example, take a 300mm $f/4$ lens, add a 2X multiplier, and their combined focal length is 600mm, while the wide-open aperture is now $f/8$. If you are going to use them with long lenses, buy the best multiplier you can and use it on the best lens that you can. Since there is such a speed loss with this combination, you'll be tempted to shoot at a fairly wide-open aperture, but there is also a definite loss of quality wide open, so the lens must be stopped down. You'll have to compromise by shooting somewhere in the middle.

When used for closeups, multipliers don't work exactly as you would expect. Whether or not you are adding extension, and if you are, precisely where you are adding it are critical factors. If you put a multiplier directly behind a lens that is set at infinity focus or very close to it, then you are multiplying the focal length. However, place extension behind a lens and add a multiplier behind the extension next to the camera body, and you are now multiplying the magnification, not the focal length. Only at infinity focus is multiplying the focal length the same as multiplying the magnification. This is easier to understand if you look at some figures.

Let's assume you have a number of extension tubes and a 50mm lens. To reach life-size on the film with the lens alone, you must add 50mm of extension. Working distance is roughly 4 inches, while light loss to extension is about two stops.

Let's get to life-size another way. Set the 50mm lens at infinity focus, add a 2X multiplier, and you now have a 100mm lens. To make it focus to life-size with extension you need 100mm of extension. The working distance is that of a 100mm lens, about 8 inches, double that of the 50mm focal length, while the total light loss is approximately four stops (two stops to the extension, two to the multiplier).

Let's do it a third way now. Take the 50mm lens and set it up for 1/2X with extension; in other words, add 25mm of extension. Now add the 2X multiplier to double the magnification. You still end up at life-size on the film, but now the working distance is about 6 inches, while the light loss is about three stops (one to the extension, two

to the multiplier). The question here is what is the effective working focal length? It's not 50mm, because that is the first method, and it's not 50mm doubled (100mm) as that is the second. Somehow we've created a variable-focal-length lens.

We could actually use the multiplier a fourth way to get to life size on the film, by adding extension in two places. If you mount a 2X multiplier onto equipment set up for a closeup by means of extension, and then add extension equal to half the focal length of the lens between the multiplier and the camera, you effectively increase the power of the multiplier from a 2X to a 3X. Start out with a 50mm lens and add 17mm of extension to get to 1/3X magnification. Add a 2X multiplier behind that and you double the magnification to 2/3X. Now add 25mm more extension, half the 50mm focal length, and the final magnification obtained is 1X. Your working distance is roughly 7 inches, while light loss is about three-and-a-half stops.

We're getting the same image size four different ways, with four different working distances, four different amounts of light lost, and four different effective focal lengths. You will have to decide which of these is most important for your field work in any given situation.

Standard macro lenses are the reason you should know where the extension is placed. Add a multiplier to a macro set at infinity focus, and the focal length is multiplied. Rack the lens out to its closest focus, though, and you have added extension between the lens and the multiplier, which is a whole different procedure.

If you already own several lenses, you probably won't often need to make a longer focal length; instead, you'll just change lenses. Going from a 100mm to a 200mm focal length, change to your 200mm lens rather than doubling the 100mm lens with a 2X multiplier. You'll find that multiplying the magnification is the way you will use multipliers most of the time.

The main drawback to using multipliers is the loss of focusing light, since your final lens combination is slowed by the power of the multiplier. A 1.4X multiplier changes the focal

length or magnification by 1.4 times, and changes the aperture by one stop. A 2X multiplier doubles focal length or magnification and slows the aperture by two stops. A 3X multiplier triples the focal length or magnification, and means a three-stop change in speed. For closeup work a lens that ends up being wide open at $f/8$ is awfully slow to focus, regardless of how you get there, so it is wise to work with the least powerful multiplier you can use.

It is often said that you "lose" f-stops with multipliers. A better way of saying this is that multipliers "move" the f-stops. You move all the f-stops over a certain number of stops, depending on the power of the multiplier. You may no longer have access to the wide-open stops, but you gain stops on the small end. However, above 1X you won't want to use these very small stops—in fact, avoid marked $f/22$ and $f/32$—because of a loss of resolution due to diffraction (see Part VII on diffraction).

You neither lose nor gain depth of field when using a multiplier. Remember that all lenses give the same depth of field when used at the same image size and aperture. With a multiplier you have created a new f-stop, and you get the depth of field of that stop at that image size. Add a 2X multiplier to a lens set at $f/8$, and you are now working at $f/16$ with the depth of field of $f/16$.

While it seems as if there should be a definite loss of image quality using multipliers, I have not seen it as much in closeup work as when multipliers are used to make long lenses into even longer focal lengths. The shutter speeds needed by long lenses dictate that they be used wide open, while for closeups the depth of field needed requires the lenses to be stopped down several stops, right into their optimum apertures. And for some strange reason, people seem to be more careful when shooting closeups, for which they will routinely use their tripods and cable releases, yet they will try to handhold a 200mm lens with a 2X multiplier.

For the best quality, resist the temptation for power. I have seen very little good field work done with a 3X multiplier. Reserve it for the studio, if you use it at all. You definitely lose quality as the power of the multiplier increases, so stay with the 2X models, or better yet, the 1.4X ones. Use them with the best lens you own. Use the best technique you can, and only use multipliers when you must.

If you have a multiplier and some extension, play around with different combinations to see what can be done. The time to do this is at home on a gray, rainy day, not out in the field when the good light is rapidly fading.

I shot the scene on the left at ¼ sec. without a multiplier. Given the extension I had with me at the time, it was the most magnification I could get.

To make the photo on the right, I added my 1.4X multiplier behind the close-focused equipment, thereby multiplying the image. I opened the shutter speed one stop to ½ sec. in order to compensate for the multiplier.

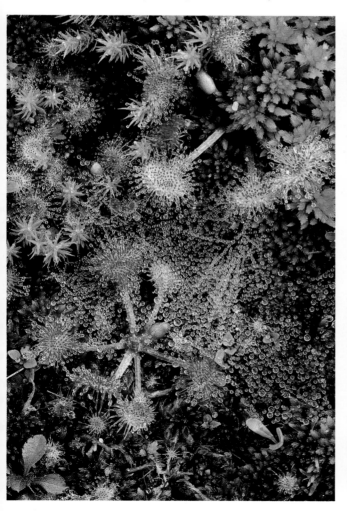 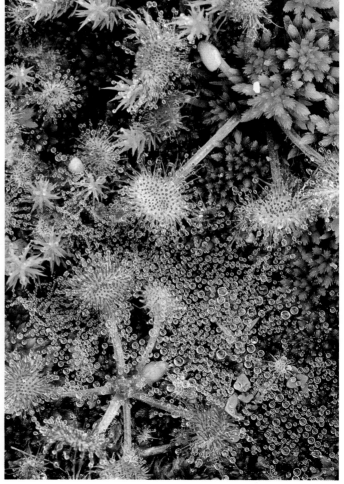

Round-leaved sundew and spider web. *Kodachrome 25, 105mm lens, 1/4 sec. at f/22*

Stacked lenses

There are two big advantages to using supplementary lenses: they gain magnification without using extension, so there is no loss of focusing light or shooting speed; and since no extension is used, diffraction problems are at a minimum. However, the magnifications obtained with supplementary lenses are extremely limited, especially if you want the best quality possible. Remember the formula for magnification with diopters: Magnification = Diopter power of supplementary × focal length of lens in meters. If you want to reach 1X magnification using a 200mm lens for some working distance, you would need a +5 diopter. No one to my knowledge makes a multi-element +5 diopter; you would need to resort to stacking together two single-element diopters, which would definitely lead to soft images. And what if you want to reach 3X magnification on the film? Now you would need a +15 diopter. Imagine the results you would obtain by stacking together five +3 diopters.

Extension is not a very practical answer for working in the field at magnifications that are greater than 1X. Suppose you're using a 105mm lens; you would need to carry 105mm of extension to get to life-size, 210mm to get to 2X, and 315mm—almost 12½ inches—to get to 3X. Light loss at 3X

would be at least four stops. If you start out with an F4 macro lens, you'll end up trying to focus at effective f/16.

There is another way. You already own several extremely high-quality, multi-element, flat-field optics that you can use as supplementary lenses to reach the higher magnification ranges. These are your regular camera lenses. Using them as supplementaries is a technique that I call "stacked lenses." Mount a longer-than-normal focal-length lens on your camera (I'll call this the prime lens). Now

take a shorter focal-length lens, set it wide open, and reverse mount it on the front of the prime lens so that the front elements are facing. All you're doing is using the shorter lens as a supplementary, but now it is a very high-power one. The diopter power of the reversed lens is 1000mm divided by the focal length of the reversed lens. In other words, a reversed 100mm lens is effectively a +10 closeup supplementary, while a 50mm becomes a +20. That's a lot of power.

Above, a 105mm F4 short-mount lens stacked on the front of a 200mm lens. Note that the short mount is set wide open.

The 105mm F4.5 enlarging lens to the left is stacked on the front of a 200mm lens and is also set wide open.

Section of dew-covered orb web.
Kodachrome 25, 105mm short-mount lens on 200mm lens, 1/2 sec. at f/11

Only during the stillest of mornings can you attempt to shoot this magnification of a dewy web. One problem is that you are so close to the web that your own body heat creates minute convection currents, and the web starts to move.

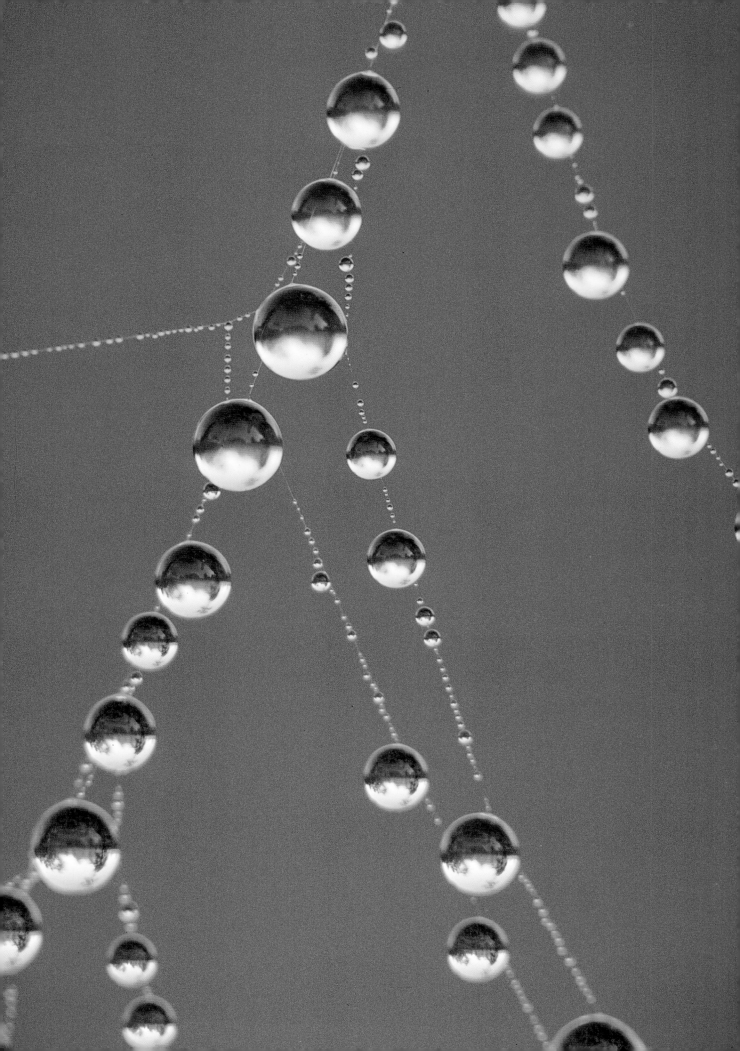

Waterdrops on tips of spruce needles. *Kodachrome 25, 105mm short-mount lens on 200mm lens, 1/60 sec. at f/4*

I intentionally used the prime lens wide open while looking into the backlit waterdrops in order to photograph the out-of-focus circles.

The magnification obtained with stacked lenses is roughly that given by this formula:

$$\text{Magnification} = \frac{\text{focal length of prime lens}}{\text{focal length of reversed lens}}$$

Stack a 100mm lens on the front of a 200mm lens, and you're immediately at 2X; stack a 50mm lens on the same 200mm lens, and you're at 4X. For field work 4X is the practical limit of magnification. Think about it—2X means a full-frame shot of a house mosquito, and 4X is the mosquito's portrait. A magnification of 6X is possible in the field, but you'll miss more shots than you get. Even at 4X it's hard

enough to find the subject while looking through the viewfinder, and what about maintaining sharp focus? The slightest camera or subject movement is now a gross focusing error, and any vibration during the exposure is a total disaster.

How do you physically mount two lenses together? If you're only going to photograph at these higher magnifications once or twice a year, just tape them together securely. If you plan on working this way more often, a connecting ring of some sort works far better. A possible solution is to purchase two filter adapter rings that are the sizes of the two lenses you plan on using and glue them together with super-strength adhesive. Buying a male-to-male, or macro-coupling, adapter ring is an even better solution. This is *not* a standard lens reversal ring with filter threads on one side and a camera mount on the other; it is

a ring with male filter threads on both sides. To use it, you just screw a lens onto each side. These rings are available in various standard filter sizes such as 52mm or 55mm on both sides; some rings even have different filter threads on either side so you can join lenses of different diameters. Try to keep the two lenses reasonably close in filter size, but a few millimeters difference is no big deal. You can also add step-up or step-down adapter rings to change size if you need several sizes. Your local camera store should be able to order male-to-male coupling rings from either of two camera-accessory distributors, the Kalt Corporation or the Dotline Corporation.

First you should find out which of your lenses work for stacking. Remember, avoid the temptation of power—stick with combinations that yield no more than 4X at the most. In

my teaching workshops I've checked every camera system on the market, and in every one there is some combination of lenses which works; you have to keep trying different lenses together until you find a combination that you like. However, I can make a few generalizations that might help you:

1. Use a telephoto for the prime lens. The best lens I've ever found is a standard 200mm.
2. Use the fastest reversed lens you can to yield a specific magnification. Suppose you have the choice of reversing either a 50mm F3.5 or a 50mm F1.8. Pick the fast lens, since you are only using it as a supplementary—the wider the glass is physically, the better the lens will work since there will be less light lost.
3. Don't use a heavy lens as the reversed one; it will cause too much strain on the prime lens's filter threads.
4. I've never seen two zooms that will stack together. While some long zooms can function as the prime lens if set at their longest focal length (such as the Nikkor 80–200mm F4.5), none that I know of will work as the reversed lens.
5. Two macro lenses generally do not stack well together.
6. It does not matter where the focusing mount of the reversed lens is set because it's not connected to anything.

Ideally what you want is to use the front reversed lens simply as a supplementary, leaving its aperture wide open and controlling exposure with the aperture of the prime lens. This way you'll have a fully meter-coupled, auto-diaphragm system just like you do normally. And since the working diaphragm is in its usual position and not greatly extended away from the film, diffraction is lessened.

The problem you run into with stacked lenses is vignetting, or the cutting off of the corners of the frame. You must check for this. Mount your two lenses together, or hold them together, with the reversed one wide open. Now set the prime lens to its smallest f-stop and use the depth-of-field preview control to stop the lens down. Look through the viewfinder at a light source, and you'll be able to see if you're getting a full frame image. If you're not, just add some ex-

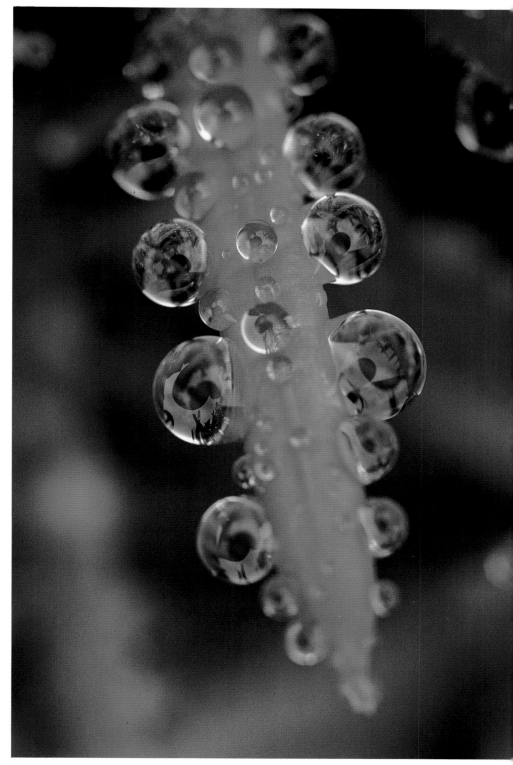

Raindrops on yew needle. *Kodachrome 25, 105mm short-mount lens on 200mm lens, 1/4 sec. at f/16*

You certainly don't have to travel far to find a good subject. These very organized water drops were on a yew planted next to my front door.

tension between the prime lens and the camera, and keep checking until you see the full frame. Almost all combinations will need some extension; enough extension will solve any vignetting problem, although if you insist on reversing a wide-angle lens, enough extension might mean a full bellows. Adding some extension also increases the magnification somewhat, which is not accounted for in the magnification formula for stacked lenses. You might discover there is enough extension in the focusing mount of the prime lens to take care of vignetting.

You can leave the aperture of the prime lens wide open and control exposure with the diaphragm of the reversed lens, but when you're shooting in the field, this is really a desperation move. Doing this you lose all the advantages of automatic-diaphragm coupling and wide-open viewing which you desperately want for field work.

Exposure with stacked lenses is easy—meter through the lens as you normally do. Since there is very little extension, there is not much light lost, although you lose some because the reversed lens acts as a fixed smaller aperture.

Short mount lenses are the best lenses for reversing. These lenses are designed for use on bellows: they are composed of only the glass and the diaphragm, and they have no focusing mount of their own. One problem with reversing regular lenses, especially physically large ones or macros, is that when reversed, the focusing mounts take up space and eat up precious working distance. By using a reversed short-mount lens, you can maintain all the working distance possible.

My favorite combination is a 105mm F4 short mount reversed on my standard Nikkor 200mm F4. This gives me roughly 2X magnification, and adding some extension ups this to 3X. Working distance is 3½ inches, which is considerable for this magnification. If I reverse my Nikkor 105mm F4 macro or a Nikkor 100mm F2.8 Series E on the 200mm lens, I cut my working distance to 1½ inches.

Short-mount lenses are not that easily found anymore. Pentax and Minolta still offer 100mm F4 lenses, Novoflex has a 105mm F4, and Spiratone sells a 75mm F3.5 and a 150mm F4.5. Since all you are doing is reversing it wide open, it certainly doesn't matter if the lens is the same brand as your camera or not.

Another possible option is to use an enlarging lens as the reversed lens. I've seen excellent results with a Componon 135mm F5.6 lens stacked this way. The enlarging lens doesn't have to be a great one; fairly cheap ones work well, too. I picked up a very inexpensive Lentar 105mm F4.5. The problem was figuring out a way of reverse mounting it—the lens has no filter threads. Since the lens didn't cost very much and I certainly had no plans to use it as an enlarging lens, I was willing to use any possible method to reverse it. Several accessory manufacturers offer metal filter-stacking caps, made to screw into either side of several filters mounted together, thus saving space in a camera bag. I bought a male-threaded stacking cap that in effect is a metal screw-in lens cap. I found its exact center using a machinist's centering gauge (available from most tool supply shops for a few dollars) and drilled a hole slightly smaller than the diameter of the lens into the cap. Finally, I simply glued the lens reversed onto the metal cap. A touch of black paint over the glue joint to keep it light-tight finished the job.

If you're using a camera lens or a quality enlarging lens reversed, you'll want to protect the rear elements and the diaphragm linkage. Make one more accessory: a reversed lens shade. Cut the center out of a standard, plastic rear-lens cap, and you're all set.

At the magnifications achieved with stacked lenses, focus is best done by moving the entire camera-and-lens assembly back and forth on a focusing rail. Turning the lensmount on the prime lens only adds a little bit of extension and is not a workable way of focusing.

Multipliers can also be added to a stacked-lens combination. Mount one behind the prime lens next to the camera body, and you will multiply whatever magnification you were at previously. Stack a 105mm lens on a 200mm lens for 2X, then add a 2-power multiplier and the final magnification is 4X. If you substitute a reversed 50mm lens for the 105mm lens, the final result is 8X. However, multipliers can be used behind the reversed lens, too. Assume that you are stacking on a standard 200mm lens and the only lens you have to reverse is a fast 50mm, but this combination yields far more magnification than you need. Mount a 2-power multiplier on the 50mm lens to create a 100mm lens, and reverse that combination on the 200mm lens for a final magnification of 2X.

Flash with stacked lenses

I shoot far more photos using flash with stacked lenses than I do photos with natural light because I like the motion-stopping short duration of the flash. Adding flash to a stacked-lens combination by using a flash bracket frees me in the field to photograph at high magnifications with all the flexibility of a handheld camera. Often, even when working on inanimate subjects, it is easier, faster, and simpler for me to handhold the camera rather than setting up a tripod; using flash makes this possible.

Either TTL flash or inverse-square flash works with stacked lenses. Be sure to position the flash so that its light clears the end of the lens. Working distance is so limited, especially at the higher magnifications, that it's easy to shadow the subject unintentionally. Use your TTL flash the same way you would on larger subjects. Don't use the wide-open *f*-stops because the flash cannot turn itself off fast enough for them—you'll get overexposed photos.

With inverse-square flash you must run another middletoned-subject exposure test. Remember that every time you change one of the variables—flash, film, lens, or combination of lenses—you must change your base exposure. Once again pick a reference point on the equipment; I use the coupling ring between the lenses. Position your flash over this reference point, and aim it at the subject. Run an exposure test on a middletoned subject, shooting in half-stop differences. Critique your resulting slides, and pick the proper exposure. You change the base exposure only when the reflectance of the subject changes, the same as when you shoot inverse-square flash on a regular closeup subject. Now, however, your flash-to-subject distance is very small, perhaps only a few inches, so precise flash positioning is critical. If your flash-to-subject distance should be 4 inches and you're off by 1 inch, at 3 inches you will have missed the correct exposure by almost one full stop.

Working with inverse-square flash, you'll discover that the real problem is too much light. Even the small flashes put out so much light that with the flash positioned over the coupling

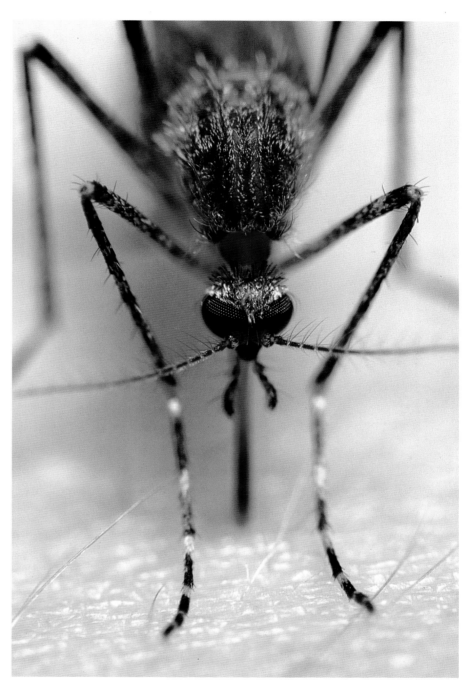

Mosquito biting. *Kodachrome 25, 50mm lens on 200mm lens, 1/60 sec. at f/32*

As I've said, a mosquito's portrait is 4X magnification! I had to back the flash off a little bit because I knew that if I had kept it in its normal position, the image would have been overexposed at f/32. Since that is the smallest stop on my 200mm lens, I couldn't stop down any farther to correct the exposure.

Wood tick. *Kodachrome 25, 105mm short-mount lens on 200mm lens, 1/60 sec. at f/22–32*

Sometimes you bring subjects home unintentionally. After a morning's shooting, I discovered this tick on my arm. Photographing the biting insects teaches you how to work your camera one-handed since your friends will disappear at the mere suggestion of being part of the background.

ring, you'll need to use about *f*/22 or *f*/32 on the prime lens. You might also need to shoot Kodachrome 25 or weaken the flash by moving it away from the subject.

Focus is absolutely critical. Even the slightest movement translates into a gross error. Brace yourself as much as possible, and focus by leaning in and out, not by trying to turn the focusing mount of the prime lens. Hold the stacked lens-and-flash assembly by gripping the camera with your right hand, index finger ready to press the shutter, and supporting the end of the lens by cradling it in your left hand. If you are working on an animate subject, be sure to fine focus on the eyes.

Because working distance is so limited, approach living subjects *very slowly*. Any fast movements on your part will quickly scare your subject away. Ease in slowly with your camera all ready to shoot, brace yourself for focusing, and carefully squeeze the shutter. Keeping the film plane parallel to the most important subject plane is absolutely necessary. Working at these magnifications with a handheld camera and flash is physically very demanding, as you'll soon discover.

Carpenter ant. *Kodachrome 25, 105mm short-mount lens on 200mm lens, 1/60 sec. at f/22*

I noticed carpenter ants repeatedly traveling along an old log. By bracing my camera carefully on the log I was able to photograph them.

Combination techniques

Long-legged fly with prey. *Kodachrome 25, 105mm lens with 3T diopter plus 1.4X multiplier, 1/60 sec. at f/11*

Trying different combinations of equipment to reach various magnifications is the best way to advance your closeup techniques, noting the pros and cons of working with each one. Some combinations are far more practical than others. For example, photographing 2X magnification with straight extension is not that convenient in the field due to the amount of extension needed, but when you shoot with stacked lenses, working distance is quite limited. Which would be the best method? That depends on what equipment you have with you and a host of other factors, such as the light loss you can afford, the slowest shutter speed the weather will permit, and the working distance

absolutely needed. However, the time to play around with equipment and to discover the practical answers is long before you're faced with a shooting situation outdoors.

Don't be afraid to string together seemingly improbable combinations. Shoot a few frames to test the equipment. And don't take anyone else's word as to what works and what doesn't work. Don't even trust *my* advice until you've tried it yourself with your camera equipment, working on your subjects. What works for me may not work well for you. Experiment with your lenses and your methods of photographing.

You will discover that working in the field means you often must simply

I set my 105mm at life-size with extension, then added the diopter. This did not yield enough magnification so I added the 1.4X multiplier next to the camera body. I used this combination for only one reason—it was the only equipment I had with me to give me this coverage.

Giant robber fly taking yellow jacket. *Kodachrome 25, 105mm lens, 1/60 sec. at f/16*

I used extension with my 105mm lens to photograph this robber fly at life-size. Robber flies are one of the most highly predacious creatures on earth, which is obvious considering the prey this one takes. If robber flies were the size of cocker spaniels, I seriously doubt if we would dare go outside.

use the equipment you have with you, regardless of any optical considerations. Getting an image is far more important, even if you must sacrifice some quality, than getting no image at all. As a result, I've shot some strange combinations of extension and lenses and multipliers because that's all I had with me at the time.

Here are some ideas for you to try. They have worked well for me; you should use them as starting points for some experimentation.

Macro lens plus two-element diopter used with flash. I shoot with this combination of equipment quite a bit. I use my 105mm *F*4 macro lens with extension to get to life-size, then add either a +1.5 diopter (the Nikon 3T) or, more often, a +3 diopter (the 4T) to the lens. With the 4T diopter I end

up at a maximum of 1.6X magnification, yet I can simply turn the focusing mount of the macro lens if I need to back off a little. I shoot this combination mostly with flash on my butterfly bracket. When I'm out chasing insects, it's so handy to carry the 4T diopter for more magnification, rather than hauling around additional extension tubes. Screwing the diopter onto the end of the lens is also easier than adding a tube between lens and camera, a real consideration when I'm trying to change my equipment without scaring off a highly mobile creature only inches away from me.

Adding the 4T diopter changes my base exposure for inverse-square flash since the diopter alters the focal length of the lens. To determine how much the exposure changes, I set up my outfit without the 4T and measure the flash-to-subject distance. Then I add the 4T and, without changing the amount of extension, move the camera in until it is in focus, and measure the flash-to-subject distance. By working in stops and comparing the two distances in stop values, I learn that I have moved the flash closer by 2/3

stop of light. In other words, when using the diopter, I stop down this amount from all my normal inverse-square flash exposure variations depending on the reflectance of the subject (see Part V on extension and inverse square exposure).

For example, suppose my normal middletone exposure is *f*/16 with inverse-square flash, but my subject is a little, brightly colored butterfly. I know that normally I would have to stop down 1/2 stop for it, halfway between *f*/16 and *f*/22. Now add the 2/3 stop caused by the diopter, and I end up shooting this subject at just a smidgen down from *f*/22. Using TTL flash would automatically take care of all these calculations except for the non-middletoned subject, but I want to know how to compensate for the diopter in case I don't have a TTL flash with me.

Macro lens plus two-element diopter plus multiplier used with flash. To the combination described above I add a teleconverter behind the extension, next to the camera body, to multiply the magnification obtained. Most

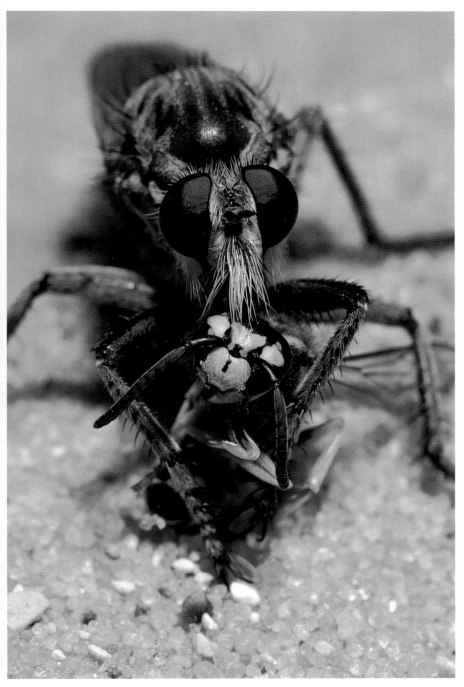

Giant robber fly taking yellow jacket. *Kodachrome 25, 105mm lens with 4T diopter, 1/60 sec. at 1/3 stop open from f/22*

Here I have added the 4T diopter in order to move in a little tighter on the robber fly. I saw the fly come down with its prey, stalked it to take the first photograph, then carefully added the diopter to get this portrait. I tried to align the film plane with the plane of the eyes of both the fly and its prey.

of the time I do this with a 1.4X multiplier since I normally have it with me in the field. To figure out exposure I start with my final answer above, then open up one stop (a 1.4X multiplier changes exposure by one stop). Using the same shooting situation as on example, I open up to just a smidgen past *f*/16 for correct exposure of the little butterfly. Here again, TTL flash would take care of all but the nonmiddletoned subject.

Stacked lenses plus multiplier used with flash. Occasionally, I use my 1.4X multiplier behind a stacked lens combination for a little more magnification. I do this when I'm stacking my 105mm short-mount lens on my 200mm lens, which is the combination that gives me the most working distance. Adding the 1.4X raises the magnification to about 2.5X. I have at times tried using my 2X multiplier instead of the 1.4X but I've gotten rather mediocre results that I think were partially caused by the lack of focusing light. Shooting indoors I would not use a 2X-multiplier combination at all, but would stack my 55mm lens on my 200mm lens, which would yield the same magnification at less working distance but with more focusing light.

As for my flash exposure with the multipliers, my base exposure opens up by one or two stops, depending on which multiplier I'm using. My normal middletoned subject exposure with my 105mm short-mount lens on my 200mm lens and my small flash positioned over the coupling ring is halfway between *f*/22 and *f*/32 for Kodachrome 25. If I add the 1.4X multiplier, I set the lens to between *f*/16 and *f*/22; the 2X requires it be set between *f*/11 and *f*/16. Of course if I shoot Kodachrome 64, I compensate one stop for its faster speed, but if I'm using TTL flash, it takes care of all this.

Part VII
SPECIAL CONSIDERATIONS

Reversing a lens

A normal or shorter focal-length lens designed for general use will supposedly not provide its best performance when magnifications approach 1X or higher. Normal lenses are designed to be used so that the distance from the rear of the lens to the film is smaller than the distance from the front of the lens to the subject. If you add enough extension to create magnifications of 1X or higher, this relationship becomes reversed; now the lens is greatly moved away from the camera and nearer to the subject, and the lens-to-camera distance is much greater than the lens-to-subject distance.

Theoretically then, a lens's optical performance will improve if you reverse mount it so that its rear elements are now facing the subject. A standard reversal ring lets you do this; it has male filter threads on one side, and a female camera mount on the other. This reversal ring lets you mount the lens directly on the camera itself or on some sort of extension. If you mount the lens on the camera, the magnification rate and the focused distance are fixed. Mounting the lens on a variable length of extension is the only way to change focus. Either way, turning the focusing mount

of the lens itself has no effect whatsoever.

In the studio this reversal technique is workable. It does give you some quick magnification since most 50mm or shorter lenses have a retrofocus optical design—turn them around and you instantly get a magnification on the film of at least 1X. You will also gain considerable working distance compared to the working distance you would have at any magnification with the lens in normal position.

It's another story in the field. Any theoretical advantage to reverse mounting a lens quickly disappears, as far as I'm concerned. The problem is that reversing a lens also disconnects all the linkages between camera body and lens—the meter coupling is gone and so is the diaphragm coupling. Automatic full-aperture metering is something that you can easily live without; instead you can take a stopped-down meter reading. You'll have to check your camera's instruction manual for this procedure. (Take a lens off-camera and see if the diaphragm still operates. If so, just reverse the lens, turn the camera meter on, and change the aperture or shutter speed until the meter gives you a cor-

rect reading. You have a manual-diaphragm lens—a throwback to the 1960s. However, if the aperture of the lens doesn't move as you turn the f-stop ring, read your instruction manual *very* carefully.) However, loss of diaphragm automation is another story and is exactly why I would not suggest field work with reversed lenses.

Almost all lenses today have automatic diaphragms; that is, you view through the lens wide open, even though it is set at some other f-stop. When you press the shutter release, the lens stops down to the selected aperture, then opens wide again after the exposure. You don't have to view the subject at the smaller shooting aperture. An auto-diaphragm lens gives you a brighter image to focus, and less depth of field to confuse where you are focused because this lens automatically presents you with the least depth of field at the widest f-stop. Otherwise, if you have considerable depth of field, how do you know when one exact point is in perfect focus?

Losing diaphragm automation means that you either have to focus at a stopped-down aperture, or you focus wide open and then manually stop down just before shooting. Loss

Here is a 55mm lens reversed on a bellows. Whenever you reverse a lens, add a lens shade to the reversed lens to protect the elements and the diaphragm linkage. An easy way to make a shade is to take a standard rear lens cap and cut out its center. Now add it to the reversed lens, and you have a neat little shade and protector.

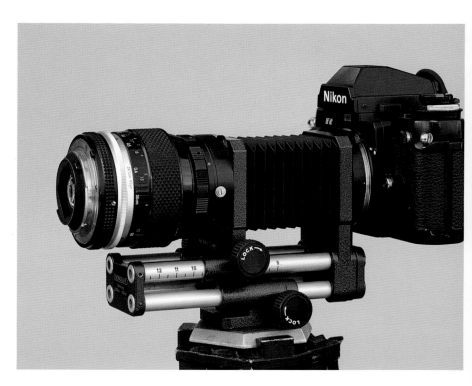

of focusing light is easily solved in the studio by additional modeling lights. Outdoors, there is no substitute for a wide-open aperture. Even on a sunny day, focusing at 1X with the lens open to f/16 is a monumental problem, and how often do you work in bright sunlight? Well, you could focus wide open, and then stop the lens down. This will work for inanimate subjects, but it is a disaster if you're working on moving creatures. Try to hold precise focus on a snail crawling while you're stopping the lens down to shooting aperture, and you will soon give up theoretical quality for practical results. Reserve lens reversal for the studio where you're working in good light with your tripod on a flat, hard surface. There are more practical ways to work in the field.

The hardest part of snowflake photography is picking up the flake. I catch the flakes on a towel, then transfer them with a short plastic stick onto a clean microscope slide that I use only as a holding stage. The blue background is a piece of poster board about 6 inches below the snowflake. Obviously this all has to be done outside.

Snowflakes. *Kodachrome 25, 55mm lens reversed on bellows*

Movie-camera lenses for high magnifications

If you want to do very high magnification work—anything over 4X on the film—you won't be working in the field. A 4X magnification is the extreme practical limit of what can be photographed outdoors with any consistent success. In fact, I would consider 2X a more reasonable limit; 4X is pushing it. Remember that 4X means a subject ¼ × ⅜ inches. Above that degree of magnification, it's basically all studio work.

The ultimate lenses for sharpness and contrast at high magnification in the studio are undoubtedly the true macro lenses offered by most of the major camera manufacturers: for example, the Macro-Nikkors from Nikon, the Luminars from Zeiss, the Leitz Photars. These are short-mount lenses (most come with microscope threads so you need an adapter to mount them on a bellows), and their focal lengths are matched to certain magnification ranges. (For example, Leitz offers the following Photars for these magnifications: 12.5mm $F1.9$ for 15X–30X; 25mm $F2.5$ for 7X–16X; 50mm $F4$ and $F2.8$ for 3X–8X; 80mm $F4.5$ for 1X–4X; and 120mm $F5.6$ for 1/2X–2X.)

Unless you're doing a lot of very high magnification work, though, macro lenses have some definite drawbacks. First of all, they are very expensive. Plan on spending a minimum of five hundred dollars per lens head, and you still need a camera-mount adapter, a bellows, and a focusing rail. If you are going to do a range of magnifications, you'll also need different focal lengths. Some of the lenses are cold in their color rendition since they are basically made for tungsten lighting; trying to filter a lens of this type is impossible, so the lights must be filtered instead. Since macro lenses are for use in magnification ranges where the diffraction caused by stopping down can be significant, they are sharpest at their wide-open apertures, which of course means the least depth of field. They are also manual diaphragm, and at 6X or 10X, trying to turn a diaphragm ring without bumping the whole outfit can be very frustrating.

There are some alternatives if you don't need the absolute, ultimate quality of these lenses. Up to 6X I simply use stacked lenses because they are so convenient, plus it gives me the benefits of auto-diaphragm coupling. My 35mm $F2$ lens stacked on my 200mm lens gives me just about this magnification, and frankly, I almost never shoot subjects that small. But if I need more magnification I use a reversed movie camera lens from an old 8mm camera. My Keystone-Elgeet ½″ $F2.5$, with apertures to $f/22$ cost all of five dollars. I found it in a camera store's junk drawer, and for the few times I ever need the magnification, it works just great. For the best results you should use a reversed movie-camera lens for subjects that are the actual size of the original film format or smaller. In other words, a lens from an 8mm camera can be reversed for 7X or higher magnification, while that

This reversed movie-camera lens is mounted on a plastic body cap. The mounted lens is then added to a bellows and focusing rail.

from a Super-8 camera can be used at 6X or more.

Mounting it on a bellows is a little tricky. My lens actually came with a retaining ring that screws into the front of the lens so that tiny drop-in filters can be used. This retaining ring has threads and a lip just wider than the threads, and it looks like the eye-piece ring that screws into most cameras' viewfinders. I took a standard plastic body cap with a Nikon female-bayonet mount on it and used a machinist's centering tool (a little V-shaped angle available at Sears or other tool outlets) to find the exact center. The retaining ring is just a little thicker than the plastic body cap, and since it screws right into the lens, mounting the lens was easy. I carefully drilled a hole in the body cap just large enough to insert the threads of the ring from the rear of the cap, and then simply screwed the lens onto the other side. Results: a reverse-mounted lens centered on a body cap. To use it, all I do is mount the cap on a bellows.

Figuring out the correct exposure is the hard part. In actual practice, the lens should be used fairly wide open to avoid diffraction, yet this particular lens is definitely soft at its maximum f-stop. I use $f/4$ as a compromise. One flash placed about 45 degrees to the side is all the lighting that's needed. The flashtube and reflector of even the tiniest flash are huge compared to the subject area now being photographed.

Through-the-lens flash is most useful here. You simply position the flash wherever you want it and shoot, controlling exposure with the auto-compensation dial if the subject is not middletone. (You could shoot inverse-square flash on manual by first running a series of tests to determine a base f-stop. Set the flash at a measured distance and note the magnification by recording the extension. Leave the flash in the same location, but shoot several different magnifications at different f-stops, and keep careful notes. This should give you a working range of stops and magnifications. Given a choice, TTL flash is a lot easier.)

Wing scales of tiger swallowtail butterfly. *Kodachrome 25, movie-camera lens on bellows, 1/60 sec. at f/4*

One light is definitely all that's needed here. Note how the shallow depth of field cannot quite accommodate the curvature of the wing.

Plastic bowl lighting

At times the natural light level may be so low that exposure with an extension-based closeup system becomes impractical, even if there is little wind movement. Very long exposures are definitely time consuming, and a series of 30 sec. exposures on the new electronic cameras will quickly wear down batteries.

One solution is to use flash, but this rarely re-creates the soft light in which you originally viewed your subject. Bouncing the flash off a foil reflector helps, although even this gives very direct lighting. One simple solution for small, fairly flat subjects is to make a light tent that will totally surround the subject with open light. An indestructible tent for field work is easily made from translucent, plastic, food-storage containers or bowls. Find one

that is a diffused, opal white, and not clear plastic or a solid color.

Cut a hole in the bottom of the plastic bowl through which to photograph. Now place it upside down over a small subject, and it makes a perfect, rigid tent. Aim a flash at the subject from the outside, firing it right through the plastic to diffuse the light. You can use two flashes, one on either side, to balance the light, or line part of the inside of the container with crumpled aluminum foil and use one light from directly opposite to bounce light around inside.

Determining exposure is best done with a series of test shots if you're using inverse-square flash. The plastic will absorb some light, the exact amount depending on the plastic's thickness and color. Set it up on a

The natural light exposure required by the shot on the far left was very long. My base meter reading was 1 second at f/4, but I wanted to shoot at f/16. Reciprocity would indicate 16 seconds at f/16, and doubling the time to correct for reciprocity failure gave me a final exposure of 32 seconds at f/16. That's a long shutter speed.

Photographing with one light diffused through my plastic bowl was the answer. For the photo below, I used TTL flash at f/16. The light is very similar to the open, soft, natural light although there is a slight color difference. In this case I much prefered the warming light obtained through the bowl over the cool natural-light exposure.

Mosses. *Kodachrome 25, 105mm lens*

middletoned subject, and run a test series of exposures that vary by 1/2 stops. Start with your standard inverse-square exposure and open up from there. You'll probably discover that if your plastic container is the diffused milkish plastic, not the solidly white plastic, you lose less light than you would expect. Using TTL flash is an even easier way to control exposure since the flash will compensate for the light absorption. Remember that with either system, you still have to compensate for non-neutral subjects.

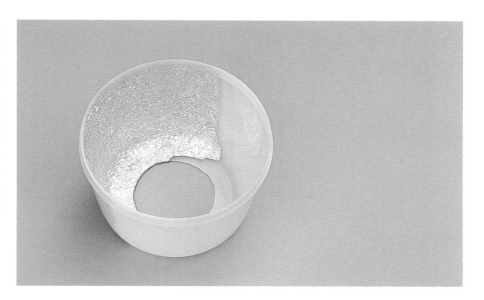

This plastic bowl has a hole cut in its bottom. You can see the foil lining part of the inside.

This pair of photos shows the difference between direct flash and flash through the bowl. The straight-flash photo on the top has dark shadows, while the bowl flash shot on the bottom is far more open.

Rocks. *Kodachrome 25, 105mm lens, 1/60 sec. at f/11*

Nikon's 300mm ED-IF lens with extension

Animals have a particular range, a "fear circle," and if you stay outside of it, they will ignore you. Enter into this fear circle, and they will quickly leave. A long focal length is therefore necessary for photographing dragonflies, damselflies, large butterflies, or frogs from a distance with natural light. Even when you're shooting inanimate subjects, there are times a long working-distance perspective is exactly what you want.

Owners of long focal-length lenses that have exceptional close-focusing abilities can take advantage of this fact. The Nikon 300mm *F*4.5 ED-IF is such a lens. All by itself, the lens goes down to a magnification of 1/7X at a working distance of 7 feet 4 inches from the front of the lens. Adding some extension lets the lens reach ever higher magnifications, yet it retains the extra working distance of the long focal length.

One major problem when adding lots of extension to physically long lenses is that the whole assembly starts to teeter-totter on a tripod head. Vibration is a major concern. Any connections between tubes, or between lens and tubes, or between tubes and camera are potential weak links. You need to build a brace to cut down vibration and the slight movement inherent in so many connecting joints.

Nikon users have an advantage in that the PN-11 extension tube is available. This 52.5mm tube has a rotating tripod collar on it. Add some extension behind the 300mm *F*4.5 ED-IF, then add the PN-11, and now there are two tripod sockets: one on the lens, and one on the large tube. A wood or metal brace can tie these two sockets together, and a tripod socket added to the brace itself lets the lens assembly be mounted centered on a tripod. To shoot verticals, loosen both tripod collars and rotate the lens. Nikon's large tube is the only one I know that has a built-in tripod collar. However, you could still build a brace that pushes up against a rear tube or even connects into the camera's tripod socket, although doing the latter means flopping the tripod head to shoot verticals.

My usual outfit is the 300mm *F*4.5 ED-IF with the Nikon PK-12 and PN-11

Robber flies mating. *Kodachrome 64, 300mm ED-IF lens with 80mm of added extension plus homemade brace, 1/125 sec. at f/5.6*

Due to a constant breeze, I was forced to shoot the top photo with the lens almost wide open. Although I waited for lulls in the wind, I only managed to take two frames. In the photo to the right, I was concerned with limiting the background. A long focal-length lens on a brace was the answer. I chose my camera position carefully, making sure I was parallel to the subject. Because the light level was low, I couldn't stop down too far.

Frost on milkweed seed caught on dried star thistle. *Kodachrome 25, 300mm ED-IF lens with 80mm of added extension plus homemade brace, 1 sec. at f/11*

tubes stacked together, for a total of 80mm of extension. I can still use the focusing mount of the lens to change image size. With the lens set at infinity I'm getting 1/4X with 60 inches of working distance. When I rack the lens to its closest-focusing distance, I get 1/2X from 38 inches. Talk about reach! While I don't often need this, it definitely yields pictures that I can't get otherwise.

Don't run out and buy this lens only to do closeup work. The point I want to make is that you should experiment with your own equipment, trying different combinations to see if you can get double-duty from some of the equipment you already own.

Working early in the morning, I needed the reach of the long lens, as the bur-reed was growing several feet out into a pond. I didn't need as much extension as in some other photos because this is a larger subject.

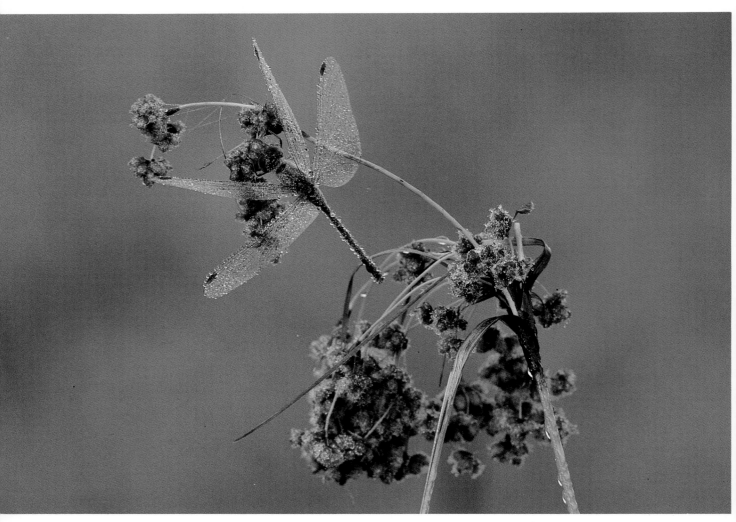

Dew on dragonfly and bur-reed. *Kodachrome 25, 300mm ED-IF lens with 52.5mm added extension plus homemade brace, 1/4 sec. at f/16*

Here is the Nikon 300mm ED-IF lens with 80mm of added extension from Nikon's PK-13 and PN-11 tubes and a homemade brace mounted on tripod.

Micro aquariums and well slides

There are many small organisms that live all or part of their lives in pond water. Included in this group are mosquitos, diving beetles, dragonflies, damselflies, and true aquatic life such as water fleas. Photographing the latter presents a problem since you're obviously not going to work on location. The only answer is to bring them into the studio.

The first problem is collecting your subjects. The easiest method I know is to go wading in the ponds. Chest waders are definitely better to wear than hip boots, since the latter have a nasty habit of filling up from the rear when you squat down to peer through the water surface or check a specimen. If you have never waded in a pond before, try it first in daylight and use a wading staff to search out any holes or drop-offs. Having a second person along might not be such a bad idea, either.

My collecting materials include several white plastic bowls with lids (such as the ones nondairy topping comes in). Small creatures readily show up against the white background. Just dip up some pond water and take a look at what you have. I use a small eyedropper or pipette to transfer very small subjects such as water fleas between collecting bowls. To gather larger subjects or ones too deep to reach readily by dipping, I use a small tea strainer taped to a three-foot section of broom handle.

Photographing these subjects means shooting them in their habitat, so you'll need to construct some micro aquariums. The best one that I've come up with for mosquito-larva-sized subjects is made from standard 2-inch squares of slide mounting glass glued together. Make a small cube, open at the top. If you glue the sides to the outside edges of the bottom piece, instead of to the top surface of it, then you'll still be able to drop a final piece of slide glass into the micro aquarium and use it for manipulating your subject. Fill the aquarium with distilled water, so that all the particulate matter from the pond water doesn't show. Remove all air bubbles from the glass surfaces by reaching in with a watercolor brush and touching the bubbles. (If you don't do this, every bubble will show up as an out-of-focus highlight.) Now take your subject and, after running it through a series of distilled water baths, add it to the aquarium.

Unless you want a black background, you'll have to add an artificial one. Take a piece of paper and swirl watercolors on it. The appropriate colors are the greens, tans, and browns of pond vegetation. Prop this up a little distance behind the micro aquarium.

Mosquito larvae. *Kodachrome 25, 105mm lens with extension to 1X (plus 1.4X multiplier behind the extension) 1/60 sec. at f/16*

These are photos of mosquito larvae, commonly called "wrigglers" because of their swimming motion. Although they live in water, all mosquito larvae come to the surface to breath air through the gills at the end of their abdomens. These larvae were photographed in a glass-slide micro aquarium with one light on the aquarium and one light on a watercolored background.

Daphnia water flea with eggs photographed at 5X. *Kodachrome 25, 55mm F3.5 lens stacked on 200mm lens mounted on bellows, 1/60 sec. at f/22–32*

I made these photos with my homemade well slide by photographing these subjects against my "black hole."

Midge larva, *Eucoretha underwoodi*, photographed at 4X. *Kodachrome 25, 55mm F3.5 lens stacked on 200mm lens, 1/60 sec. at f/22–32*

You'll have to use flash for your lighting. One main light coming from above and in front of the aquarium should suffice for most subjects. Watch out for reflections. You can easily tell if your lighting position will work by holding a flashlight or high-intensity desk lamp at the flash position. Look through your camera viewfinder and see if you're getting the reflection of the lamp. If so, just change the position of the light until you don't have the reflection. Add a second light on the background, about the same intensity or a little less (see Part V on flash theory). It's easier to use a slave unit on this second light rather than stringing the two lights together. (A slave unit is a tripping device that fires the second flash from the burst of

light from the main flash connected to your camera's PC terminal.) I put a little piece of crumpled aluminum foil under the aquarium to act as a reflector from below.

Now determine your exposure. Decide what closeup system you want to use, remembering that you need a fairly narrow angle of view to limit your background coverage. Run an exposure test, shooting at various *f*-stops. I use my standard butterfly-bracket outfit. Depending on the magnification I need—and a mosquito larva is about 1-1/2X or 2X—I use my 105mm lens set up at life-size with extension, with a T3 two-element diopter on the front of the lens, or I use the 105mm lens at life-size with extension and a 1.4X multiplier next to the

Hydracarina water mite photographed at 6X. *Kodachrome 25, 35mm F2 lens stacked on 200mm lens, 1/60 sec. at f/22–32*

camera. I know the normal exposure for these outfits, and the little amount of distilled water in the 2-inch square aquarium doesn't absorb enough light for me to worry about.

For the very small creatures, such as water fleas or red Hydracarina mites, you'll have to make a well slide. This is a slide that holds two or three drops of water. Commercially available well slides are not satisfactory for photography; they are glass slides about 1/4- or 3/8-inch thick with wells hollowed out in the glass. On most commercial slides, the bottom of the well is curved. In my experience with my lighting setup, a curved well bottom yields uneven lighting. My solution is to take a standard microscope slide and draw a small circle on it with glue. If you place a water drop on a plain glass slide, the surface tension of the water curves the droplet to form a meniscus. You want to flatten out the drop as much as possible, and the glue circle forms the sides of a flat-bottomed well, resulting in the least curvature of the meniscus.

You can also use an artificial background with these small subjects, placing it several inches below the well slide. Many of them stand out best against a black background. I made a "black hole" by lining a plastic film canister with black felt. I just tape it to my microscope slide, directly below the wall. This yields a shadowless, true black background.

One light, skimmed across the well, is generally enough for minute pond creatures. Such small subjects often dictate using a stacked lens setup because of the magnifications needed. Although it is wise to keep some notes, you will probably use an exposure close to your normal one for stacked lenses. TTL flash might not work here; it tends to lighten the background. Run your flashes on manual and keep meticulous notes on your tests.

Use distilled water in the well and wash the subjects in several baths. Look through the viewfinder to make sure there are no particles floating around in the water. A high-intensity desk lamp placed to the side helps. To reach in and remove any particle, use a probe made from a needle inserted into a wooden match stick.

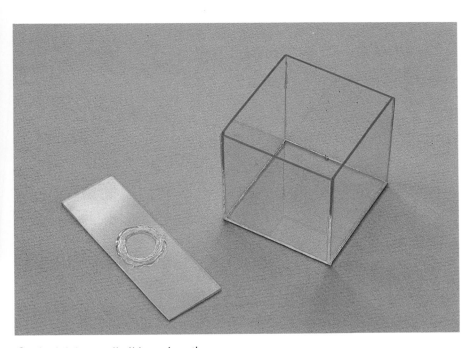

On the left is a well slide and on the right is a micro aquarium. Both are indispensable for photographing aquatic organisms and are easily constructed using slide mounting glass.

Articulating bellows

Prostrate bluets and dandelion. *Kodachrome 25, 105mm short-mount lens on articulating bellows, 1/2 sec. at f/16*

I used the articulating bellows here to maintain my point of view. The bluets' blossom normally tilts to one side with the light, and in order to shoot into the blossom, rather than down at it, I had to work from the side. The dandelion was not on the same plane as the bluets, so I had to stop down to include it in my depth of field.

Normally, we think of a bellows as a means of gaining extension. However, there are a couple of special bellows that also let you move the front standard of your camera in different directions: from side to side, parallel to the film plane (*shifts*), or pivoting around the optical axis (*swings* if it is a horizontal pivot, *tilts* if it is a vertical pivot). In other words, you can achieve some of the controls featured on a view camera.

Stopping a lens down is the usual way of gaining depth of field. When you do this, the plane of depth is always parallel to the film plane, even if the subject is not. Let's assume that you want to photograph something that lies at an oblique angle to the film

plane; that is, you don't want to photograph with the camera squarely parallel to the subject. The only way to achieve edge-to-edge sharpness—if it is possible at all—is to stop down, sometimes to the smallest stops available. However, this in turn means you are forced to use an ever slower shutter speed, and at times the wind defeats such slow speeds.

How then can you get can around limited depth of field or gain working distance with the lens fairly wide open? One answer is to change the plane of the lens. If you can move the lens so that its plane, the film plane, and the subject plane all intersect in a common point, you have maximized depth of field by using a law of optics

called the Scheimpflug principal. What you are actually doing is controlling the plane of focus, then you stop down the lens to retain the depth of field coming out of this plane.

As far as I'm aware, there are three models of articulating bellows. Minolta offers the Bellows III, Nikon used to make the now-discontinued but still findable PB-4, and Spiratone sold what they called the "Bellowsmaster." The latter can sometimes still be found under the Samigon label. The Spiratone unit is a T-mount system and as such will fit just about any camera mount. The Minolta and Nikon bellows fit those brands respectively, and a competent repairman could change the rear mount to accommodate other cameras since these bellows are manual-diaphragm units. Both the Nikon and Minolta bellows offer swings in their normal mounting position. To use the tilt movement, which I think is the most useful, just mount the bellows on a tripod, flop the tripod head for a horizontal, and then rotate the camera back into whatever orientation you need. With the Nikon PB-4 you'll have to mount the bellows so that it is to the right of the tripod head, or else the camera will be upside down when shooting a horizontal. All three bellows also incorporate focusing rails as part of their systems.

Finding a lens that will give good coverage when you move it off-axis is a problem. For closeup photography, many normal and longer lenses, including macros, will work so long as you don't use extreme movements of the standards. For the most flexibility, though, a short-mount lens is the way to go. This is a lens made especially for use on a bellows, and most will permit a good deal of camera movement. When you mount a normal lens on a bellows, you can only work up close because even when the bellows is closed all the way, it is still a considerable amount of extension, roughly 45mm. In order to move the lens standard around, you must have the bellows extended a little bit so that it can flex. A short-mount lens is the answer. Because it has no focusing mount of its own, it must be mounted on some sort of extension in order to focus, which means the bellows has to be extended. View-camera lenses are all short mounts—they must be mounted on a view-camera bellows in order to be focused. Enlarging lenses are an-

Magenta paintbrush. *Kodachrome 25, 105mm short-mount lens on articulating bellows, 1/4 sec. at f/8*

Notice here the front-to-rear sharpness, yet I shot at a moderate aperture. I was working in the mountains, and there was enough of a breeze that I wanted the fastest possible shutter speed.

This is the discontinued Nikon PB-4 bellows with a 105mm F4 short-mount lens on it. I had a repairman shorten the rails 100mm to make the bellows easier to pack in the field.

other example of short mounts. In fact, some enlarging lenses such as the Schneider 135mm *F*5.6 Componon S can be used on a 35mm articulating bellows if you cannot find a normal short mount lens.

Nikon once made a 105mm *F*-4 short-mount lens, Novoflex sells a lens with this focal length and speed, and Pentax and Minolta still offer 100mm *F*4 short mounts. These lenses will permit you to focus to infinity on the bellows or, by extending the bellows, to focus up close with the working distance of any 100–105mm lens. As far as I know, you cannot use any shorter focal lengths with a bellows except for extreme closeup work. To gain longer focal lengths, use a multiplier behind the bellows, next to the camera. I've got the Nikon 105mm short-mount lens and have shot with both the 1.4X and 2X Nikon multipliers to gain longer focal lengths. I've done this for both scenics and closeup photos. You cannot use the teleconverter, or multiplier, right behind the lens, because it is not focused on anything; remember, a short mount lacks a focusing mount of any kind. If you put a multiplier directly behind a short mount, you simply cannot focus it at all, regardless of what you do.

To use an articulating bellows, pick the position from which you want to photograph. Now determine the principal plane of importance in the subject. Focus on a foreground part of the subject. Watch through the viewfinder as you move the lens standard off-axis by swinging it or tilting it. You'll see the plane of focus change. Then you'll also have to shift the lens off-axis to recenter the image in the frame; this means you're doing a combination of movements. Finally, touch up your focus, meter and shoot. This tends to be a very slow, studied kind of photography, and an articulating bellows certainly is a very specialized tool. Don't bother looking for one unless you have in mind some very specific photos that you couldn't do any other way. Even now that I have one, I certainly don't use it for the majority of my work; it is a large, fragile, bulky item to carry.

By the way, Canon makes a lens that offers tilts, the Canon perspective control (PC) lens, the 35mm *F*2.8 TS (for *T*ilts and *S*hifts). No other perspective control lens has tilts; most PC lenses only shift off-axis. However, for closeup work the Canon lens is limited due to its short focal length, although by using multipliers behind it, you could gain some length.

Diffraction and effective f-stops

As you gain magnification by increasing the extension in a closeup system, you lose depth of field. That's an optical fact of life, and so it would seem to make sense to regain the lost depth by stopping your lens down to its minimum *f*-stop. At magnifications up to about 1X you can basically do this without any real problems, but at higher magnification rates you will notice that although you gain depth of field, you lose sharpness. You've just discovered diffraction.

Diffraction is a physical problem dealing with the way light bends around the diaphragm blades in a lens. If you use a physically small hole, or one of the smallest *f*-stops, moved some distance from the film plane, you will definitely have trouble. Note that I say the hole is moved away from the film plane; in other words, you will encounter this problem most frequently when shooting high magnifications with large amounts of extension. The farther the aperture is from the film, the more the image resolution suffers.

F-stops are *f*-stops only when the lens is at infinity focus. An *f*-stop is a mathematical ratio between the focal length of the lens and the diameter of the optical diaphragm; it has nothing to do with the actual amount of light passing through the lens. We can call a measured amount of light a transmission stop or *t*-stop. When you extend a lens away from the film plane, the difference between the marked *f*-stop set on the lens and the *t*-stop actually being used may be considerable.

Another way of thinking about this is in terms of stops of the light lost to extension. Assuming a symmetrical lens, two stops of light are lost to extension when you photograph at 1X. If your lens is set at marked *f*/16, the two-stop loss would make it two-stops slower or an effective transmitting *f*-stop of *f*/32. Of course, a TTL meter automatically takes this light change into account.

In practice, lenses are called symmetrical when, if you take them off-camera and look at them from the front and from the back, there is no difference in the apparent diameter of the aperture. Try this with your lenses; look through them from both ends and you'll discover that almost no lenses today are symmetrical. Macros come as close as any, and the newer, faster ones are no longer as symmetrical as the older, slower ones.

Take a ruler and measure the apparent diameter of the diaphragm between the same two points from both sides. If the measurements are the same, your lens is symmetrical. If not, consider the degree of asymmetry, which is expressed in terms of the Pupillary Magnification Factor (PMF). This is the ratio between the apparent size of the aperture as seen from the rear (the exit-pupil diameter) divided by its apparent size as seen from the front (the entrance pupil):

$$PMF = \text{exit pupil diameter/entrance pupil diameter}$$

Now let's go back to the effective *f*-stop, and see how the PMF affects it. A symmetrical lens would have a PMF of 1. We can figure out the actual effective *f*-stop in use for a symmetrical lens with a formula:

$$\text{Effective } f\text{-stop} = \text{marked } f\text{-stop} \times (\text{magnification} + 1)$$

Say I want to use marked *f*/16. What is my effective *f*-stop in use when I photograph at 1X?

$$\begin{aligned}\text{Effective } f\text{-stop} &= 16 \times (1 + 1) \\ &= 16 \times (2) \\ &= f/32\end{aligned}$$

Sure enough, extension on a symmetrical lens costs you two stops of light to get to 1X because the effective *f*-stop has changed by two. But what about asymmetrical lenses? I measured one of my lenses, my 180mm *F*2.8, and found that the PMF is roughly .5. When this PMF factor is added into the effective *f*-stop for-

mula, it consequently becomes:

$$\text{Effective } f\text{-stop} = \text{marked } f\text{-stop} \times [\,(\text{magnification/PMF}) + 1\,]$$

Work the formula for the 180mm used at life-size at marked *f*/16 and look what happens:

$$\begin{aligned}\text{Effective } f\text{-stop} &= 16 \times (\,[1/.5] + 1) \\ &= 16 \times (2 + 1) \\ &= 16 \times 3 \\ &= 48\end{aligned}$$

This is just over three stops of light loss, instead of the two stops that a symmetrical lens loses. But consider what happens as magnification goes up and I try to use the smallest *f*-stop on the lens, marked *f*/32. Let's work it out for 3X magnification:

$$\begin{aligned}\text{Effective } f\text{-stop} &= 32 \times (\,[3/.5] + 1) \\ &= 32 \times (6 + 1) \\ &= 32 \times 7 \\ &= 224\end{aligned}$$

This is about five-and-a-half stops smaller than the marked *f*/32 at which the lens is set. Even a truly symmetrical lens at this magnification loses four stops of light, so that marked *f*/32 becomes effective *f*/128.

What this all leads to is a real loss of resolution, or the ability to record fine detail. Field work often demands using a longer focal-length lens to gain as much working distance as possible, but the longer the focal length, the more extension needed for any image size. And the more extension you need, the worse your diffraction problems will be. We tend to forget that we're not working at normal *f*-stops when we get into the higher magnifications. Now the small stops have become effectively minute holes, and as I said, diffraction is a problem caused by small aperture openings far away from the film plane. As a rule of thumb, avoid using any aperture smaller than marked *f*/16 at magnifications over life-size when using straight extension.

There are several solutions, but not all are that practical for field work. Re-

versing a lens at magnifications over 1X helps, since this requires less extension to get to any given image size. Less extension means less diffraction since the *f*-stops aren't changing that much. For field work, however, I don't consider reversing a lens a good option (see Part VII on reversing a lens).

Some subject matter doesn't have much fine detail, so loss of resolution may thus not matter as much as a gain in depth of field. Smooth-surfaced subjects may render diffraction problems essentially meaningless.

I think the best answer for field work is to avoid the whole problem by gaining magnification in some way that doesn't use much extension. This way you'll avoid most diffraction problems, keep the viewfinder image as bright as possible, and use the fastest shutter speeds possible which will eliminate some reciprocity failure. So what is this magical answer? Using stacked lenses is one way (and I believe the best way), and using multipliers to up the magnification is another. For my own field work, I normally use straight extension for magnifications up to life-size, then I add two-element diopters for magnification between 1X and 2X. Working over 2X in the field, I stick with stacked lenses.

Bunchberry and clubmoss. *Kodachrome 25, 105mm lens, 1/25 sec. at f/22*

Index